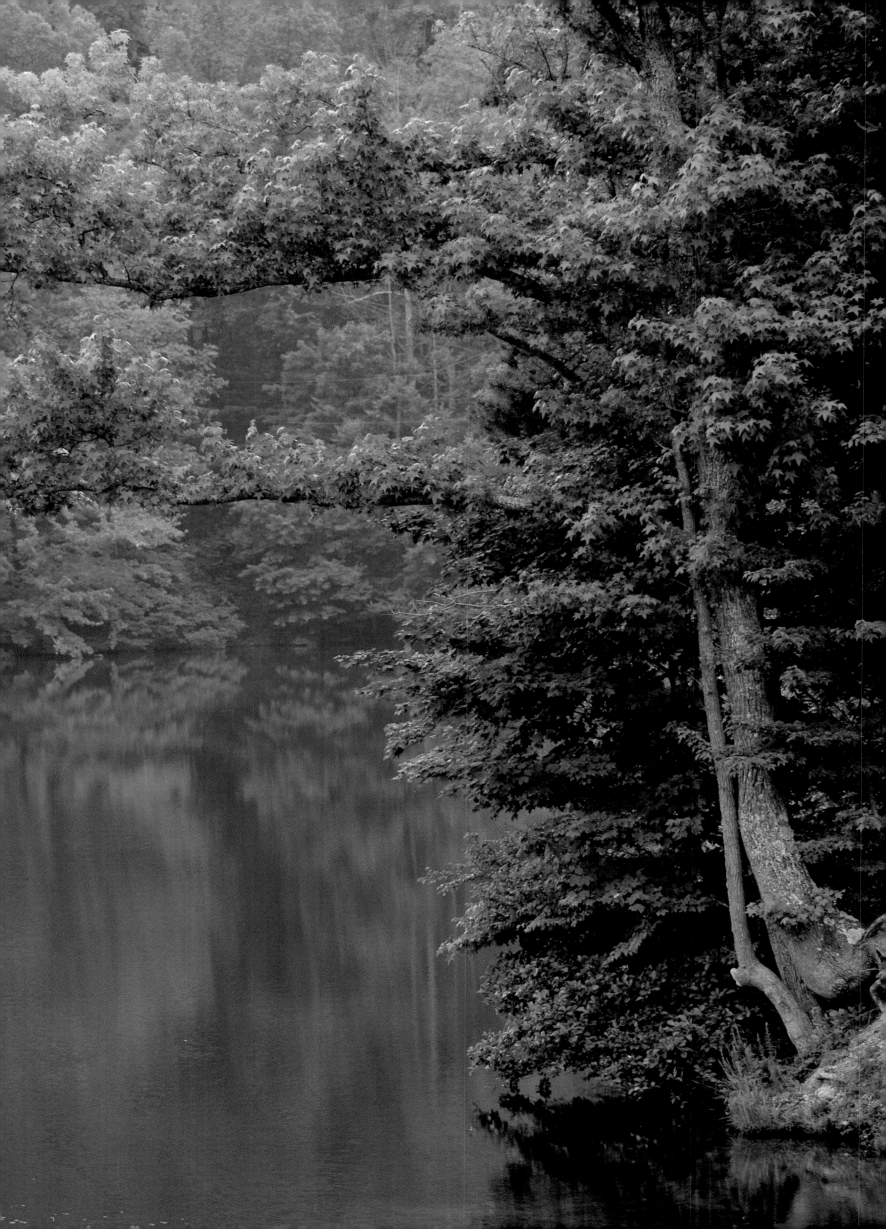

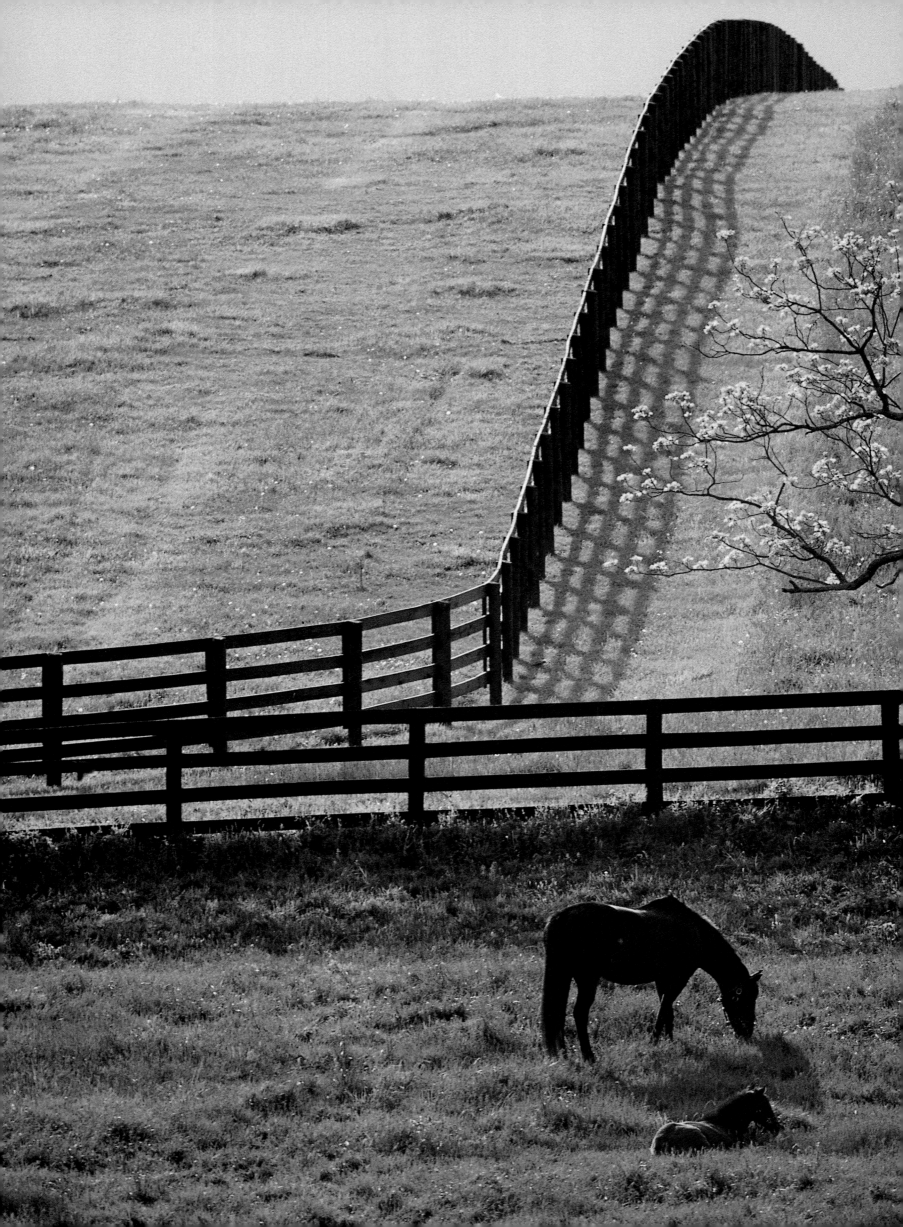

Dear Andrew,
As I glance at these
pastoral pictures of my environs following
a wonderful week immersed in yours, I am / What an
awed by the unbelievable contrast in the two. What an
unbelievable gift you have given us in this intense, exciting,
scenry, relationships and event filled week! And we are fully
aware and appreciative of your sacrifice in terms of stress, planning
time, expenses, and trip delay.
Venetian delay.
We can only communicate our thanks by returning
in kind — but of course, differently to you, your friends,
and family. A complete treasure — an "Andrew week in
his London" and Andrew, himself!
With my love —
Jackie
March 21, '03

KENTUCKY III

PHOTOGRAPHY BY JAMES ARCHAMBEAULT

ESSAY BY THOMAS D. CLARK

Andrew,

Just wanted to thank you for one of the
best weeks I have ever experienced. I look forward
to seeing you soon.
Cheers,

GRAPHIC ARTS CENTER PUBLISHING®

Library of Congress Cataloging-in-Publication Data:

Archambeault, James.
 Kentucky III / photography by James Archambeault : essay by Thomas D. Clark.
 p. cm.
 ISBN 1-55868-409-3
 1. Kentucky—Pictorial works. I. Clark, Thomas Dionysius, 1903-
II. Title. III. Title: Kentucky 3. IV. Title: Kentucky Three.
F452.A74 1999
976.9'0022'2—dc21 98-51957
 CIP

President/Publisher • Charles M. Hopkins
Editorial Staff • Douglas A. Pfeiffer, Ellen Harkins Wheat, Timothy W. Frew, Diana S. Eilers,
Jean Andrews, Alicia I. Paulson, Deborah J. Loop, Joanna M. Goebel
Production Staff • Richard L. Owsiany, Lauren Taylor
Designer • Robert Reynolds
Cartographer • Tom Patterson and Manoa Mapworks
Book Manufacturing • Lincoln & Allen Company
Printed in Hong Kong
Second Printing

◄ ◄ A maple clings to the shore of Fern Lake in the Cumberland
Mountains of Bell County. Once a gathering place for Middlesboro
society, the lake is now the domain of a private fishing club. ◄ With
her foal napping nearby, a thoroughbred mare grazes in a bluegrass
pasture on the Darby Dan Farm near Lexington.

KENTUCKY

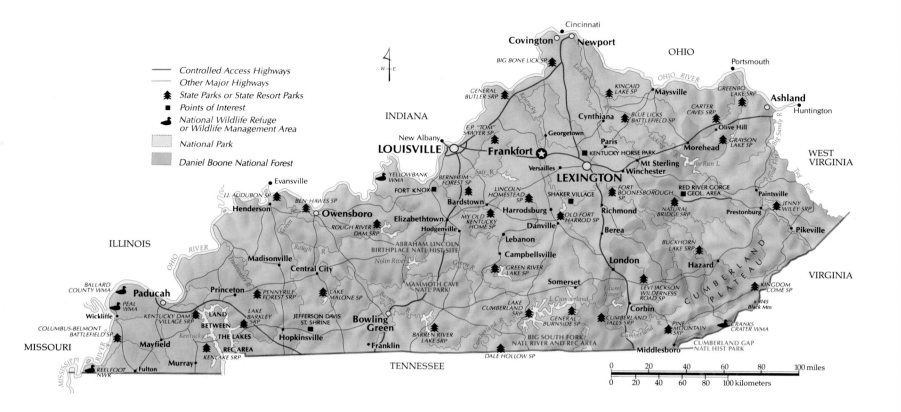

State Capital • Frankfort, founded 1786

Nickname • Bluegrass State

State motto • "United We Stand, Divided We Fall"

State song • "My Old Kentucky Home" by Stephen Foster

Statehood • June 1, 1792, the fifteenth state

Population • 3,698,969 (1990 census)

Name origin • From a Cherokee word meaning "land of tomorrow" or "meadowland"

State horse • Thoroughbred

State flower • Goldenrod

State bird • Kentucky cardinal

State tree • Kentucky coffeetree

State animal • Gray squirrel

State fish • Kentucky bass

State butterfly • Viceroy butterfly

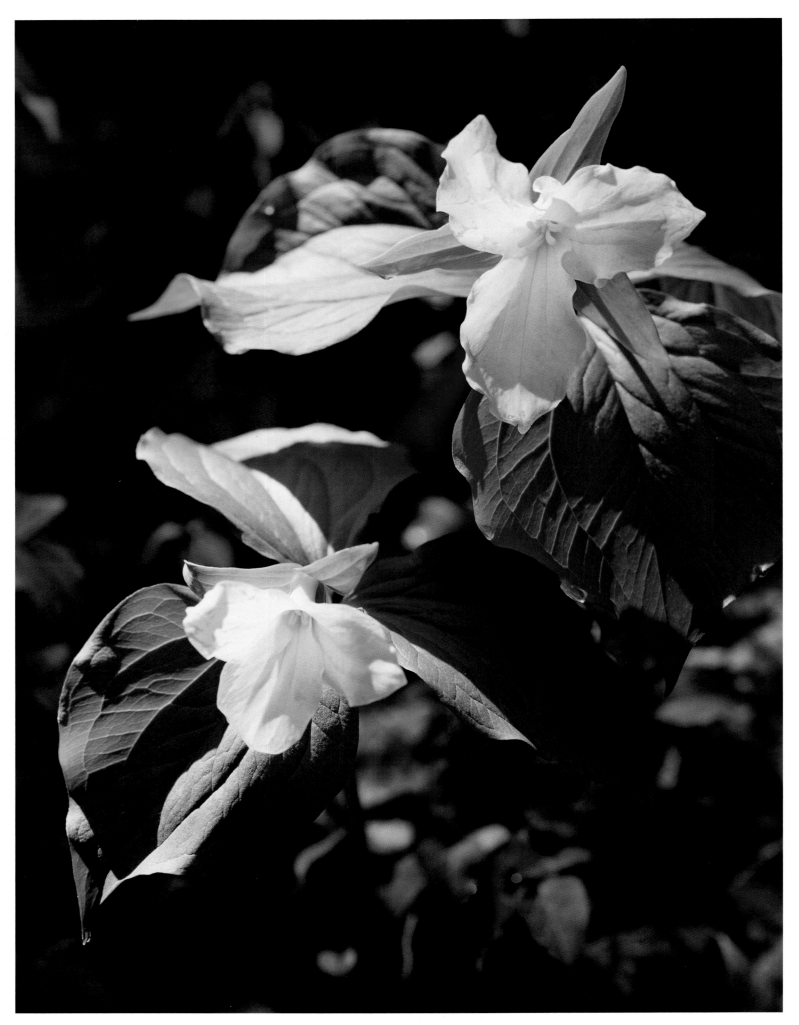

▲ The trillium is April's gift to the mountains of south central and eastern Kentucky. Entire slopes are covered with the white and occasionally pink flowers, such as these near Laurel River Lake.

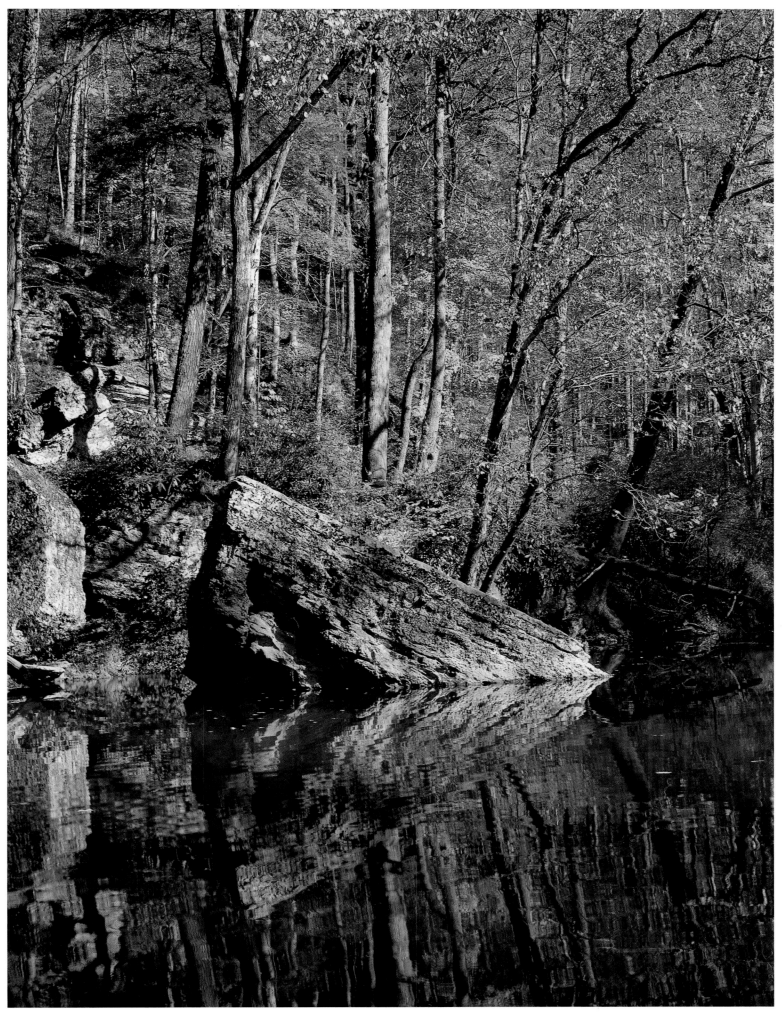

▲ Accessible only by kayak or canoe, the remote upper gorge of the
North Fork of the Red River has been designated a Kentucky wild river.

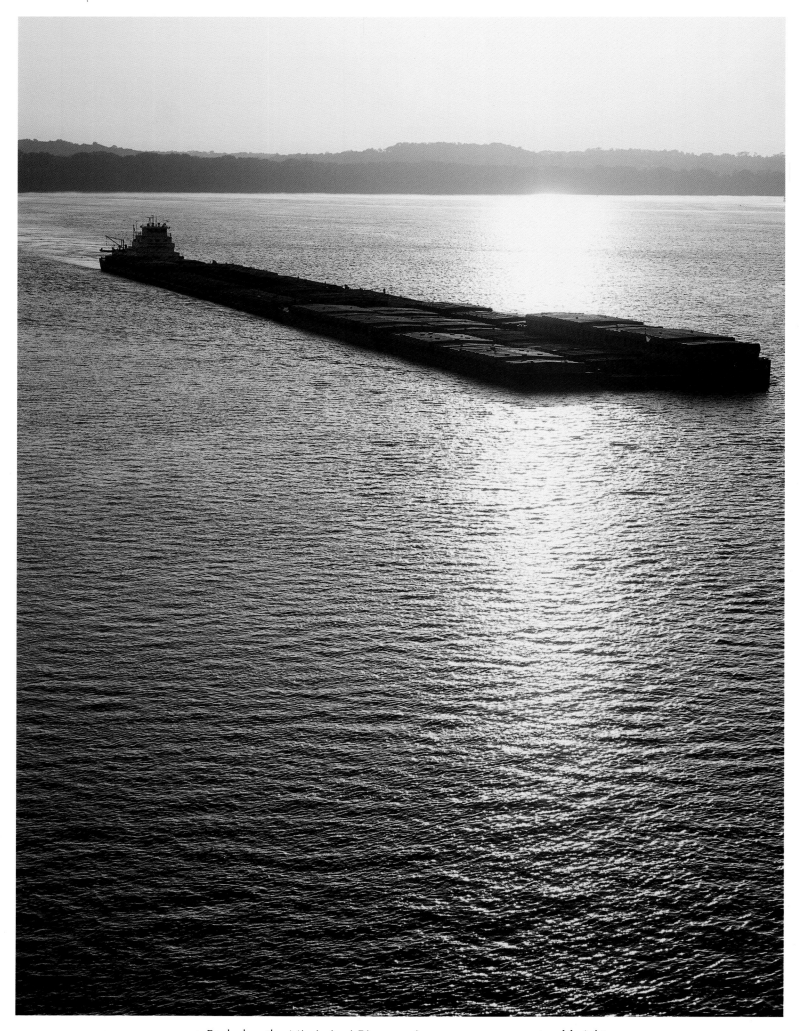

▲ Each day, the Mississippi River carries enormous amounts of freight from New Orleans upriver to St. Louis and beyond. This barge slowly makes its way north below the bluffs at Columbus in Hickman County.

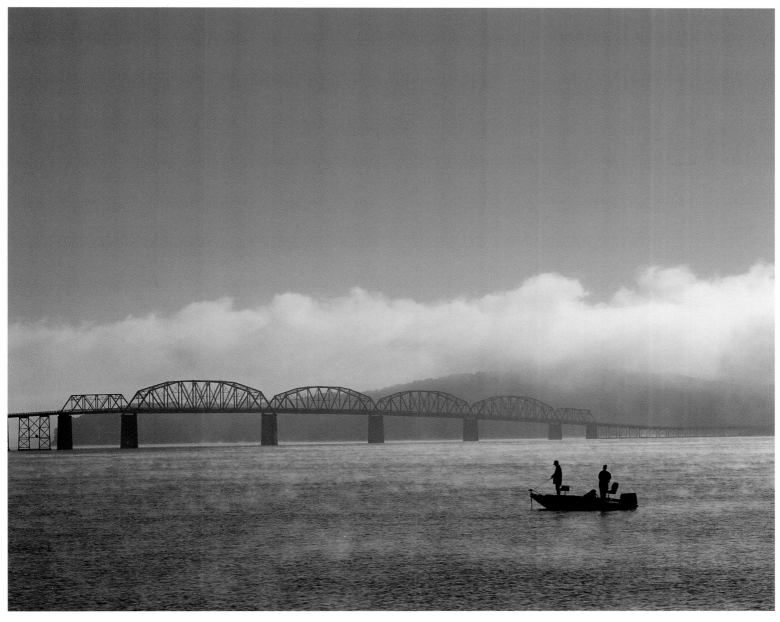

▲ Created by the Tennessee Valley Authority during the height of the Depression years, Kentucky Lake was formed by damming the Tennessee River. It makes possible not only hydroelectric power but also many recreational activities in western Kentucky.

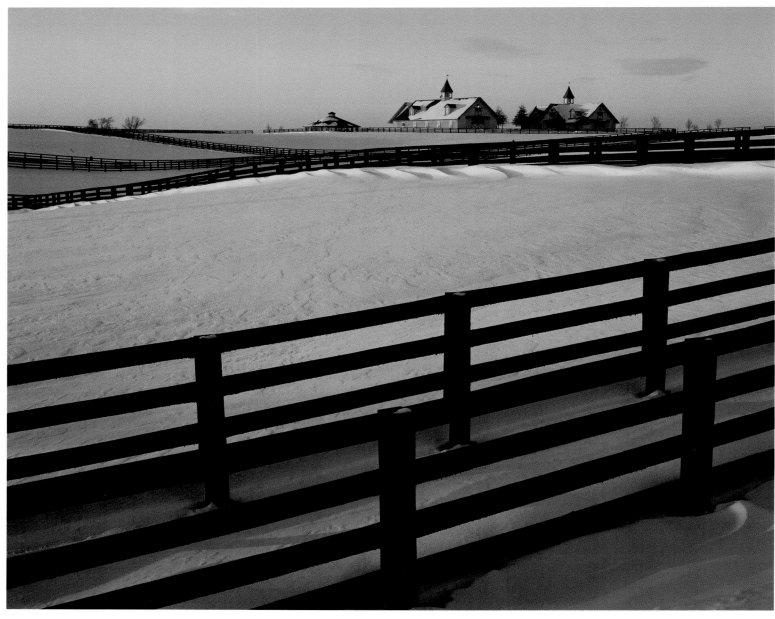

▲ The last light of a winter sunset tints the wind-driven snow on one
of the many elegant horse farms that showcase the Bluegrass region.

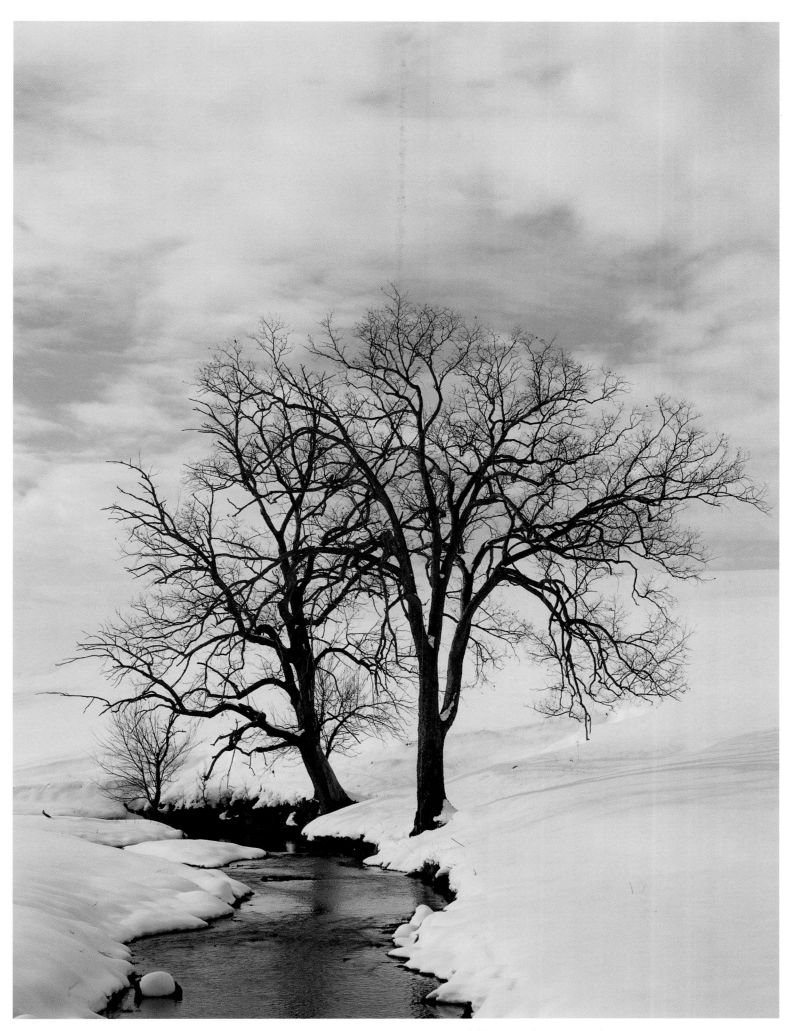

▲ A study in blue and white, a deep, rare snowfall covers the pastured hills bordering this stream in the heart of Kentucky's Bluegrass country.

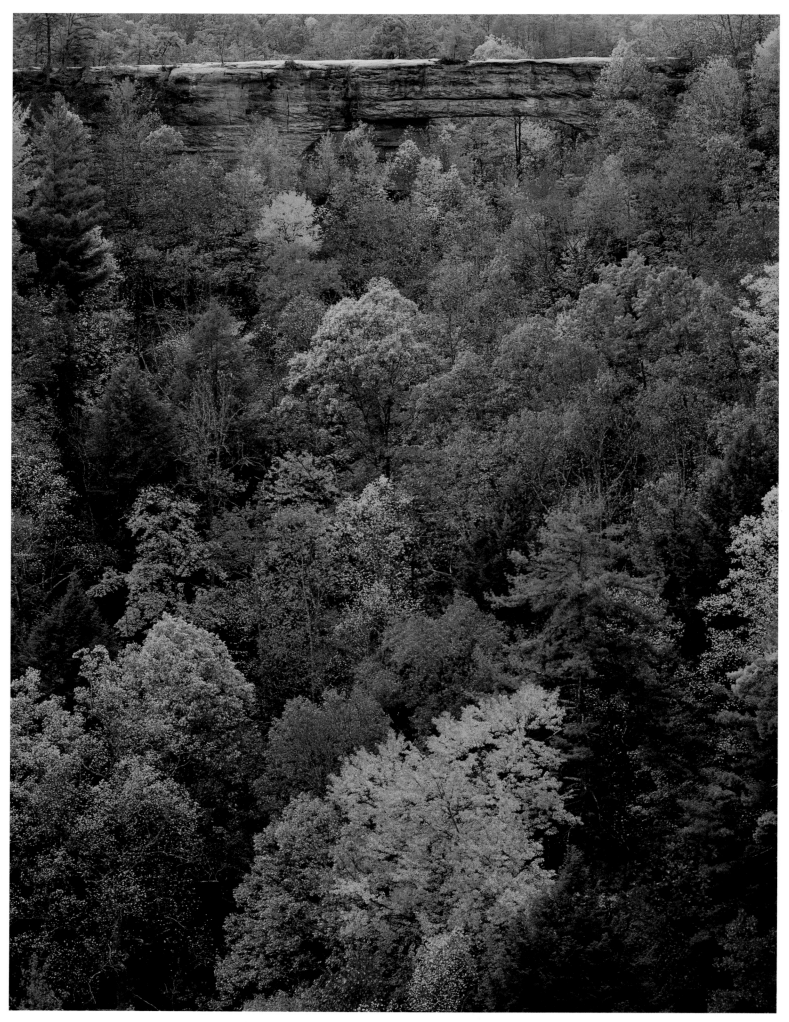

▲ Natural Bridge, a giant rock span in Natural Bridge State Resort Park, in Powell County, is the largest and most famous of the state's more than one hundred natural arches.

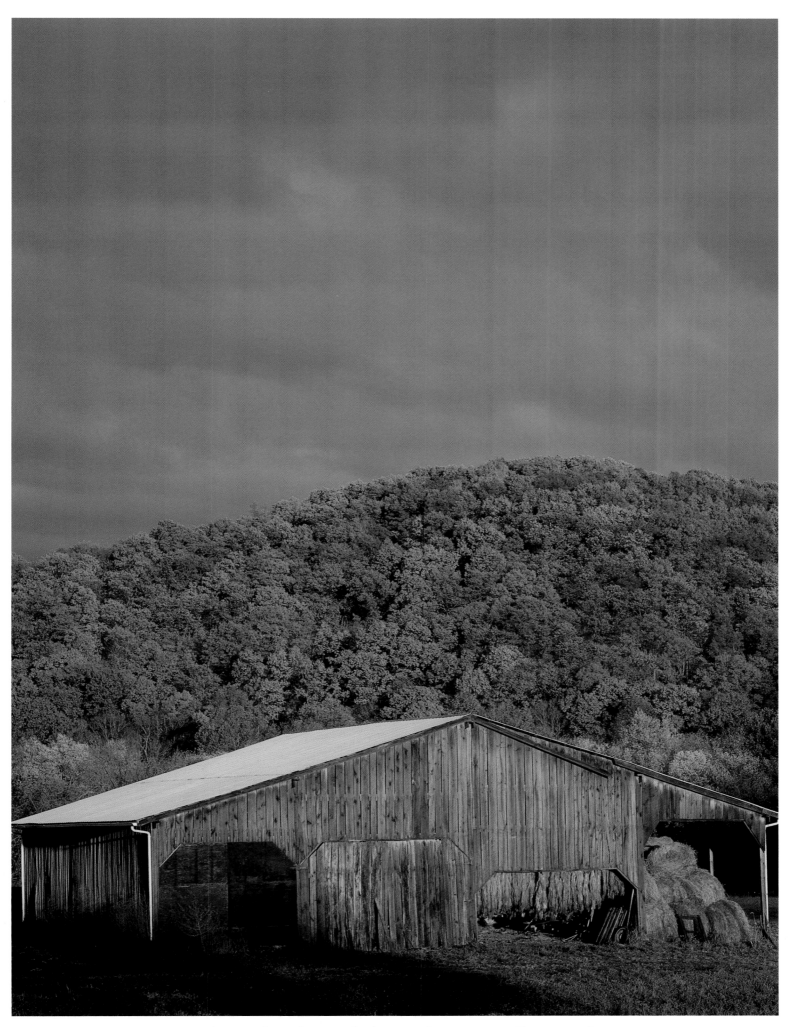

▲ The assault on the use of tobacco is beginning to affect Kentucky farmers. Here, burley tobacco leaves air-dry in a Carter County barn.

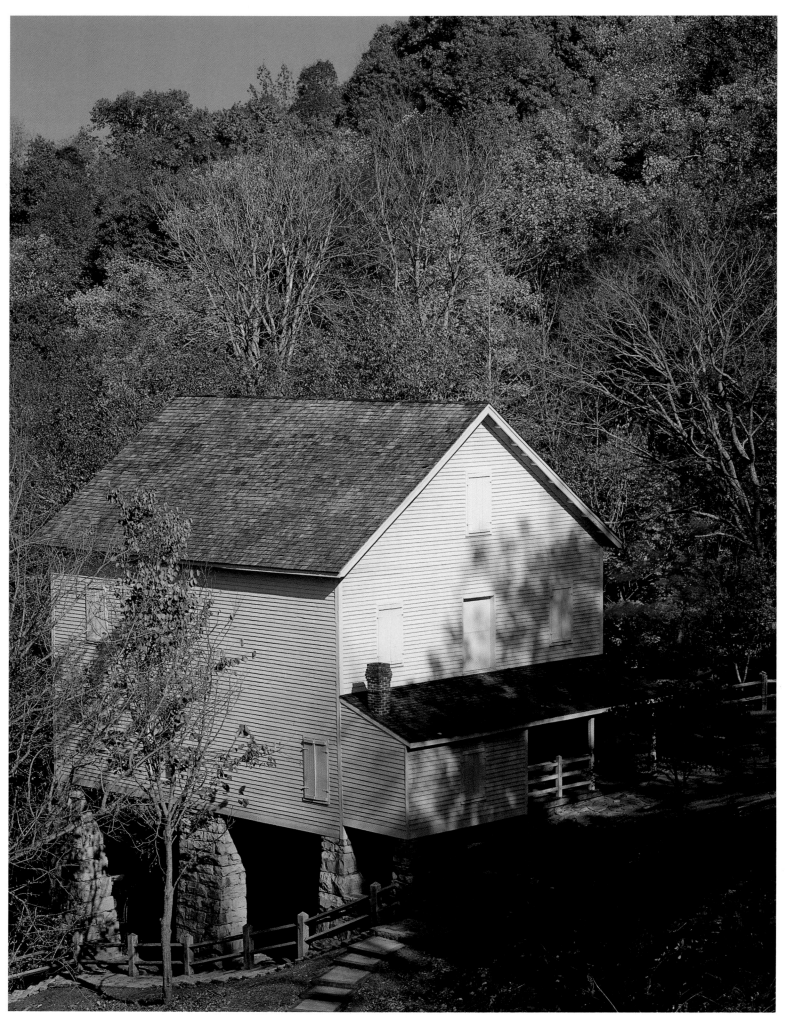

▲ Because of its location on the Cumberland River, the mill at Mill Springs in Wayne County was a site of military action in the Civil War.

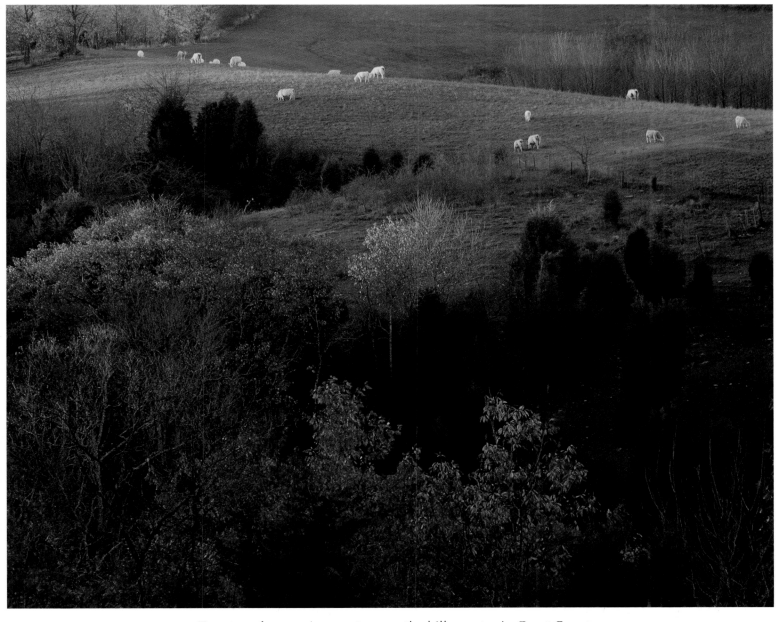

▲ Too steep for growing most crops, the hill country in Grant County
is ideal for grazing cattle, one of Kentucky's biggest farm products.

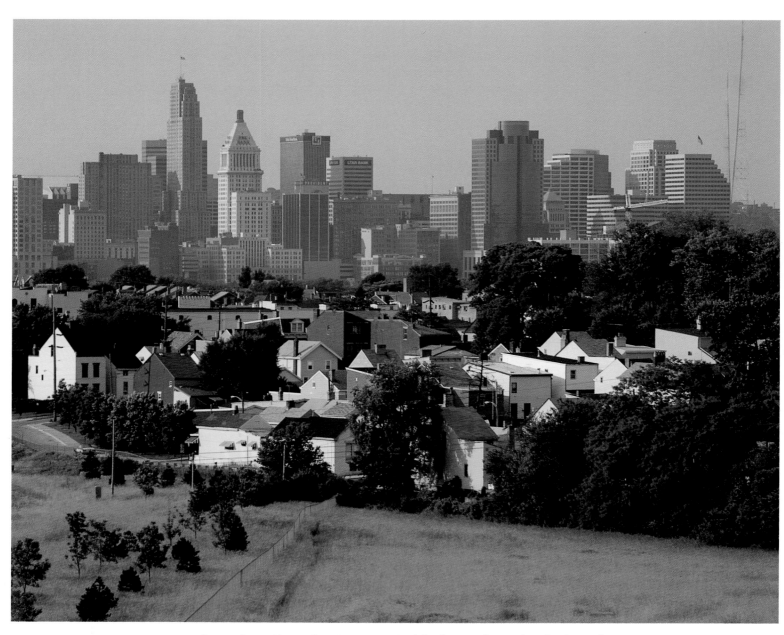

▲ In northern Kentucky, Covington's older homes lie in the shadow of downtown Cincinnati, Ohio. Between the cities flows the Ohio River, once a pioneer path that carried settlers into the western territories.
► Flowering trees make spring a stunning season. Here, dogwoods and redbuds cluster along Cumberland Parkway in Russell County.

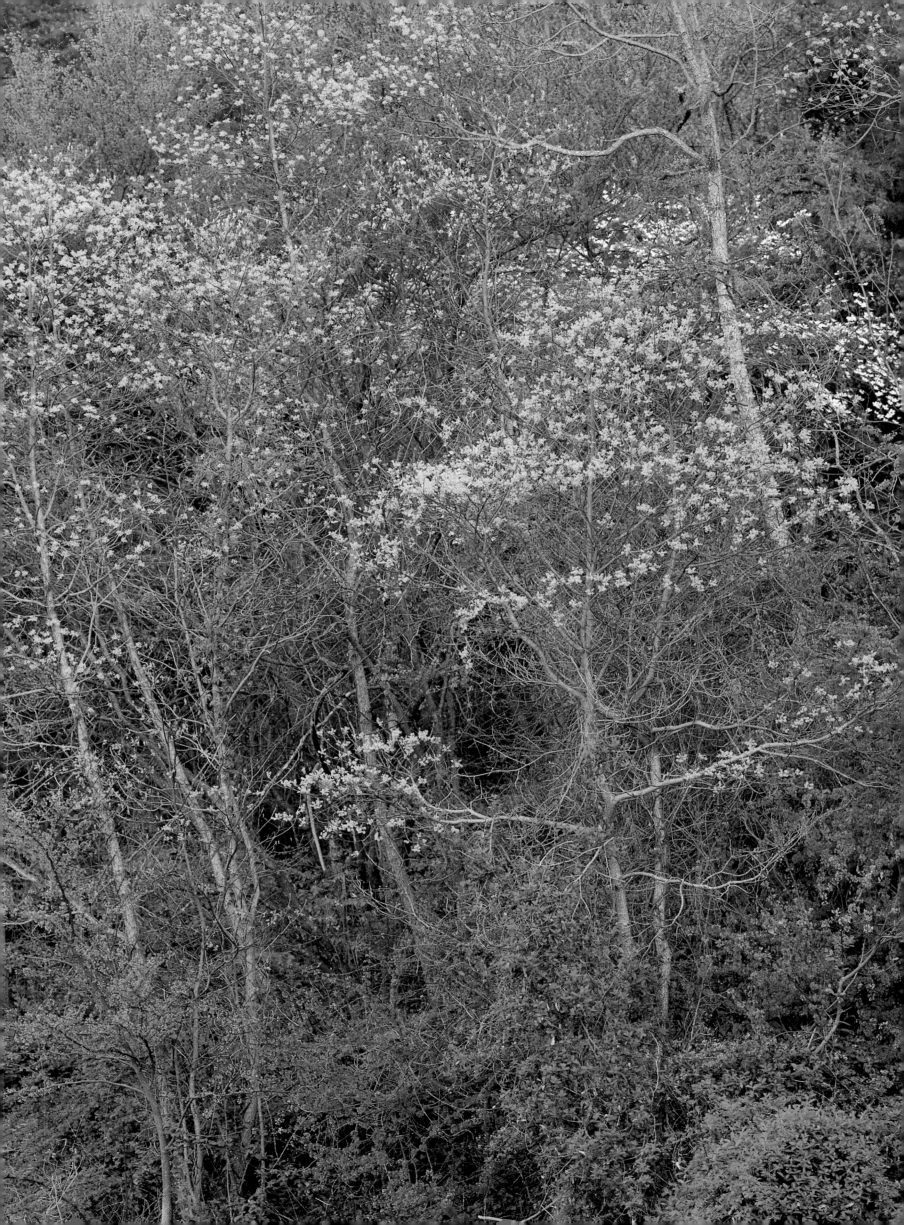

An aura of the past and the mist of future expectations hang over Kentucky as a new century dawns. There prevails in the state today a keen anticipation for what the future will bring, along with a fear of how it might blur the past. More than two hundred years ago, many an expectant pioneer with roseate vision hailed the Kentucky frontier as a "new Eden" where dreams might be realized and new beginnings made. Kentuckians as they enter the twenty-first century are looking back into their state's history and asking: "How well have the people of all eras treated this western Eden? How well have we realized our ancestral dreams?"

From the historic southern gateway to Kentucky at Cumberland Gap northward and eastward to the Ohio River, this land remains a geographical anomaly. In creating the topography, Mother Nature surely had a puckish

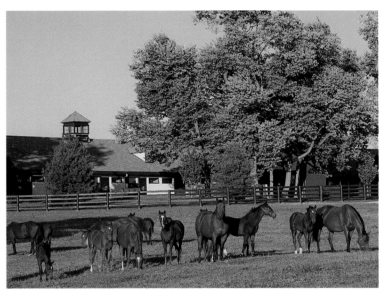

Thoroughbreds graze on the Gainesborough Farm in Woodford County. The older foals will soon be weaned.

sense of humor. Not even topographical engineers with their bag of sophisticated instruments have fully and finally untangled the snarls of Kentucky's external and internal boundaries, relying instead upon the catchword "indefinite" to relieve their dilemmas. In its present form, Kentucky is a collective political entity of many sectional parts with vaguely defined boundaries.

Whimsical observers have compared Kentucky's distorted physical outline, with its big hump in the middle, to that of a squatting camel. Others say it looks like a pear. But whatever its form, the boundaries in good part were set both by

◀ *In Jenny Wiley State Resort Park near Prestonsburg, a maple tree shows effects of the first hard freeze in late October.*

the natural lay of the land and by politicians no doubt ignorant of Kentucky geography.

To declare Kentucky a land of contrasts is an understatement of obvious geographical and political fact. Since the staking of the first western land claim, Kentuckians have made cultural and political compromises within their sectional fiefdoms. The people of the farms and fields in the Bluegrass, of the rural heartland known as the Pennyrile (the Pennyroyal), of the eastern highlands, and of the Jackson Purchase lands in the far southwest exist in manageable harmony, despite the depth of sectional instincts and loyalties. Kentuckians live, happily or not, under the unifying provincial cliches of "Bluegrass State," "Home of beautiful women and fast horses," "Home of bourbon whiskey," "Politics, the damnedest," and the everlasting "hillbilly" tag.

* * *

The essence of Kentucky's human history derives in large part from the remote and unrecorded past. For millions of years the forces of nature have been active in shaping the area now politically designated as Kentucky. They have slashed deep river and creek beds through rockbound land, indented coves and ravines, tumbled down monstrous boulders, and stripped bare countless miles of lime and sandstone cliffs. Long before the western country was first explored, nature had already stamped upon the land the patterns that would shape the economies, social institutions, and political mores for centuries to come. Planted in the land were fertile soils and abundant veins of clay, coal, and iron. The stone resources are perhaps inexhaustible and have been used by humans from the beginning to reshape the Kentucky horizon.

Paleolithic people built mounds and rock walls. Later, Indians hunted across the entire face of what became Kentucky, tramping out trails and, in one instance, establishing a temporary village. The European-American pioneers used the natural resources of the earth in building cabins, forts, roads, and even the tangible structural features of government. From the moment the first self-taught stonemason laid the foundation for a pole cabin and raised a chimney, down to the modern era that brought gargantuan shovels able to gulp up multiyards of earth in uncovering a thin seam of coal, Kentuckians have been industriously engaged in reshaping the landscape.

Somewhere in the postglacial past, herds of buffalo plodded through a deep pass in the Pine Mountain Range—a pass that became known as Cumberland Gap—to pad out trails to the Kentucky grasslands and salt licks. Indians, both warriors and hunters, were drawn to the region in pursuit of buffalo and other animals or enemies. Warriors

padded open the great intersectional trace from Cumberland Gap to a crossing of the Ohio River, and laterals of this trail led deep into present-day Kentucky. Atop the central plateau, animals and Indians laid out a primitive plan of roads. Once the gateways of Cumberland Gap and the Ohio River were found in turn by settlers, the primitive trails led to land claims, water resources, and sites for cabin building. Superimposed on a modern map of Kentucky, this trail system clearly outlines the paths of emigration and settlement, and later much of the state's system of roads.

Kentucky's storied equine history began with early visitors who came astride horses. Indians rode their animals into the region. Dr. Thomas Walker's party was mounted in 1750. John Finley came on horseback in 1752 to trade with the Shawnee village of Eskippakithiki, and in 1769 he returned with Daniel Boone and eight other horsemen.

Atop the ridge of Wildcat Mountain, just above the Hog Fording of the Rockcastle River, one can sit today on a clay bank berm of the Wilderness Road that was pioneered by these early travelers. At this spot one can almost visualize the phantomlike passage of Cherokee warriors on their way to contest hunting and grazing rights to the central canelands, and later to confront emigrant parties. Here you can also imagine the passage of the emigrants, even sense their conflicting dreams and uncertainties about the new land just up the trail beyond the Kentucky River. It's also possible to imagine a later day when supplicant settlement messengers made their way back to Virginia with petitions seeking help in resisting the original native users of this land, whose hunting grounds and way of life were gravely threatened by the settlers. One can almost hear the footfalls of Benjamin Logan rushing east to beg for militia aid against the Indians to save his fortress settlement.

There also came this way into Kentucky congregations of the traveling churches on the trail of a western Zion. In their wake came those grim messengers of the various denominational faiths. Among them was that stern-faced apostle of Methodism, Francis Asbury, leaving deeply imprinted spiritual footsteps along the trail.

Once the great exodus of western emigrants had passed and the land was settled, there came a reverse movement on the Wilderness Road. At the Hog and Cumberland fords, one can yet hear in imagination the passage of thousands of horses, mules, cattle, sheep, and hogs—products of the new country—being driven eastward to market. Packhorses later gave way to heavy freight wagons going south and east bearing casks of bourbon whiskey, barrels of salt and flour, and bales of tobacco. The wagons returned with trade

goods from Richmond, Baltimore, and Philadelphia to stock the shelves of merchants in Danville, Lexington, and other Bluegrass towns.

On the western front, the Ohio River became a great artery of emigration, commerce, and military transport. In the opening years of the westward movement, the Ohio was a hazardous line of travel. Shawnee and associated tribesmen stalked the banks of the river, trying to halt the stream of incoming settlers. Every bend and anchorage on the Ohio from Pittsburgh, Pennsylvania, to Cairo, Illinois, is in a sense a historical landmark.

The Ohio River once was the scene of an almost continuous flotilla of drifting flatboats headed for landings at Limestone Creek, the mouths of the Licking and Miami Rivers, the Falls of the Ohio, and the mouth of the Tennessee River. There passed over the Ohio a veritable march of empire, human, commercial, and political. Between the era of the flatboat and the rise of modern

Making the most of their mountain life, a Bath County family enjoys the pink blossoms of the rhododendron.

cities stretches a broad chapter of Kentucky and national history. The tiny flatboat settlement landings grew into broad riverfront towns. At Cincinnati, the river now is literally an alleyway between that Ohio city on the north and Kentucky's Newport-Covington-Florence complex on the south, where a bold urban front has all but erased the landmarks of the pioneering past. Not even the notorious keelboatman Mike Fink or Captain Nicholas Roosevelt of the little steamer New Orleans would recognize any of the old landings.

* * *

There are few places in the Republic where so many people settled a land in so short an interval of time and generated such a variety of folkways as in Kentucky. Atop

the fertile Bluegrass plateau, many of the newcomers quickly achieved a state of affluence, displaying their status with Georgian-style homesteads. In sharp contrast were those pioneering pilgrims who turned off the great emigrant path to settle in log cabins amid the coves and hollows of the eastern highlands. In these and other regions of the new state, each group of Kentuckians created its own distinct mores and responded in its own way to the powerful influences of the environment.

The central Bluegrass region is fitted like a geographical jewel inside a setting of hills to the east and the Ohio Valley to the west. More than simply an economy, farming became a comfortable way of life, one in which you could experiment with plant and animal breeding. The people of the Bluegrass stocked lush pastures with high-strung, thoroughbred sporting horses, finely bred sheep, imported cattle, and purebred hogs. They cut hams that competed with those cured and smoked in Virginia.

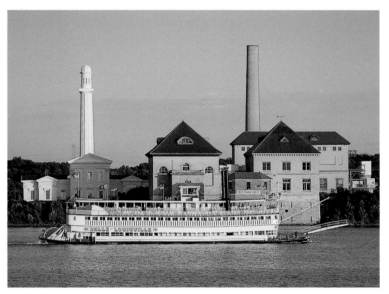

The Belle of Louisville *steams past the city's Water Tower—two symbols of Louisville's past and present.*

The region largely outgrew its frontier background even before the beginning of the nineteenth century to become a prosperous settled island in a sea of forest. So remarkable was the mature culture of the Bluegrass that it dominated social, political, and economic forces in the founding of the new Kentucky Commonwealth. The Bluegrass was a major way station for touring eighteenth- and nineteenth-century foreign travelers who came to see how American democracy fared, to locate cheap land for settler groups, and to find scientific specimens. Many of the visitors lifted critical eyebrows at the region's restless human specimens who bolted their food, slept four and five abed in backwoods taverns, chewed tobacco, and boasted of the future promise of the country.

Like the Bluegrass, the section known as the Pennyrile (Pennyroyal) projects a pronounced regional personality and embodies the very essence of the state's rural-agrarian tradition. Its people have lived close to the land, yielding to its vagaries and turnings with warm affection. The Pennyrile rolls south and southwestward from the Bluegrass and the eastern highlands to the Cumberland River.

The Pennyrile is a section where nature has been lavish with forest and vegetation. The startling exception, its western barrens, is devoid of trees. Much of the Pennyrile might well be called Kentucky's breadbasket. The area developed a substantial agrarian society, and its broad and fertile fields continue to fatten the state's statistics on agricultural production. Its culture became solidly land based and strongly reminiscent of the Piedmont areas of Virginia and Carolina, with a strong essence of the Old Cotton South.

Farm journal editors who flocked to Kentucky to inspect the herds and flocks of famous farms bypassed the outlying subsistence farms of the eastern highlands. Outsiders reading their stories might have believed Kentucky was one grand pasture and all its social life revolved around fairs and livestock rings. Not so. Kentucky's rural dirt-farm population lived comfortably without assistance from farm editors and sporting magazines. And they retained many of the old ways. They moved from pole cabins to double-log houses to the comfortable white cottages and tall two-story family seats that today stand as quiet and dignified landmarks of an important way of life. The aged trees that surround the homes are, in their own way, an artistic heritage. Here, the people made cultural contributions in the form of yeoman country life, preserving the folk music they brought over the mountains as well as old dance forms, party games, and sports that depended on personal prowess.

A third of the state has geographical and environmental connections to this cohesive region around the western slope of the Appalachian Mountains. Here, frontiersmen became mountaineers who clung tenaciously to the social habits of their origins while generating their own traditions. They looked to the abundant flora and fauna for foods, sport, and building materials. Shrubs and wildflowers that bloomed gloriously in the spring and bore fruit in the autumn offered specific remedies for human ills. Ties of kinship, patriarchal reverence, and emotional attachment to the land run strong.

The Jackson Purchase lands are another piece of the Kentucky picture. In October 1818, Isaac Shelby of Kentucky and Andrew Jackson of Tennessee negotiated a treaty with

representatives of the Chickasaw people in which the natives ceded to Kentucky that section of the present state that lies west of the Cumberland and Tennessee Rivers. Geographically the acquisition balanced Appalachian highlands with a low-lying river basin corner, for it is here that the Ohio, Mississippi, Tennessee, and Cumberland Rivers converge to form a commercial and recreational network of lakes and streams. The river and delta bottoms of this southwestern tip of Kentucky became cotton country, and for more than a century cotton was listed among the state's agricultural products.

* * *

In the early days of Kentucky settlement, there ran through all the boastfulness of the freehanded adventurers, the hunters, and the land speculators a bold thread of promotional puffery. The land they described had, they were positive, the potential to become a new American Eden, where conditions of human well-being would prevail. There never crept into their descriptions of the land or of their vision of a pastoral haven the daunting word "urbanism." The roots of fortune in frontier Kentucky were anchored deeply in the revered soil of family and place, and always in terms of cultivating and grazing the land. Thus in its formative years of settlement, Kentucky chose for all time to bear the indelible stamp of agrarianism.

Perhaps no contemporary resident can intellectually plumb the full depths of excitement and anticipation felt by his trail-weary emigrant forebears when they caught their first glimpse of Kentucky's wooded hills. No incoming settler, however, could have perceived the contrasts and diversities lying subtly across the western landscape. The heavy virginal forest cover limited both the physical and spiritual visions of the pioneers. Realistically they could have had only the narrowest concepts of the lay of the land and its physical powers.

As settlers found their place within this new world, the tight bonding of man to land became perhaps the strongest emotional fact embodied in the Kentucky personality. The mark of the power of the land, many times in the abstract, is clearly discernible in family histories, provincial literature, and even in the legal statutes. The word "home" has as strong an implication in the governor's mansion in Frankfort as it has in the simplest homestead along Troublesome Creek in the hills or at Hickman in the far western corner.

The earliest settlers to reach the western country reckoned with forest and stream, and were heavy users and misusers of both. The forest has ever been influential in shaping and giving substance to Kentucky's ways of life. A revered structural landmark is the sturdy log house of double pen dog-trot design and its stepchild, the crude pole or log cabin of the sort that witnessed the birth of Abraham Lincoln, near Hodgenville. From such homes sprang many a Kentuckian who became influential in shaping the state's civilization and culture. There still survive in some counties, like Green, log-cabin patriarchs that have withstood the ravages of time and progress to physically document an age of beginnings.

In full measure the forest cover is a glory of Kentucky. There are few areas in North America where the deeds of man, good and bad, have been so thoroughly shaded as in the woods of Kentucky. Under cover of the forest, people have stalked and murdered their neighbors in feuds, they have made moonshine liquor in wooded ravines, they have hunted game in season and out. There has ever raged in the state a conflict between man and forest. Since that day when the first settler applied a torch to the woodlands to clear the land, Kentuckians have befouled their economy

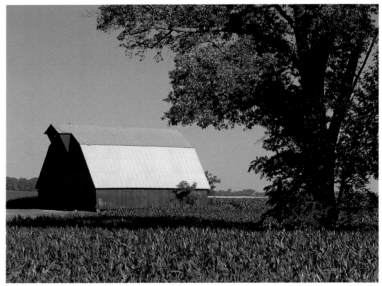

Typical of rural western Kentucky, many older barns boast a unique overhang and hay hook pulley system.

and natural setting by willfully setting wildfires. The greatest offense against the Kentucky woods has been committed by "cut out and get out" loggers. Even so, it seems safe to say there will always be woods to give form and beauty to the rolls of the land. The broad Kentucky woodlands of today stand as bold testimonials to the indefatigable recovery power of nature.

Hanging on the walls of homes and public buildings alike are paintings and photographs of these woods, and of fields and farms and other sentimental rural-agrarian scenes. Grooved deep in the Kentucky psyche is the romantic concept of a quiet retreat to a timeworn family homestead, there to be insulated against stresses of the workaday world. Hunters for just the right spot to drift off into the cocoon of

simple rural tranquility are almost as numerous in Kentucky as rabbit and coon hunters.

This hunt for a simple life is a persistent theme in Kentucky history. The rural-agrarian way of life in its own way transmits to one generation after another a quality of human integrity, integrity that seems to wither and evaporate in an urban environment. Even far into the twentieth century, one of the brightest credentials a Kentucky politician could bring to the voters was the fact that he or she was born in a log house, was hoeing corn at five years of age, and was plowing by age ten. By some strained magic this background conditioned men and women to be public officials.

Despite the fact that family farms in Kentucky are disappearing as rapidly as the leaves of fall drop to the earth, reverence for the farm is still alive. Mechanization, technology, and agribusiness are soulless when it comes to the past, the simple ways of the subsistence farm, and even to the farmer himself. However, individual Kentuckians still visualize the

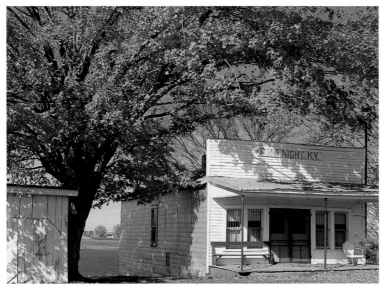

The Matthews family still maintains the building of the now-closed family store in the village of Goodnight.

state in the context of its rural origins. They conceive of Kentucky as home to thousands of churches, stores, and schools lining country roads and clustering about crossroads junctions.

Kentuckians have ever cherished the institution of the family farm as one representing social stability. To them the simple farm surrounded by outbuildings represents "home" and "place." No one has kept count of how many thousands of unadorned homesteads have existed across the face of rural Kentucky, but clearly they have outnumbered the mansions up River Road in suburban Louisville and along Richmond Road in Lexington. When feature writers and photographers run short of subjects they can always make a foray into the Kentucky countryside and find a

nostalgic rural-agrarian setting. Since that far-off moment when settlers escaped the confines of frontier forts to establish open-country homesteads, these have been central to Kentucky's way of life. From their hearthsides sprang family dreams and memories. These homesteads have ever been points of departure and return for sons and daughters who have gone forth to seek their fortune beyond Kentucky's borders, taking with them a cherished memory of place and origin.

In this movement of its people, Kentucky has been both a receiver and a giver. It received that flush tide of Virginians, Carolinians, and Marylanders who crowded onto the western lands. In turn the state has seen thousands of its children leave in search of the ever-evasive Eden of frontier dreams. Thus Kentucky early assumed the status of geographical "motherhood." Annually a stream of descendants come home to plow through genealogical records, search musty courthouse records, and dig through collections in the Kentucky State Archives and the Kentucky Historical Society. They swarm to rural burying places, hoping to find bits of key information linking them to pioneering Kentucky. Chiseled on old gravestones is often personal information found almost nowhere else, including what disease or accident took the victim hence.

Historically Kentuckians have been bonded to family interrelationships even unto the sixth and seventh generation, so they search every documentary crack and cranny where a shred of ancestral information might be lodged. Nothing can assure an individual more valid claim to belonging than to discover that some distant kinsman was cooped up in a frontier fort, fought Indians, or built a cabin and claimed a tract of land. All this family news binds individuals fast to the land.

Religion also has ever been a bond to Kentuckians in their sense of place. The landscape, whether hill country, Bluegrass, or western, is dotted with church steeples of varying heights and measures of congregational contributions. Pointing to the heavens, the steeples make the positive assertion that even beyond life in Kentucky there is another rural paradise. Like many another Kentucky institution, country churches have felt the crushing fist of changing times. The memberships of many churches have dwindled to the point where they can barely pay ministers and open their doors on Sunday. Nevertheless they stand as revered landmarks and central places for occasional homecomings.

In kindred fashion, family burying grounds by the hundreds lie forlorn and neglected except on those conscience-stricken occasions when weeds and bushes

are cleared away and the inscriptions on ancient tombstones are scrubbed clear of the moss and patina of time. Back in the days when the burial of unembalmed bodies was of necessity a pressing matter, graves were strewn about in gardens, orchards, next to churches, on ridge tops, even in front yards. No one knows how many there are, and it is a rare highway or power-line project that does not involve the disturbances of graves. This delicate conflict is especially common where the earth surface has been removed to reach seams of coal.

Some of the most intriguing examples of folk art are to be found in country graveyards, where local stone carvers freehandedly created memorial shafts and pillars adorned with angels, lambs, crosses, hearts, and even pet dogs. On Decoration Day many Kentucky graveyards burst into a massive collective bloom of artificial flowers. Sometimes the tender heart overflows on this day, and memorialists have been known to adorn stone land corners in the belief they were fugitive grave markers.

* * *

As with country grave sites, perhaps nobody knows how many crossroads villages there are in the state. These are villages with houses, churches, stores, and filling stations clustered in knots, some of them enjoying the dignity of having a fourth-class post office. To read a list of the place names is to take a journey into whimsy land. Surely Kentucky over the years has harbored a rare collection of jocular masters of nomenclature. No doubt, under pressure from the Postal Service, many names were suggested on the spur of the moment. There are scattered across the state places bearing a veritable litany of names, among them Jabez, Goldbug, Uno, Nobob, Eighty-Eight, Spoon Grove, and Zulu.

Despite the murderous onslaught of the Postal Service against its fourth-class stepdaughters, Kentucky remains a thriving domain of these tiny outposts. The tradition of rural post offices has been battered and frayed by bureaucratic rulings, but so far it has not been destroyed by the building of "good roads" or by meager cancellations. None of these offices bestows a more prestigious postmark than the one given at Mistletoe, Kentucky. Through most of the year there flows through the little office on Right Buffalo Creek in Owsley County little more than a trickle of mail, but during November and December comes a flood. Annually the Postal Service devises for the little office a special cancellation plate and gives it almost worldwide publicity, and the letters arrive by the truckload.

The county is as important as the crossroads village to a Kentuckian's sense of place and of belonging. Kentucky

has 120 counties but, unlike Texas, not much space for them. Kentuckians occasionally express a sense of practical wisdom when they think of the political and fiscal overburden of the numerous counties. To foster a movement, however, to erase a Kentucky county would raise a cry of fury to be heard around the universe.

Every Kentucky county is within itself a little kingdom where politics, attachment to place, and a centricity of local life are anchored. One can pass from one little kingdom to another without passport, but not without a bump in a local road where one jurisdiction ends and another begins. To abolish a Kentucky county would be a capital act of tradition smashing. If it did nothing else it would destroy the courthouse "forums" where old men gather daily to whittle, to utter simple solutions for complex public issues, to gossip, and to while away the "dog days" of their lives. Here one might learn who was in a fight with his wife, who killed a big rattlesnake, and who is making good moonshine.

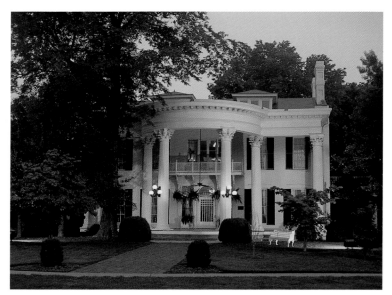

Constructed in 1866, the White Haven Mansion outside Paducah is now a welcome center for western Kentucky.

Since the creation of Kentucky County by the Virginia General Assembly in 1780, the institution of the county has been the center of the world for Kentuckians. Historically, court days were as important as the Fourth of July or Election Day. Everybody went to the county seat to enjoy the festive atmosphere of what was officially a day of attending to the county's business, but which in fact was a market day. Farmers came with droves of horses and mules, herds of cattle, and flocks of sheep. Even the coon dog breeders were on hand with whelpings.

No county court day would have been complete without its swarm of office-seekers, gun and knife traders, peddlers of "cheap john" jewelry and "silverware," and, always, the "doctors" with a full stock of their newly discovered elixirs

of life. Courthouse squares and streets were clogged with wagons, carts, animals, and milling people.

The horse, mule, and coon dog traders of past Kentucky court days have wandered off the pages of history, along with the day's political orators. In the place of court day has come the pale commercialized festival. It is an indigent county that does not now celebrate a festival of this modern sort. Promoters across Kentucky are taxed to think up some produce or event to celebrate. Thus there are 'tater days, and mushroom, sorghum, and tobacco days. Daniel Boone, Kit Carson, and Sacajawea are honored in absentia.

These Kentucky folk festival days bring out whittlers who exhibit gnarled walking sticks, imagined alligators, horses, and comic characters. Artists come with modest galleries of genre paintings of quiet natural corners of the commonwealth or simple timeworn homes, of streams, and of forest lines. Local self-published authors come to peddle their works. There surely are places in Kentucky where jewelry

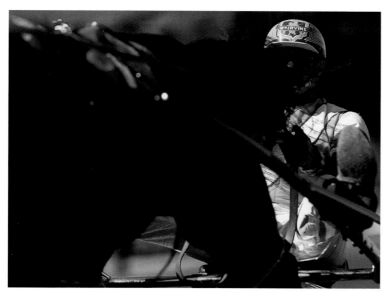

The Bluegrass region is famous for its horses. Here, a standardbred is driven at the Red Mile Harness Track.

designers, elf-like, work overtime to create chestfuls of the jewelry displays, a fixed part of every festival.

No festival day would be fulfilled if it did not crown a queen to reign over tobacco, horses, ginseng, sorghum molasses, or Hickory Chicken mushrooms, or maybe just to preside over the unruly kingdom of kudzu. For one fleeting moment, queens sit on the throne of beauty and ride at the head of the parade.

* * *

The concept of place is given more lasting acknowledgment in the writing of Kentucky's authors. In their novels, histories, and poetry, they have mined and refined the rich ore of locality. James Lane Allen of Lexington was a progenitor of the late-nineteenth-century school of American local

colorist writers. Heeding the admonition of William Dean Howells, Allen wrote of his homeland and local environment, giving precedence to the Bluegrass and its people.

John Fox Jr. wrote, instead, of hill people trapped in the rugged folds of their land, adding a new literary dimension to Kentuckians responding to place and time. His *Trail of the Lonesome Pine, The Little Shepherd of Kingdom Come,* and *A Mountain Europa* raised highland Kentucky into juxtaposition with the Bluegrass. In later years Jesse Stuart, in panning the same human ore, produced portrayals of life in the highlands in his many writings, among them *Beyond Dark Hills, Man with a Bull Tongue Plow,* and *Taps for Private Tussey.* In a gentler mood James Still, in *River of Earth,* revealed the nuances of people and a region caught in transition from extracting a meager living off the soil to becoming snagged in the tenacious grip of coal mining. Southward on the Appalachian Ridge between the Kentucky and Cumberland Rivers, Elizabeth Madox Robert in *Time of Man* and Janice Holt Giles in *Enduring Hills* and *Yara's Healing* were sensitive to the turnings of the land and the subtleties of the geographical and social forces that bore upon the lives of its occupants.

Harriett Arnow ventured boldly into the land, writing of people time had almost passed by. In a trilogy of novels— *Mountain Patches, Hunter's Horn,* and *Dollmaker*— Kentuckians caught in the meshes of two worlds, rural-agrarian and industrial. Her *Dollmaker,* a truly seminal book, captures better than any other Kentucky literary source the spiritual pain of being separated from the land, and then the soul-searing realization there would never be a return to it. The principal character, Gerty Nevilles, suffers the trauma of seeing the promises of the land evaporate and the old ways slide into the annals of history. Following scores of her Kentucky neighbors, she travels north, never finding emotional peace in an urban-industrial ghetto. She stands, in Arnow's stirring fiction, proxy for all Kentuckians trapped in the delusions of migration. In the end, Gerty, a carver, smashes the figure she has worked so long to extract from the wood. Her dream of returning to the Kentucky hills has vanished.

A younger generation of Kentucky writers has viewed their land in somewhat harsher perspective. In a region where coal miners have stripped bare the bowels of the earth, Harry Caudill wrote a bold indictment of the despoilers in *Night Comes to the Cumberlands.* In *My Land is Dying, The Moguls,* and *Slender Is the Thread,* Caudill pictures a region in a state of social failure.

From a less disturbed midland environment, Wendell Berry has viewed his Kentucky from the level of the furrow,

the pasture, and the woodlands. His writings convey passion for the land and his displeasure at the abuses that occur on it. He cries out against the impersonalization of mechanization and the electronic technologies. In viewing the past of the region in which he grew up, Berry holds tenaciously to the relationships of man, animals, and field crops on the Kentucky farm at the beginning of the twentieth century. He stands in direct conflict with the modernist preachment of "Get Big or Get Out." In his collected *Sabbath Poems, 1975-1997,* Berry presents in eloquently distilled form the very essence of rural America's bonding with the earth and the forest.

<p style="text-align:center">* * *</p>

Kentucky's pastoral dream has been nurtured and matured within both the central and western portions of the state. The central Bluegrass region, especially, early gave the state its agrarian image of well-being on the land. A Kentuckian might well conceive of a celestial paradise as a Bluegrass horse farm with its pillared mansion, million-dollar barns, paddocks, and broad meadows. Such farms make magnificent copy for state promotional materials, but popular emphases on the sporting horse all but conceal the fact that Kentucky breeders once produced far more workaday animals. There has ever been a sharp contrast between a farm that produces a multimillion-dollar thoroughbred colt and one that produces a two-hundred-dollar mule.

Ever since French traders and Indians robbed John Finley of his peddler's pack at Eskippakithiki in 1752, bluegrass has been a part of the agrarian tradition. It is said Finley introduced the English grass to the region from the grass wrappings of trade goods. In time, the place of bluegrass on the central Kentucky landscape was to be contested by a robust native of the hills. Fescue first attracted attention in 1931, hence "Fescue 31." This native grass is free of soil and sectional biases and responds readily to a tampering with its genes by plant geneticists. Currently, one would have to search with some diligence for bluegrass meadows, but fescue thrives abundantly in every section of the state. It has the power to obliterate man's sins against the land, to give a softening curvature to even the most rugged surface, and to yield millions of the giant rolls of hay that are dropped across the Kentucky farmlands. Kentucky will never be called the Fescue State, but it owes a heavy debt to this humble plant.

Kentucky agriculture over two centuries has evolved through varying stages, but always central to its crops has been tobacco. The growing of tobacco has been an interwoven part of family life itself, so much so that any change in its culture has far-reaching social implications. Under the current barrage of criticism of tobacco use, the Kentucky patches and fields are growing smaller and fewer in number. Like withering ghosts of another era, tobacco barns stand tucked away in remote places, rapidly crumbling into the dust of time.

The plant the pioneers brought across the mountains in their seed panniers was dark and heavy-bodied, a direct descendant of the tobacco introduced by the seventeenth-century colonist John Rolfe, of Jamestown fame. From the outset, tobacco in Kentucky was a main cash crop, and one which stocked a thriving flatboat trade. The Kentucky, the Cumberland, the Green, and other streams were lined with landings, warehouses, and inspection stations. Packed tightly in hogsheads, tobacco ripened and withstood handling on the downriver trip to New Orleans.

A new plant, white or golden burley, was introduced into Kentucky in post–Civil War days and in a remarkably short time became the bellwether crop. There were decided

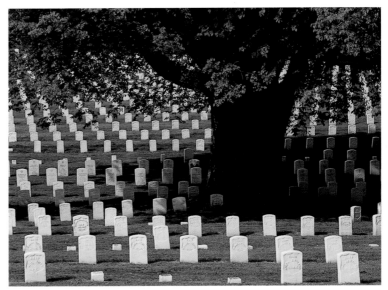

American veterans of a number of wars lie buried here in the splendid Cave Hill Cemetery in Louisville.

contrasts between burley and dark tobacco culture and processing. Burley is air-cured, for example, while the original plant is "dark-fired," requiring a more intensive heat to cure than can be supplied by nature.

Whether burley or dark-fired, the growing, curing, and marketing of tobacco has had its moments of high drama. Once farm wagons, later motor trucks, lined market streets awaiting their turns to empty their burdens onto warehouse floors. In the cavernous buildings, endless rows of baskets of tobacco were lined up for sale, each one in some way affecting a family's welfare.

Historically, the beginning of tobacco sales generated as much excitement as the approach of Christmas. The ritual of a sale became as fixed as that of a revival meeting,

a horse race, or a cockfight. Baskets of tobacco are lined up on the sales floor in almost military-perfect ranks. Marching down the lines, a babbling company of warehouse managers, auctioneers, and tobacco company buyers inspects the wares. Possibly no one fully understands the singsong chants of the auctioneers, including the auctioneers themselves. Nevertheless, by winks of the eye, the raising of fingers, or other physical manifestations, the auctioneers and bidders communicate. In less than a minute a farmer's spirits are raised, or lowered, by the mere gesture of a bidder.

The marketing of dark-fired tobacco has been colored by a remarkable chapter in the history of violence in Kentucky. During the first decade and a half of the twentieth century, the dark-fired areas of western Kentucky were embroiled in a bitter conflict between growers and the big tobacco companies that bought their crops. The so-called Night Rider War not only disrupted the economy of the

Robert Penn Warren, first Poet Laureate of the United States, was born here in 1905 in Guthrie, Todd County.

region, but also virtually destroyed official attempts to maintain law and order. The dispute's mystique of struggle and romance has intrigued writers, who have produced fiction and nonfiction books dealing with the subject. Poet and novelist Robert Penn Warren was born and raised in the heartland of the "war," and in his novel *Night Rider* he captured the spirit of a people caught in a vicious net of lawlessness based on the pretense of correcting a multitude of corporate abuses.

In the nineteenth century, Kentucky produced a field crop whose ghostly memory lingers to haunt some in the central farm areas. Hemp, like tobacco, was a cash crop. Hemp farmers, however, were never able to muster enough political clout to secure profitable naval contracts or to compete with imported jute in providing a fiber for making twine and rope. A more pertinent fact was the relationship of hemp to slavery in Kentucky. When that institution began to disintegrate after 1820, the state lost its principal source of the cheap labor so necessary to the cultivation, harvesting, and processing of the fiber. Some Bluegrass farmers today still dream of the day their fields will again become waving phalanxes of growing hemp. In their minds' eye they conjure up shocks of harvested hemp, not sticks of wilting burley tobacco. First, however, they must court public support and they must reach a compromise with government drug agents concerned about the marijuana that is grown from a similar plant.

* * *

Surely historians and conservationists in taking a look back must raise the central question of how attentive Kentuckians have been in their stewardship of the land. In Kentucky, as elsewhere, there have been no physical constants. Man has gouged the land, dammed its streams, slashed the landscape with roads and power lines. Bulldozers and great mechanical shovels have filled in ravines, scrubbed bare the tops of mountains, and laid waste farmlands, forever altering human relations to the land. They have left behind stripped coal lands, robbed of their power of recovery. In a reincarnation, Daniel Boone and his trailbreaking companions would find their wilderness path cluttered with shopping centers and concentric circles of urban dwellings, with filling stations, fast-food restaurants, motels, folk-art stands, and flea markets.

All across Kentucky aggressive commercial enterprises brassily assert their presence by arrogantly raising commercial insignia well above the height of any church or courthouse steeple. The billboard lobby has sought of the Kentucky General Assembly permission to cut through trees in order to give clear tunnels of vision from the roads to their signs, no matter how much the landscape is defaced. Even that dramatic spot where young Felix Walker stood in March 1775 and viewed the western Bluegrass plain is now a jungle of commercial signery.

There is surely no clearer monument to change than the highly technologically controlled tunnel beneath Cumberland Gap. The tunnel seems but a fantasy near the spot where Dr. Thomas Walker and his exploring party stood in April 1750 and looked beyond the Pine Mountain barrier into the new land of the west. Emigrant parties would soon come that same way, and Confederate and Union armies later contested possession of this strategic passage between North and South. In their stead now come Kentuckians obsessed with automobile and truck travel, all but oblivious

to the past. Engineers bored a mile-long hole through the mountain to expedite travel, and each day some twenty-five thousand vehicles charge through the tunnel to give new validity to Dr. Walker's observation that the route is a well-trampled one. Above the tunnel, on a shoulder of the mountain, the old Wilderness Road stands as a testimonial to Kentucky's creation.

The automobiles and long-waisted semitrailer trucks that now crowd the old route are more lethal than any Cherokee raiding party. They command the opening and widening of roads, the lowering of hills, the bridging of streams, and the laying of acres of asphalt-covered parking places. Wielding the powerful legal sword of eminent domain, engineers and road builders slice across fertile croplands, alter historic spots, smash ancient buildings.

The creation of an intricate network of roads must be considered Kentucky's most significant deed in changing the face of the land. To fully comprehend the impact of breaking through so many isolative land and stream barriers in the twentieth century, one has only to make the comfortable drive up the Troublesome Creek road in Knott County to Dead Mare-Carr Creeks and the cabin home of novelist James Still. A half century ago a traveler would hardly have dared go this way afoot or on mule back. It seems almost a sacrilege that modern Kentuckians can glide over the general route of the Wilderness Road from Cumberland Gap to the Kentucky River at Boonesboro in two hours or less, a distance that struggling pioneer groups needed ten days to cover.

In certain places in Kentucky, retired cars and trucks settle permanently into their environment. Their rusting and exhausted carcasses lie scattered on residential premises as though they had a spiritual bonding with their final owners in an almost ancestral sense. Maybe they sit as physical reminders that at some past moment they transported families to far places to earn livelihoods and then, sharing a better fate than Gertie Nevilles, brought them home to native hills.

* * *

Tenacious and inventive in creating roads, Kentucky has been even more ingenious in the bridging of myriad streams. Kentucky's bridges offer some of the finest examples of utilitarian folk art. Gradually slipping into decay or falling victim to storm, fire, and flood, the few remaining covered bridges are among the state's most precious artifacts. These structures have not only been utilitarian ones of passage, but also of nostalgia, young love, and romance. A covered bridge was a good place to sneak a kiss, or to carve a girl's name and your own, linking them with a heart figure. For the less romantic, some of the old bridges were good platforms for diving into a swimming hole.

The Big Sandy, Licking, Ohio, Kentucky, Tennessee, Green, and Cumberland Rivers have challenged bridge builders for more than two centuries. The six-lane bridge over the Kentucky at Clay's Ferry is not only a structure of architectural grace, but also one of the truly key bridges that join North and South. Patriarch of historic Kentucky bridges is the Roebling suspension span over the Ohio River, connecting Newport and Covington with Cincinnati. This bridge has been spared demolition largely because of its national historical importance. Since the 1840s at least a dozen highway and railway bridges have been built across the Ohio.

The bridge over the Tennessee River at the Kentucky Dam and the one over the Cumberland River at the foot of Barkley Lake are dramatic stream crossings. None, however, embodies such classic lines and fits so unobtrusively

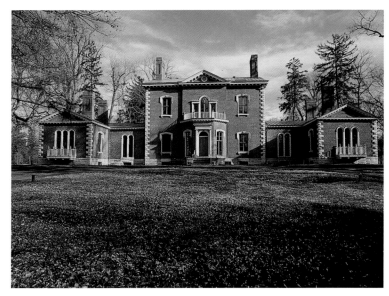

Renowned American statesman Henry Clay, the author of the Compromise of 1850, lived here in Lexington.

into its dramatic natural setting as the span across the upper Cumberland River just below the Falls of the Ohio.

In the days of flatboats and shallow-draft steamboats, Kentucky could boast that it had more miles of navigable streams than any other state in the Union. Now only the Cumberland, Tennessee, and Ohio Rivers are in commercial use. Today, however, just one towboat pushes through the high-rise locks on the Ohio more freight in a dozen barges than a thousand flatboats carried in the early days.

Tall dams and long-lock channels have converted the main streams into placid pools and created large lakes. Three major lake impoundments have been created in the Kentucky, Barkley, and Cumberland stream channels. Ninety thousand miles of drainage streams feed into twenty-seven

hundred square miles of impoundment. Still, some stretches of water have resisted taming, and 114 miles of Kentucky rivers are protected under the National Wild and Scenic Rivers Act.

Water was one of the three prime natural resources that governed a settler's decision in locating a primitive cabin site and making a land claim. The site needed good soil, a stand of timber suitable for cabin building, and a nearby fresh-water spring or stream. Most of Kentucky long ago passed this stage of dependence on springs and creek branches as water sources. Serpentine coils of water piping now follow the routes of hard-surface roads and power lines, and the horizon in much of rural Kentucky is dotted with water tanks.

Water in positive and negative contexts is still a matter of concern. Every rainy season brings the possibility of major floods, such as the great one of 1937, or flash floods on almost any river or creek in the state. Miles of flood walls have been built around vulnerable towns, but even so,

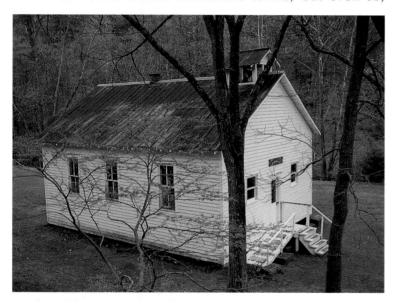

The old one-room Buffalo School rests in a hollow in Greenbo Lake State Resort Park in Greenup County.

communities continue to be surprised and battered by unexpected rises in stream levels.

Water purity is also on people's minds. The Ohio River had become so highly polluted with chemical runoff from oil refineries and stripped coal lands that its fish were unfit for human consumption. The good news is that remedial steps have made the stream clean enough that some of the fish are again edible. Public opinion, legal action, cleanup days, and stricter rules governing cities and hydroelectric plants have restored the river to at least a semblance of its purity in the primeval past.

This has not happened with the myriad internal streams, including the Kentucky and Cumberland Rivers. After every flood tide the wooded banks of these streams are adorned

with plastic jugs, disposable diapers, and so-called Kentucky hanging moss. There has crept into the Kentucky civic psyche an awareness of this desecration. Dumping garbage and trash along country roads has become unacceptable, and so has the polluting of springs and streams. There may yet come a day when modern Kentuckians, along with Benjamin Logan and the other early settlers, can kneel down and drink from a bubbling spring or brook without fear.

* * *

Easy access to water, roads, and electric power has reshaped the domestic landscape, especially near the larger Kentucky towns. There have crept onto the land new settlements of rural nonfarmers who seek to live in both the city and country worlds of modern Kentucky. Every water impoundment larger than a shallow farm pond gathers about it clusters of fleeing urban dwellers, residents who bring to the land a sense of emotional attachment far different from that of the old-time occupants.

While a good system of roads and rivers has been fundamental to Kentucky's history, the rural transmission of electric current is at least as significant. Few strokes of the pen have had so long a reach into human lives as President Franklin D. Roosevelt's signing of the executive order that brought cheap electric power to the rural countryside.

In 1938 a jubilant band of Kentuckians reverently packed an oil lamp in a casket and lowered it into the grave of history. Before the midpoint of the twentieth century, the state's promoters of rural electric cooperatives boasted that no matter how humble or remote a domicile, a power line would be built to the door. Almost overnight rows of electricity pylons were raised across the countryside, and within the latter half of the century the boast that every Kentucky household would have access to electric power was made good.

In the precise area on Lullbegrud Creek where Daniel Boone, John Finley, and their scouting companions read *Gulliver's Travels,* Kentuckians could now turn on electric lights and read the Lexington *Herald-Leader* or the Louisville *Courier-Journal.* The advent of electric light in thousands of residences was a moment of stern revelation: Never before had home interiors in all their drabness been stripped so naked. The elementary act of turning on brighter lights had perhaps a more dramatic effect on renewing the look of the Kentucky home than did all the teachings in the state's domestic-science classrooms.

With electricity, Kentuckians could turn on a radio and hear the president of the United States address the Congress, or listen to the garrulous members of the British House of Commons snap at the prime minister like dogs fighting a chained bear. Many found deeper satisfaction listening to

country music or, above all, spending a golden hour tuned to a Kentucky basketball game.

In a far more utilitarian context, the age-old Monday-washday tub was dumped onto the roadside garbage heap. The flick of an electric switch freed more Kentucky women from bondage than have the efforts of feminist crusading. Electricity took most of the "stoop" out of the Kentucky way of life and erased seasonal limitations on vegetables, fruits, and meats. With the refrigerator and deep-freeze box, every day became a summer food day.

The landscape at evening-tide soon twinkled with light, even the humblest trailer home set aglow. Looking down on the Kentucky countryside at nighttime became akin to viewing the heavens, with farmsteads, villages, and towns shining as galaxies of light.

* * *

With modernization has come the rude awakening to an understanding that the land and its resources cry out for a planned conservancy. The revolution in Kentucky's ways of domestic life inevitably created concerns for the physical and cultural environment. Kentuckians now realize that their stewardship of the land their ancestors struggled for makes heavy requisitions on human energy, imagination, and planning. There has crept into the laggard and cumbersome processes of legislative action a timid unfolding of the idea that Kentucky's rich natural heritage is worth preserving.

As Kentucky enters the new century, a reassuring fact is that generous portions of its land and of its flora and fauna are intact or in stages of recovery from abuse. Kentucky has forever been a land of seductive surprises. Tucked away in almost numberless corners and geographical cul-de-sacs, the beauties of a wide varietal nature survive. Even ancient landmarks of the earliest users of the land remain in the deep indentations of the Wilderness Road where once buffalo and Indian warriors trod.

Despite more than two centuries during which Kentucky has grown into a kaleidoscopic pattern of sections and communities between Cumberland Gap and the Falls of the Ohio, marks of the frontier persist. Much of the land is still under some kind of forest cover. If one of the early pioneers—Simon Kenton, or that doughty old Dutchman Michael Holsteiner—were to wander into some of the Kentucky woods, he might once again be able to feast on venison and wild turkey. In the Land Between the Lakes in southwestern Kentucky or in the state's shrinking wetlands, he could spot bald eagles and again cross streams filled with fish.

There remain quiet islands of lush natural surroundings and calm environment where one can get beyond the roar and stress of mobile Kentucky. Tucked away in mountain coves, midland forests, and the southwestern lowlands are places of escape. The hastening undergrowth of blossoming plants and shrubs in spring and the budding of a heavy forest canopy in a soul-tingling burst of colors bring a symphonic tone to the land. Then comes the season when the golden "end of summer" flower gives a farewell sweep of gold to the Kentucky fields. Even in the gray season of winter there is a decided nostalgic appeal. The land is laid bare and its natural and man-made scars are revealed in nakedness. Only the pileated woodpecker remains year-round in many parts of the Kentucky woods as a reminder that there is a continuity of life in all seasons.

This continuity of time, place, and life in Kentucky is symbolized by change. The National Park Service turned back the hands of time by removing the asphalt covering from the old trail through Cumberland Gap, returning it to its natural state as a dividing line between east and west in

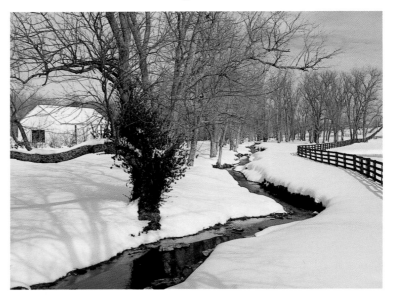

The white of deep snow ties together elements of this stark winter landscape along a Bluegrass country road.

American history. Beneath the ancient trail, however, a modern tunnel opens a fresh vista of Kentucky caught up in the vortex of time and revolutionary change. These two entryways to Kentucky, the old trail and the new tunnel, are eloquent physical symbols of the fact that the Eden of the old American West has endured the changing fortunes of the centuries. Kentucky lives today as a land and a society balancing between the primeval naturalness of trillium or ginseng hiding in a moist wooded cove and the modern assertiveness of temples of commerce towering over an urban landscape.

▶ Rupp Arena in Lexington is home court to the University of Kentucky basketball team—seven-time national champions.

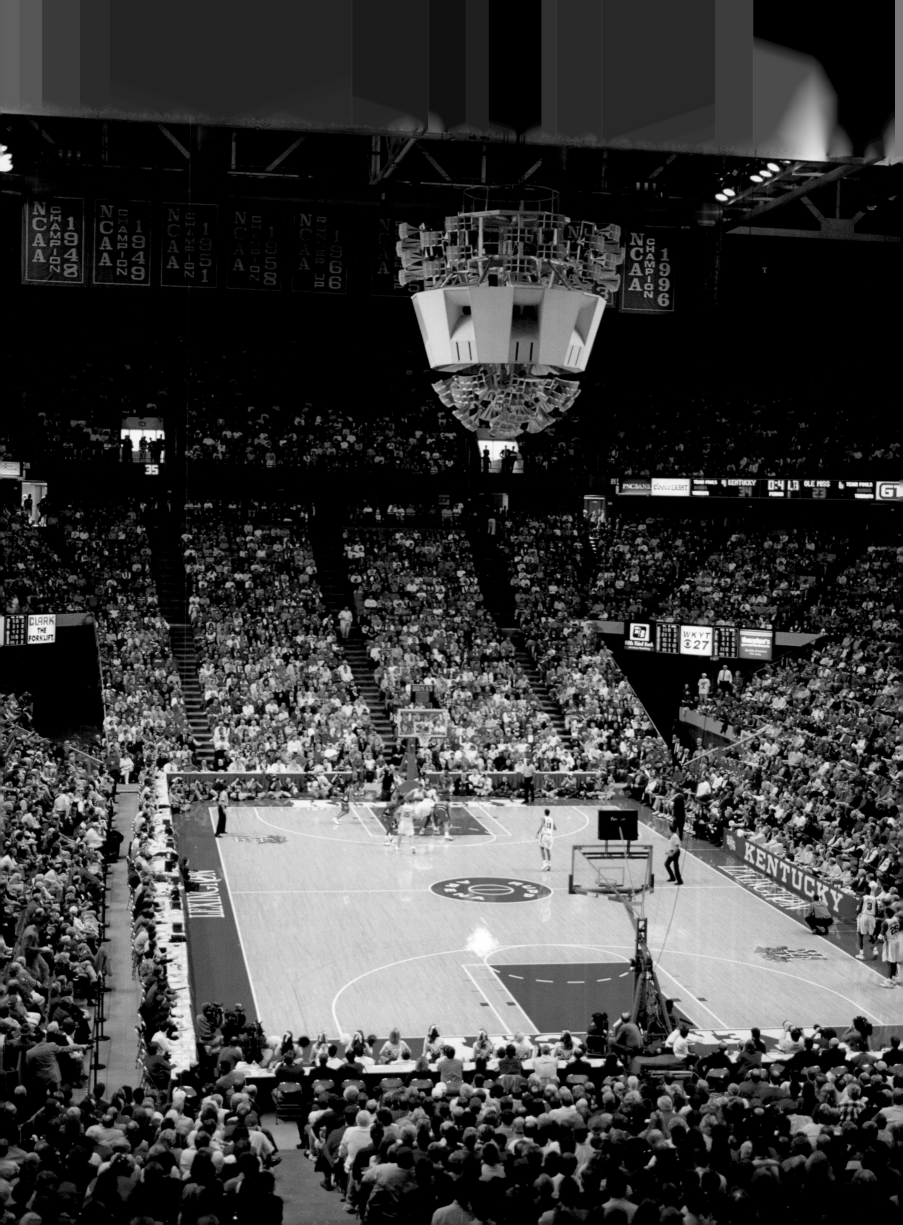

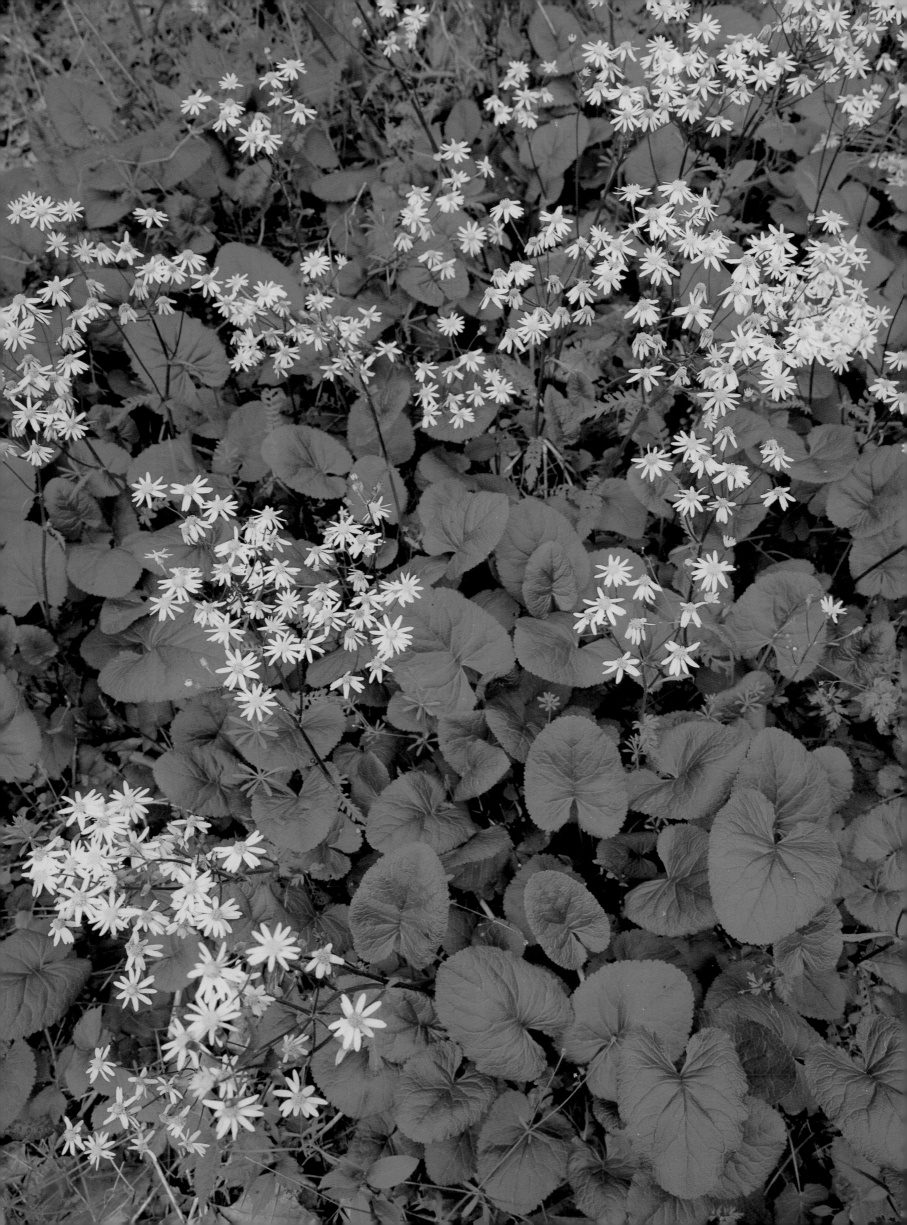

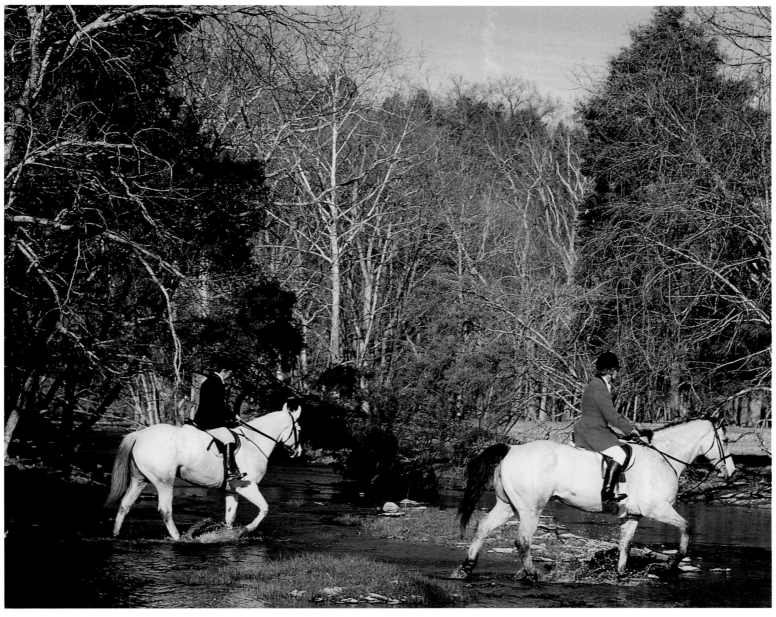

◄ In spring, golden groundsel paints the floor of second-growth forests near roads and fencerows. This stand blooms in Kenton County in northern Kentucky. ▲ In the heart of the Bluegrass, riders cross Boone Creek near the end of a day of fox hunting. Cooperative landowners allow uninterrupted riding over many square miles.

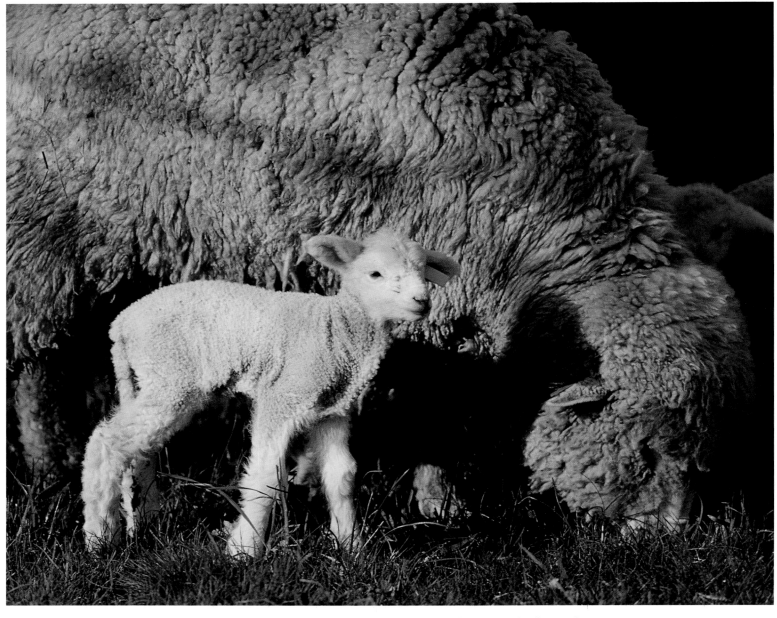

▲ Just days old, a lamb explores the world in the shadow of its mother. Kentucky's climate provides an excellent environment for the raising of sheep. ► At the restored Shaker Village at Pleasant Hill in Mercer County, a historical interpreter evokes an illustration from a book of nursery rhymes.

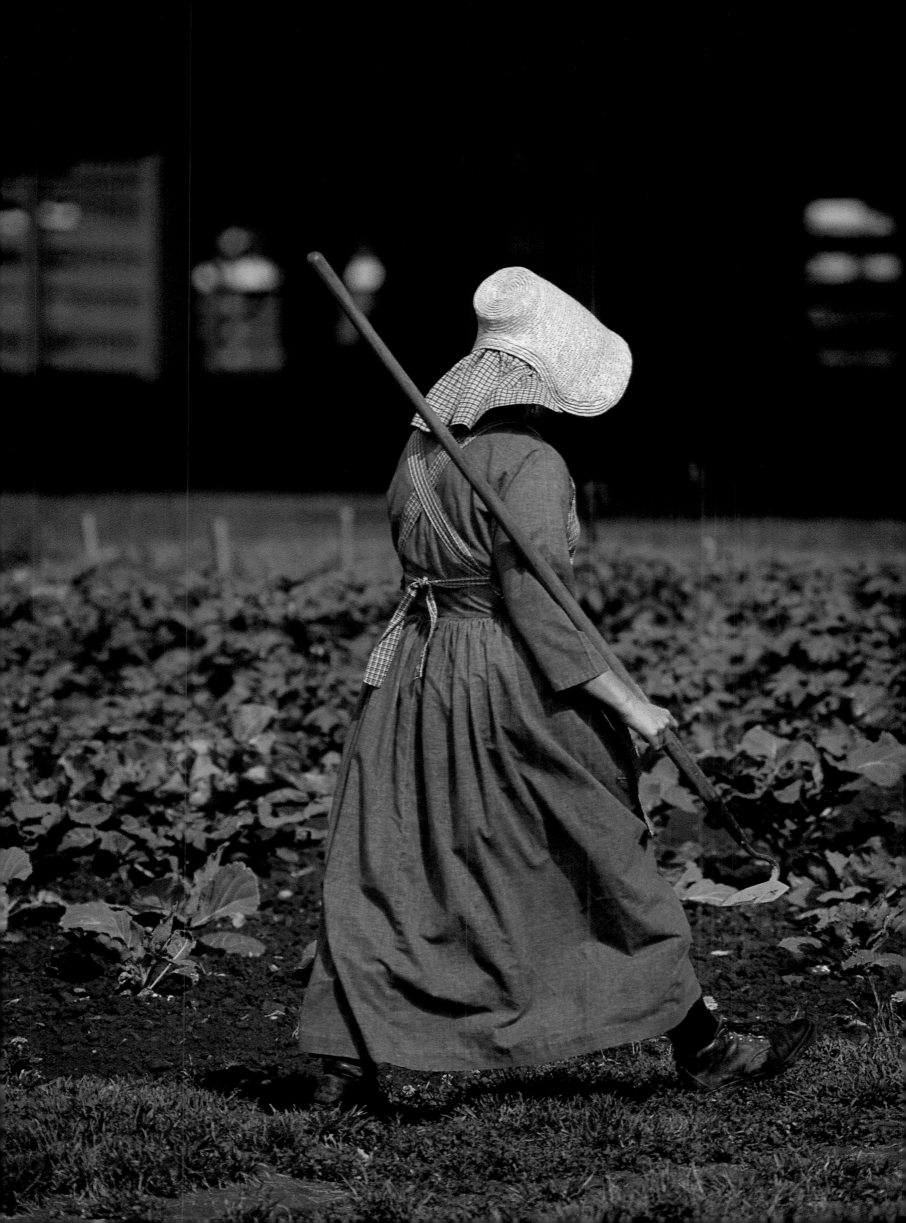

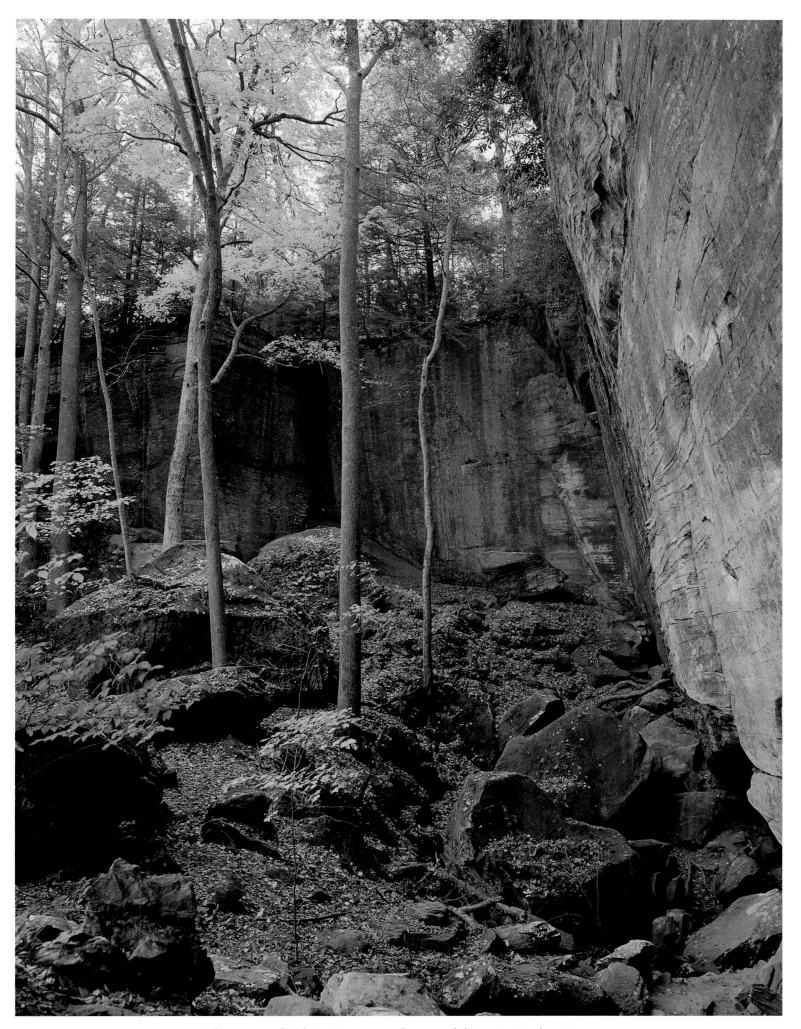

◄ The restored Ohio River waterfront and historic Market Square district of Paducah, far western Kentucky's largest city, is reminiscent of the steamboat era. ▲ The sandstone walls of a rare box canyon rise above a secluded trail in Carter Caves State Resort Park.

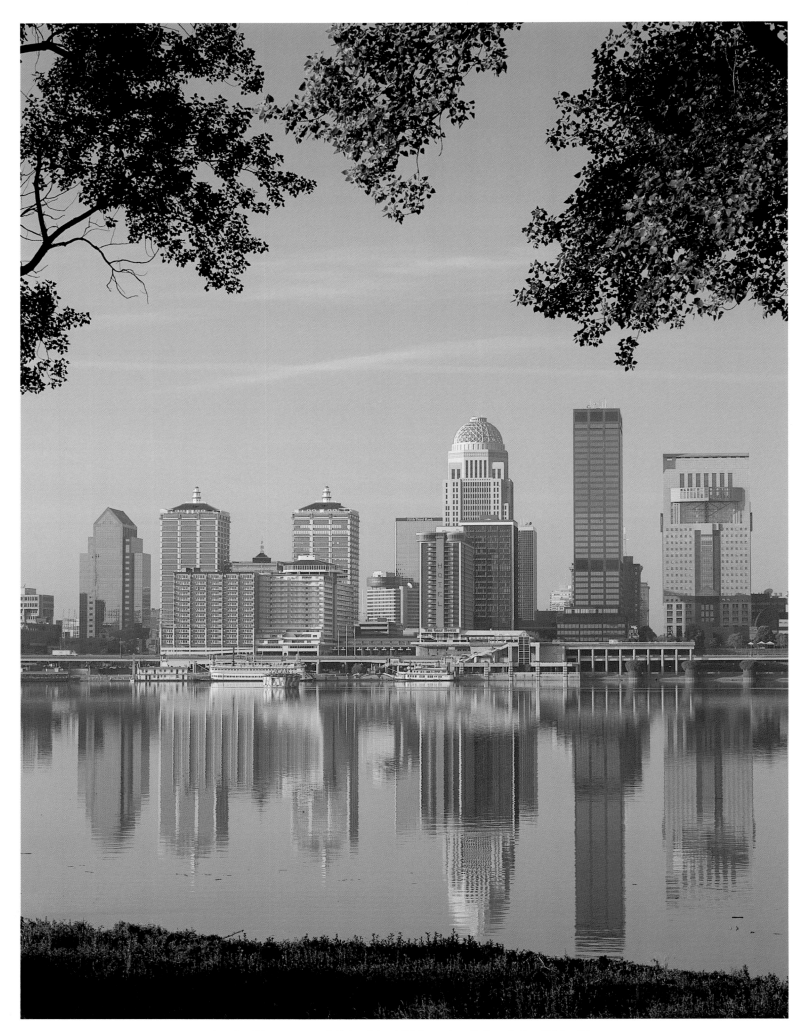

▲ Louisville was established in 1780 at the Falls of the Ohio River.
► Swimming in the pool of Eagle Falls in McCreary County is a delight
for those who walk the difficult one-mile trail from Cumberland Falls
State Park. ► ► A barn and silo in Hart County are typical of many
in Kentucky's beautiful and largely undeveloped rural countryside.

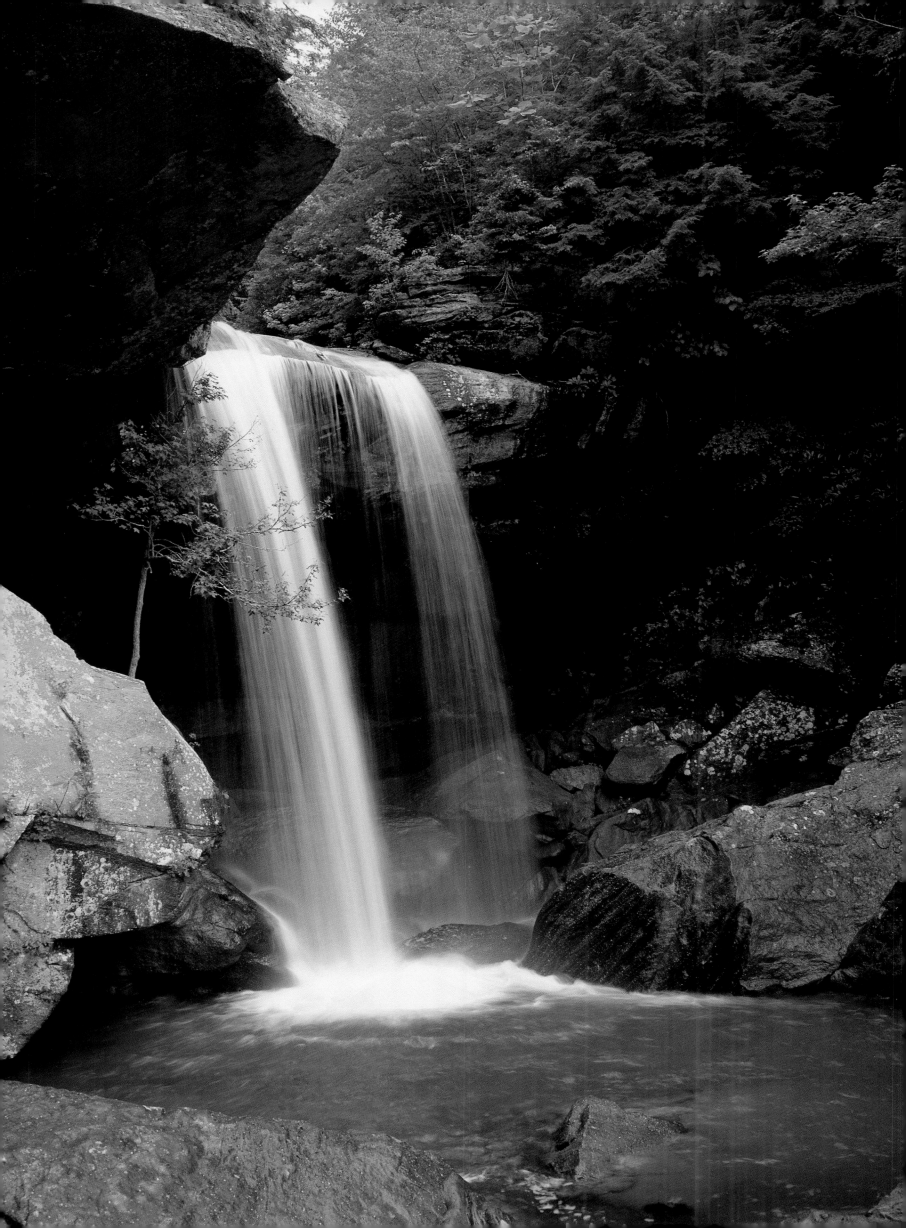

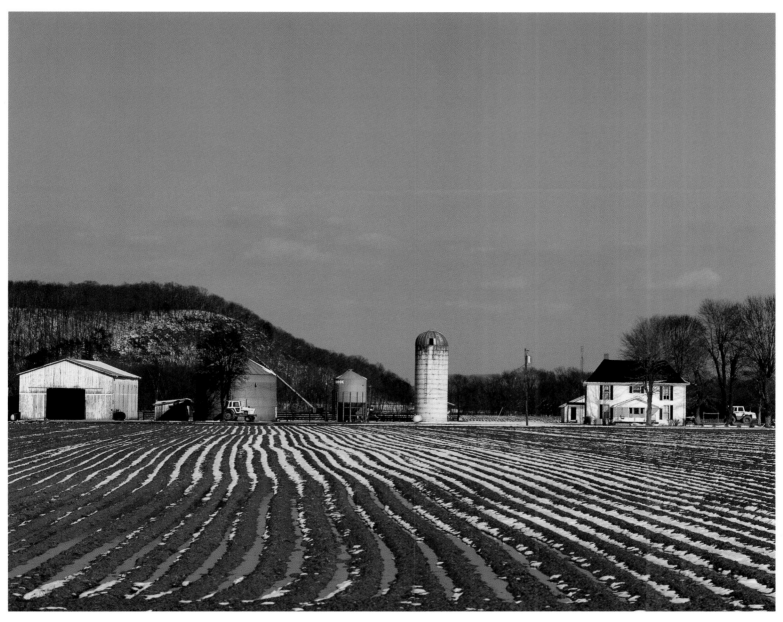

◄ In the hill country near the Green River in Green County, a barn and creek showcase the beauty of winter in rural Kentucky.
▲ Thousands of small farms, like this one in Nelson County, form the core of Kentucky's agriculture-based economy.

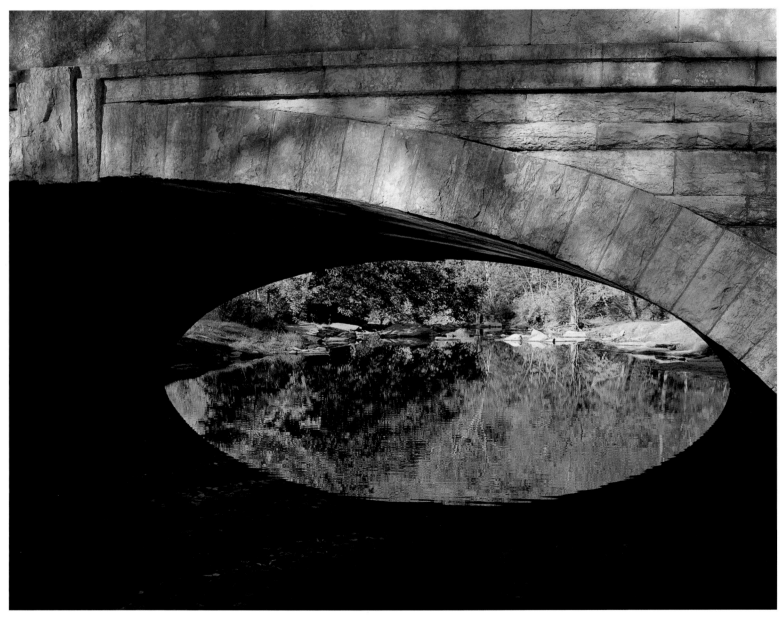

▲ The workmanship of this stone bridge over Beargrass Creek is an example of the care that has gone into the design and construction of Louisville's beautiful system of parks.

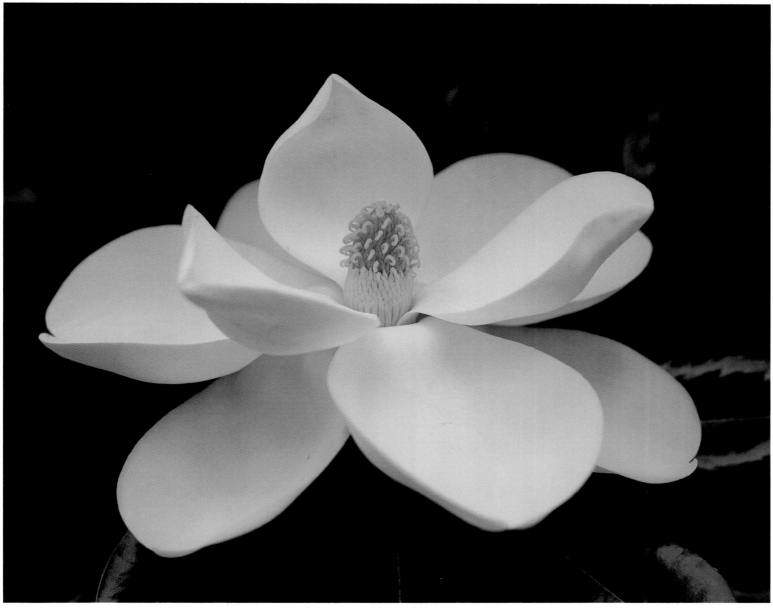

▲ In early summer, thousands of flowering magnolia trees grace yards and parks throughout Kentucky. Here, a new bloom presents its singular beauty on a suburban front lawn in Louisville.

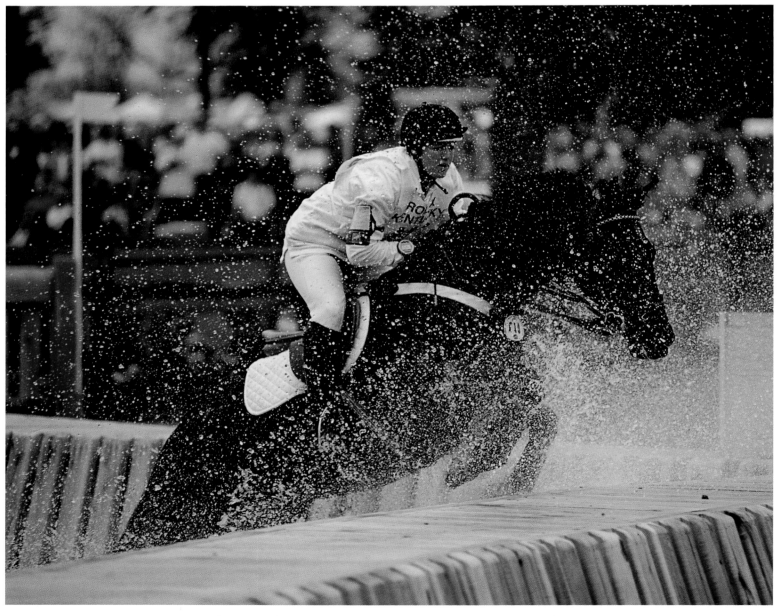

▲ Each spring, the Kentucky Horse Park hosts one of the world's most celebrated equine events. Olympic-class riders and horses compete in dressage, stadium jumping, and cross-country.

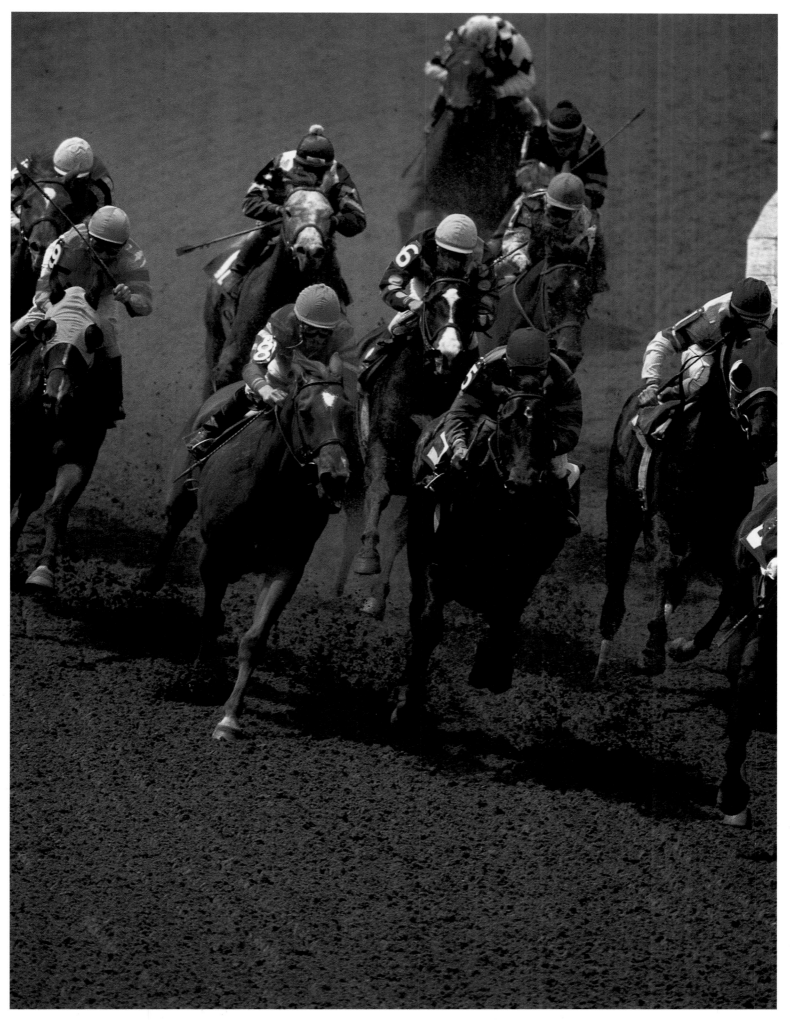

▲ Thoroughbred racing "as it was meant to be" takes place each year
in April and October at the Keeneland Race Course in Lexington.
Here, jockeys and horses come around the far turn.

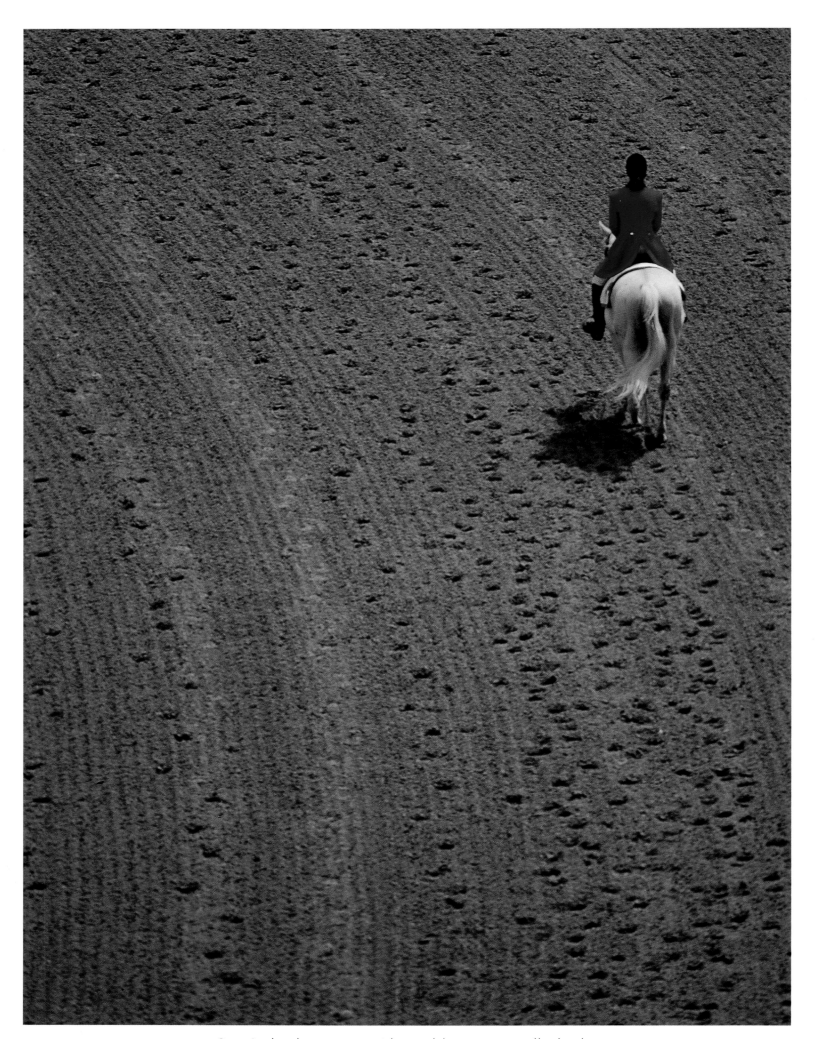

▲ Seemingly alone, an outrider and her mount walk slowly up the track at Louisville's Churchill Downs Race Course on Derby Day. In actuality, she is surrounded by more than 125,000 people.

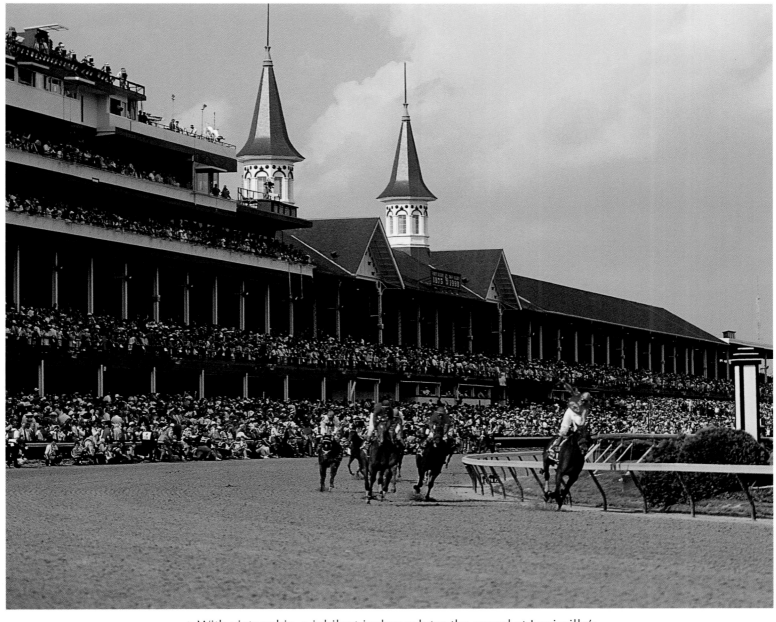

▲ With victory his, a jubilant jockey salutes the crowd at Louisville's Churchill Downs after winning the Kentucky Derby, the world's most prestigious thoroughbred racing event.

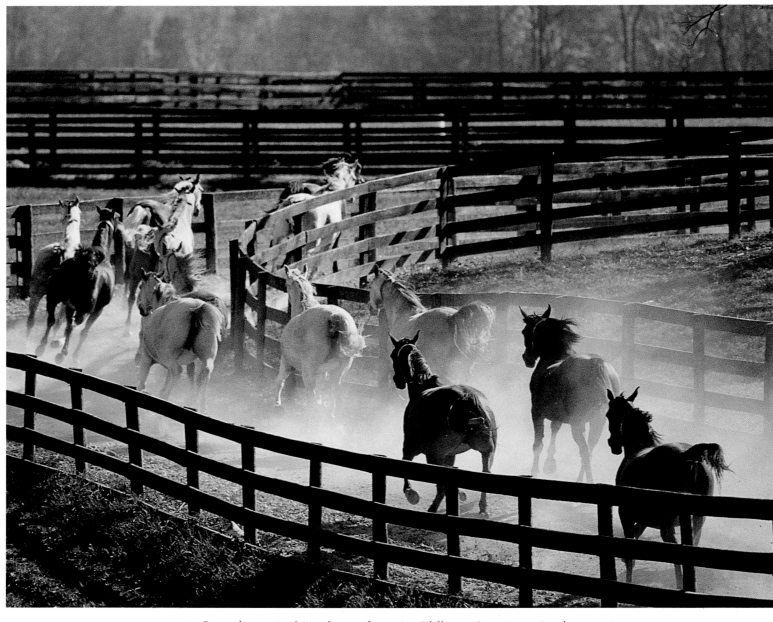

▲ On a large Arabian horse farm in Oldham County, animals are
moved from pasture to pasture through fenced corridors in a scene
reminiscent of wild horse roundups in the American West.

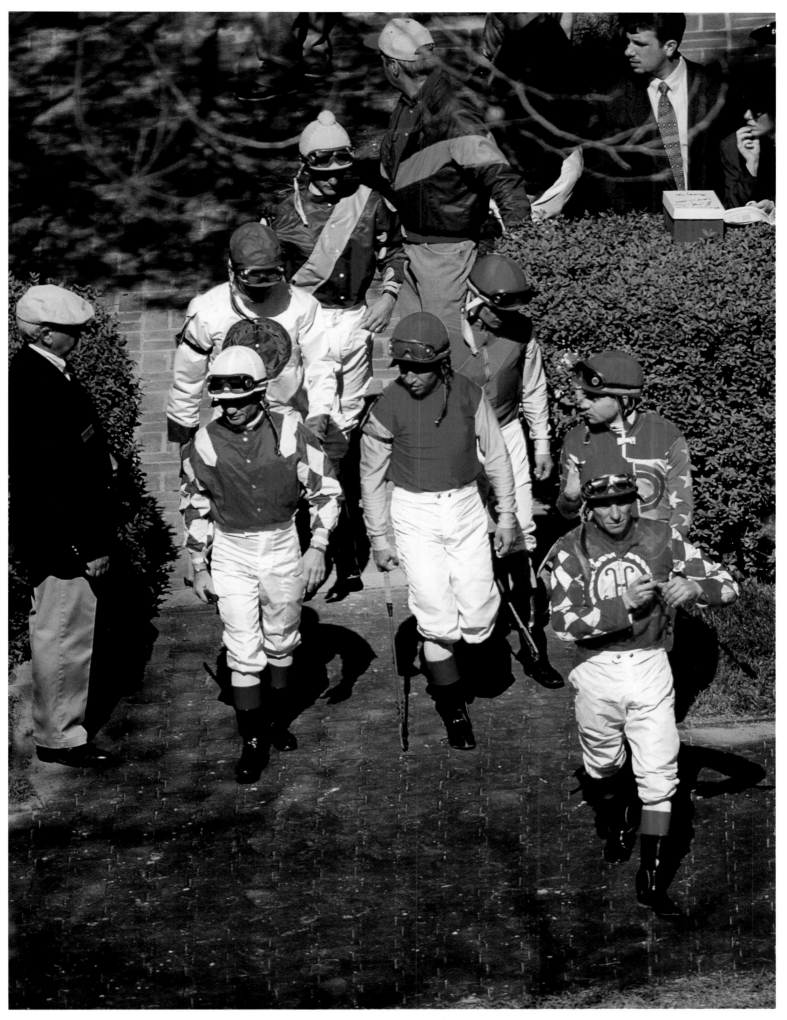

▲ Dressed in the bright silks of the owners' stables, jockeys enter the paddock at Lexington's famous Keeneland Race Course, each one hoping to bring his mount home first.

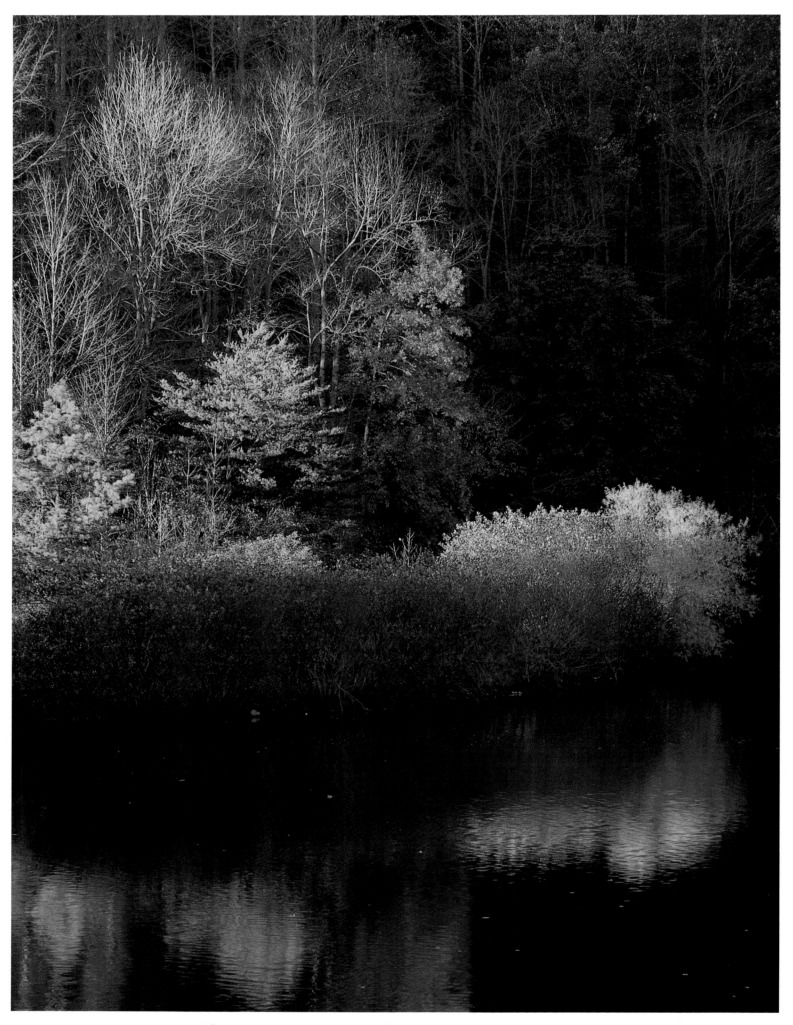

▲ The steep mountains of Harlan County enclose Cranks Creek Lake, one of many recreational impoundments in southeast Kentucky.

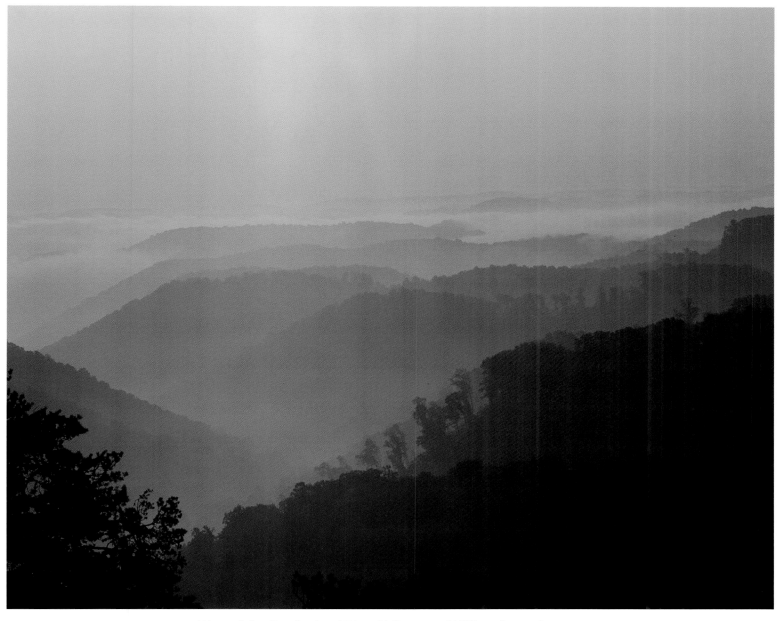

▲ West of the Cumberland River Valley near Williamsburg, the mountains are some of the most rugged in the state. Here, morning sun tries to break through the fog to warm the mountains' curved flanks.

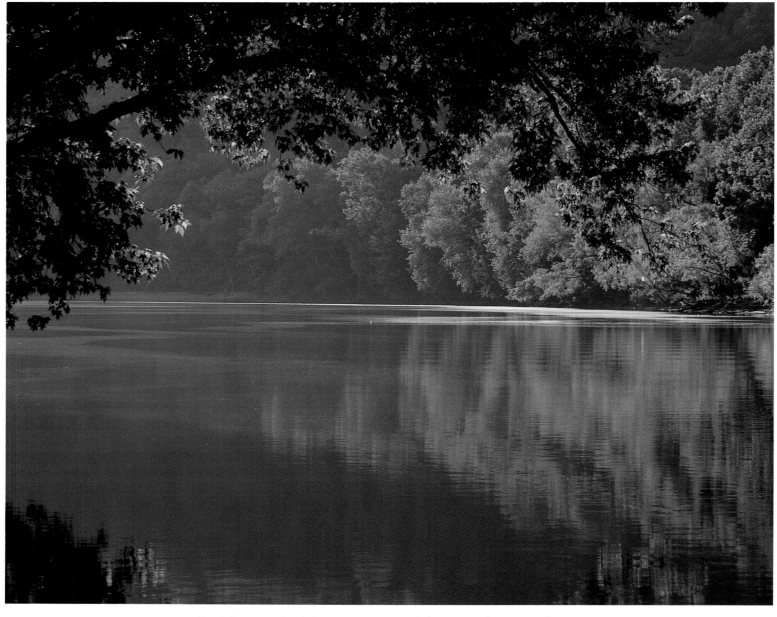

▲ Draining much of the eastern part of the state, the Kentucky River still influences cultural life as it has since early times. ▶ A flowering dogwood stands beside a tributary of the Cumberland River in Pine Mountain State Resort Park. ▶▶ Throughout Kentucky in spring and fall, extreme temperature changes shroud the hills and valleys in fog.

54

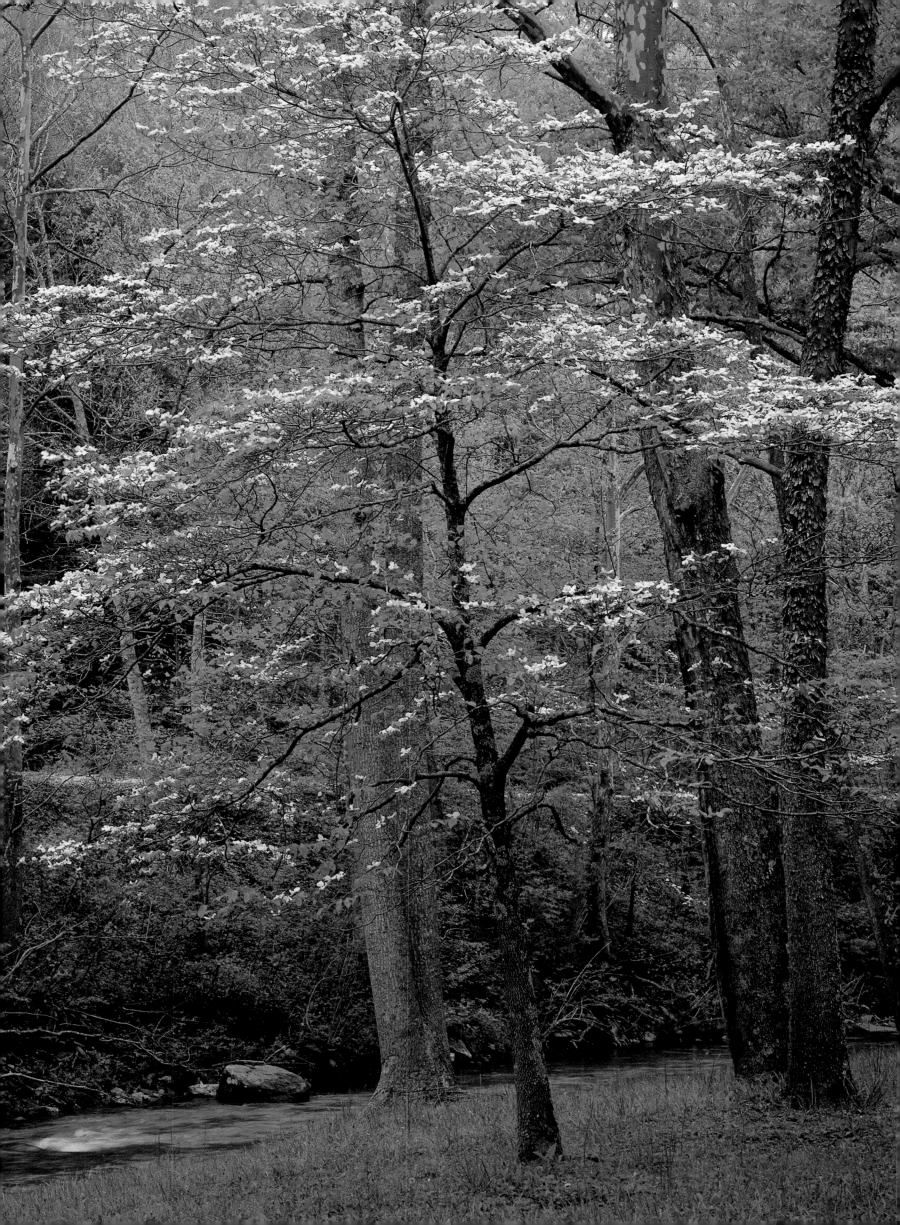

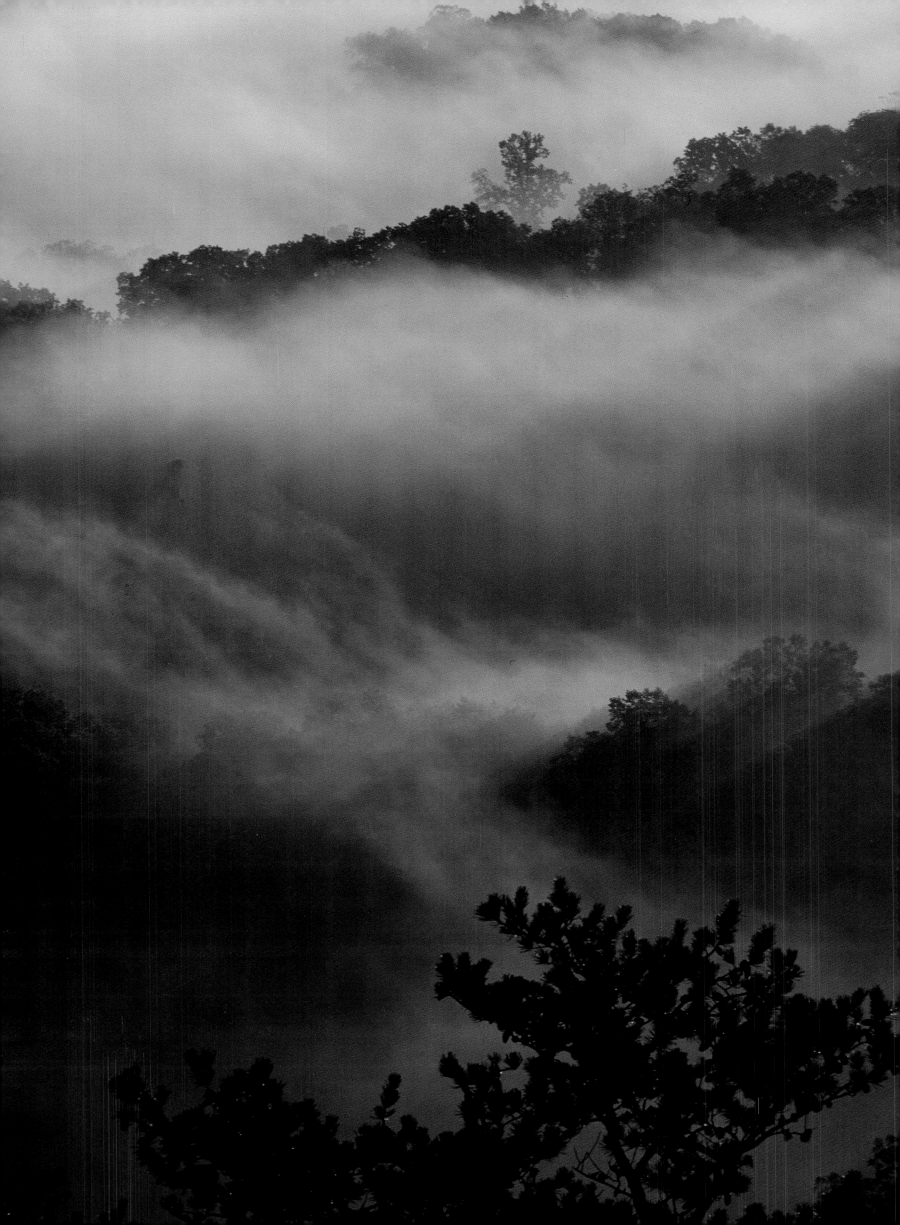

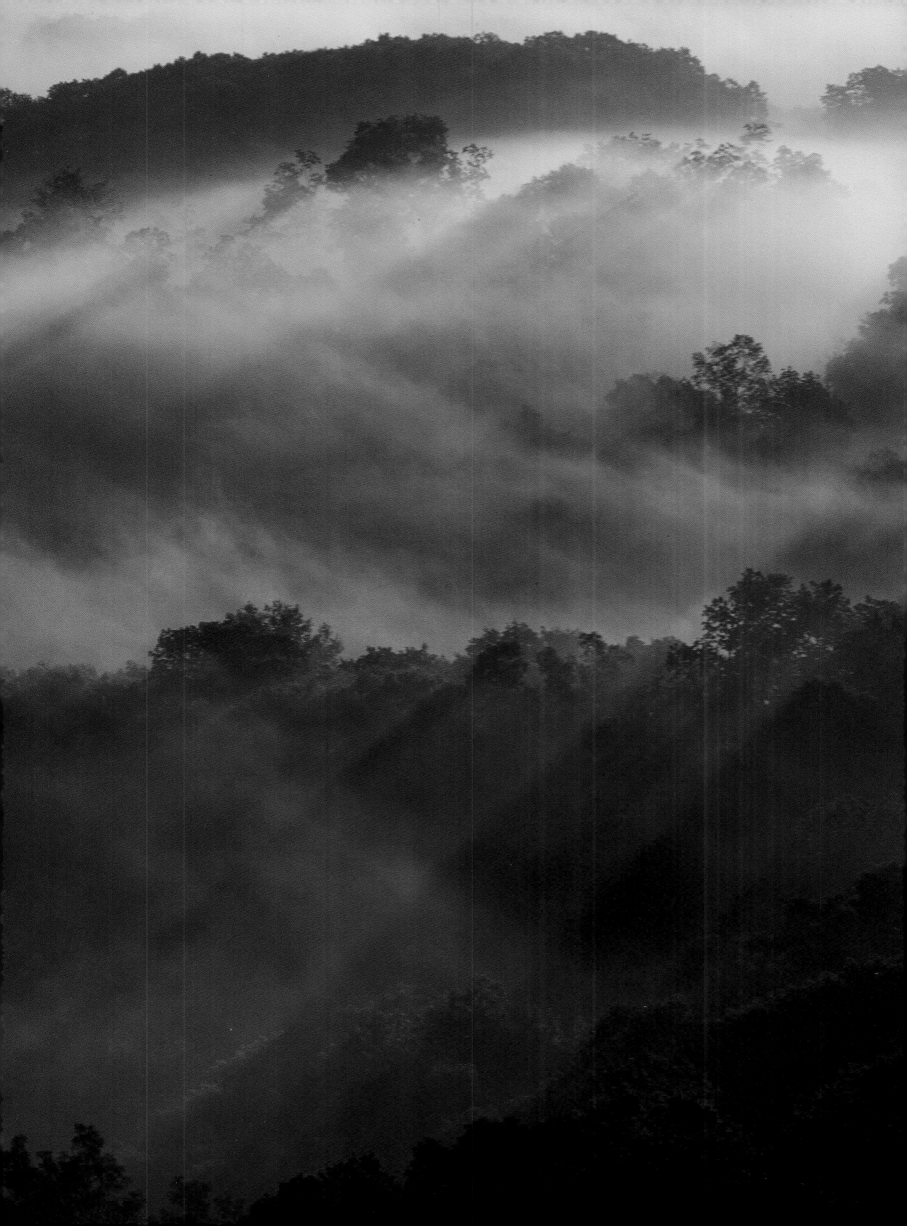

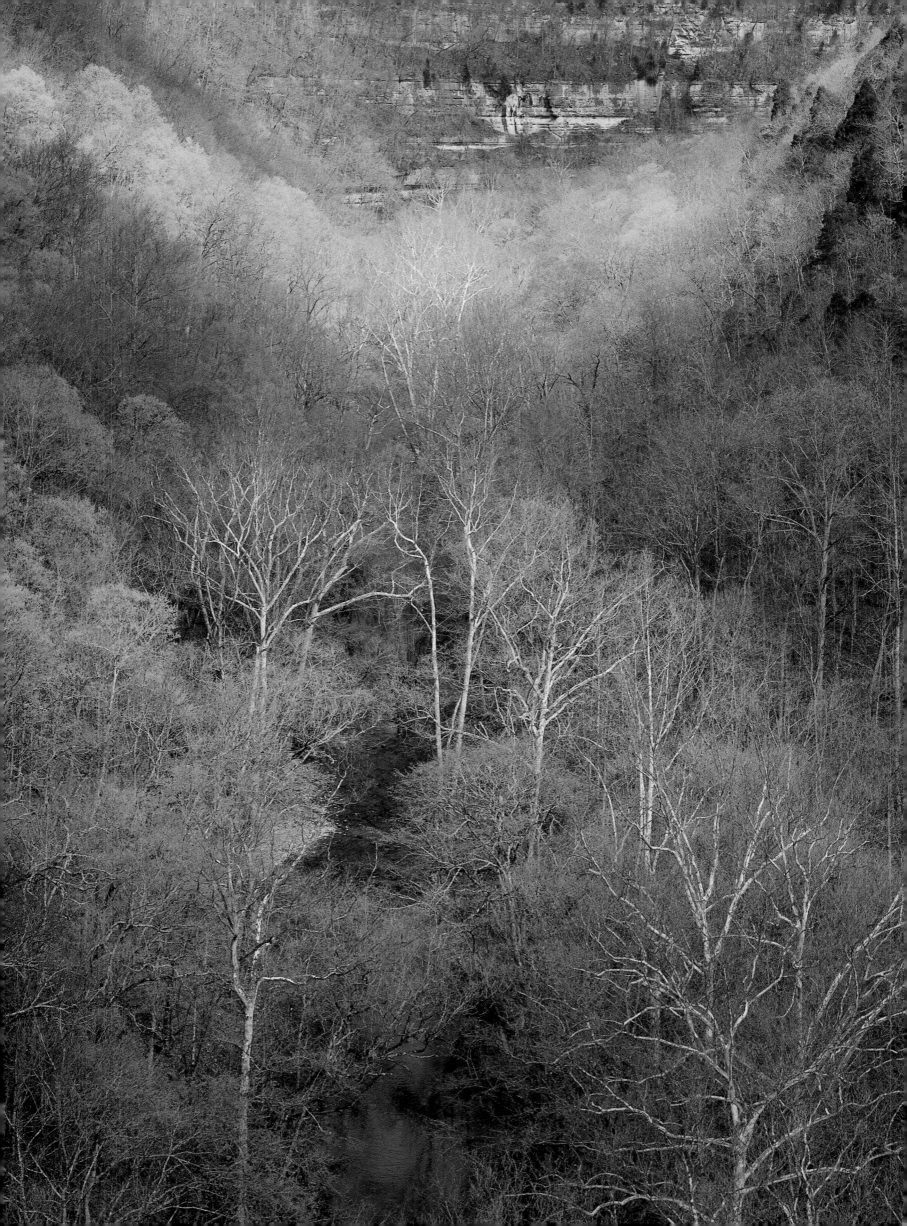

◄ Sycamores grace the Jessamine Creek Gorge, deep in the rugged Palisades area of the Kentucky River in Jessamine County. ▲ The town houses and stately homes of Gratz Park still show the period of gracious living that made this area of Lexington a center of high society in the nineteenth and early twentieth centuries.

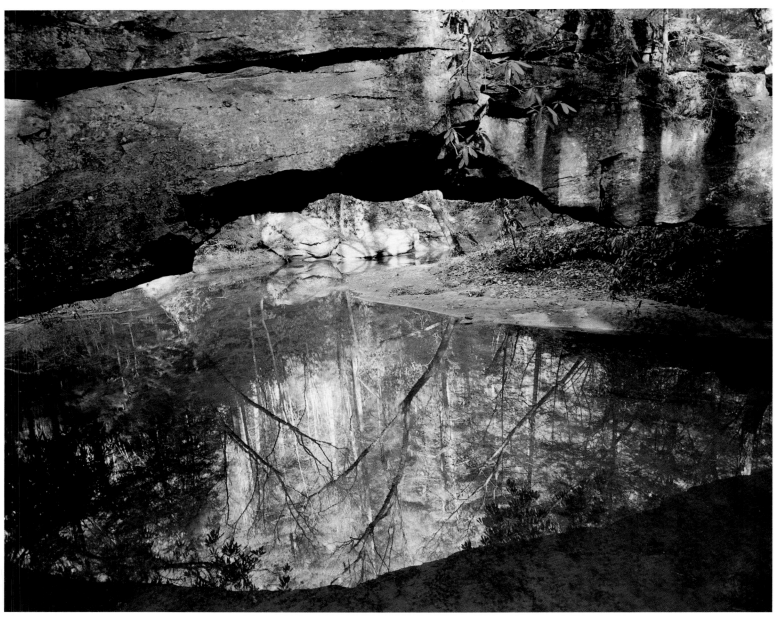

▲ Situated in the Red River Gorge Geological Area of eastern Kentucky, Rock Bridge Arch is one of the most delicate and unusual natural arches: it is one of the few that has formed over a stream.

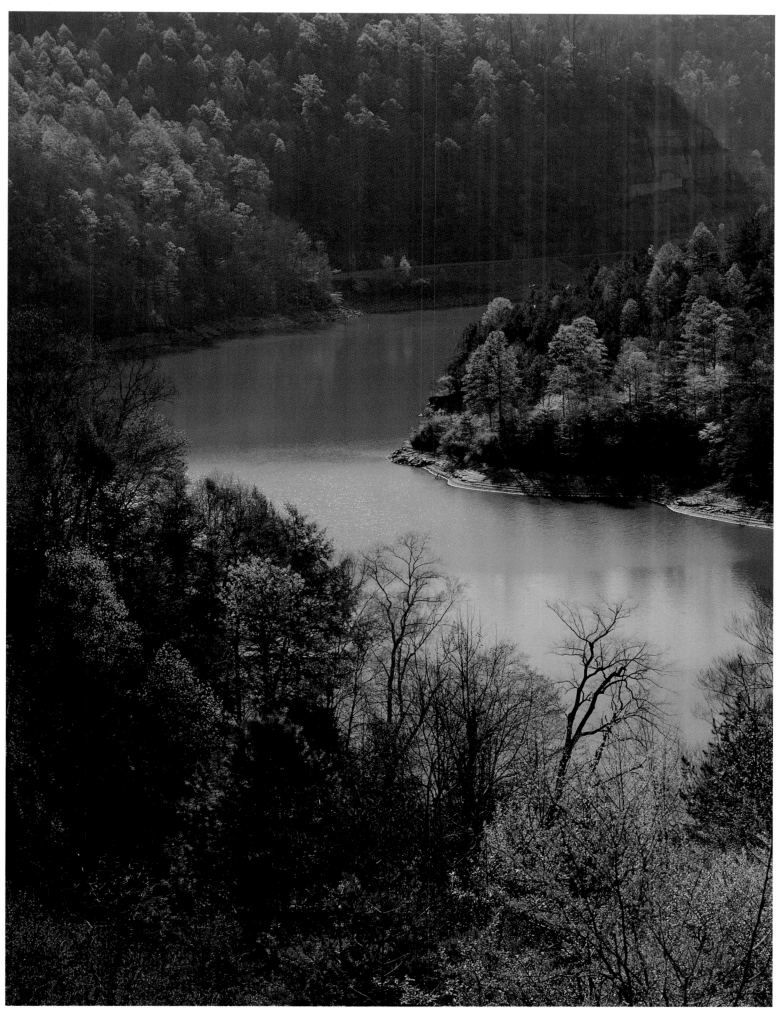

▲ Spring in the Appalachian Mountains is exemplified by this view of Carr Fork Lake in Knott County. Each April, Kentucky's flowering trees and emerald green lakes glow with fresh beauty.

▲ The surface of the Kentucky River shimmers like molten silver deep within the gorge of the river's Palisades area in the central Bluegrass.

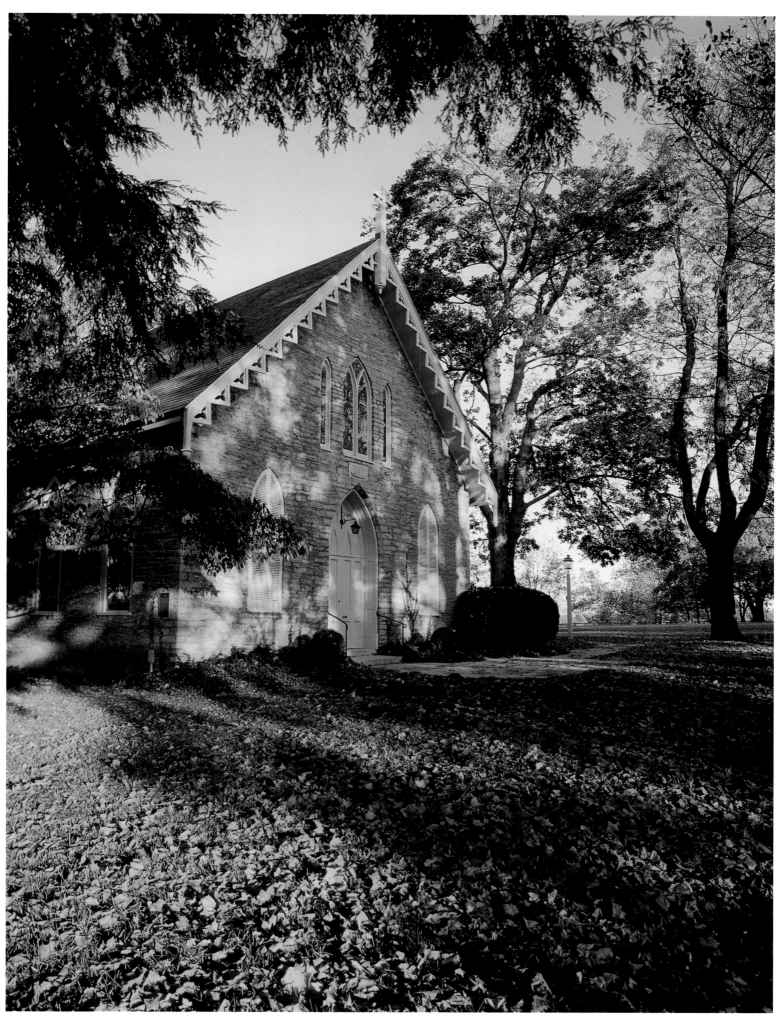

▲ Erected in 1812, the Pisgah Church is a centerpiece of the Pisgah
National Historic District, which also highlights notable farms and
homes in northeast Woodford County.

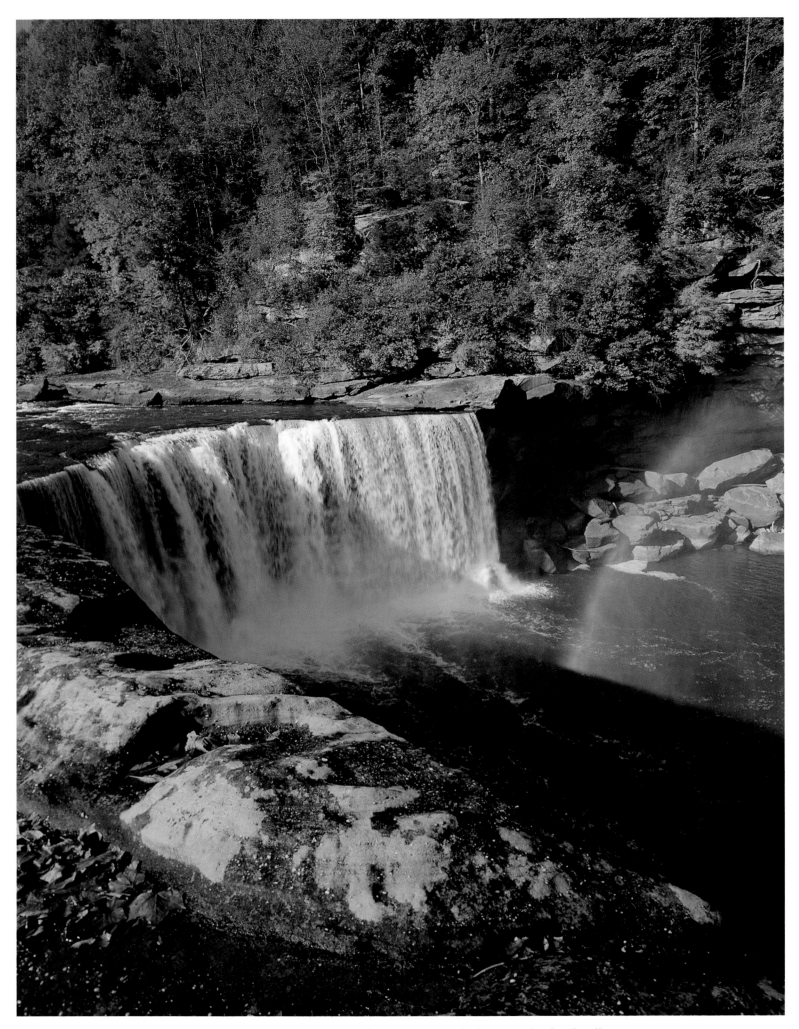

▲ Most sunny mornings produce a rainbow below Cumberland Falls in south central Kentucky. Cumberland Falls is second in size only to Niagara among the waterfalls east of the Mississippi River.

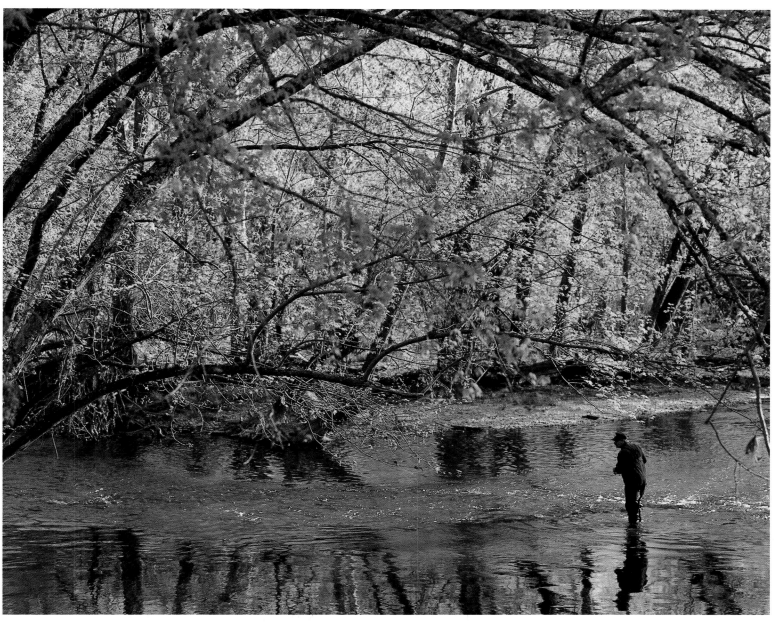

▲ With its limestone bed, North Elkhorn Creek is an excellent
wading stream. Situated conveniently near Lexington, Georgetown,
and Frankfort, the creek offers after-work smallmouth bass fishing.

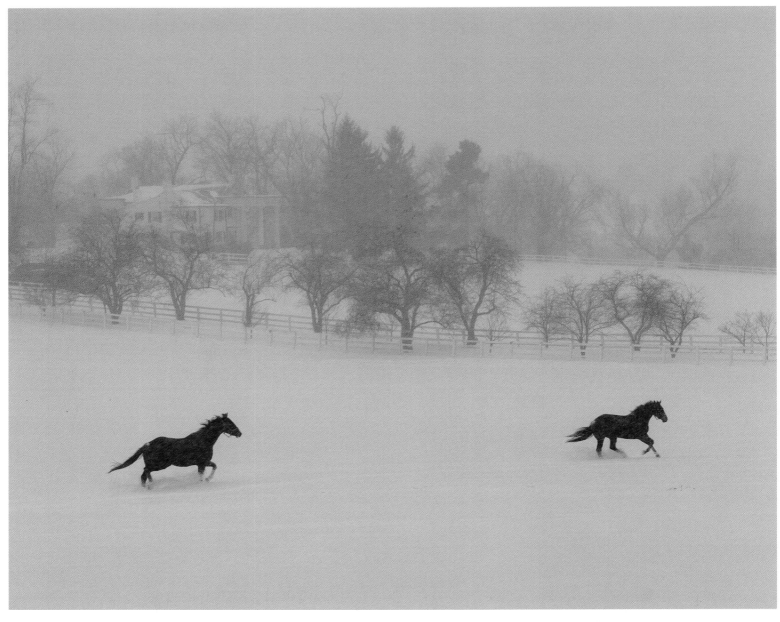

▲ The wonder of a deep snowfall is not lost on these thoroughbred mares as they gallop on the Manchester Farm in Fayette County.
► The mill at Levi Jackson State Park in Laurel County was a center of economic life in the 1800s. It was built beside the Wilderness Road, made famous by Daniel Boone and the early pioneers.

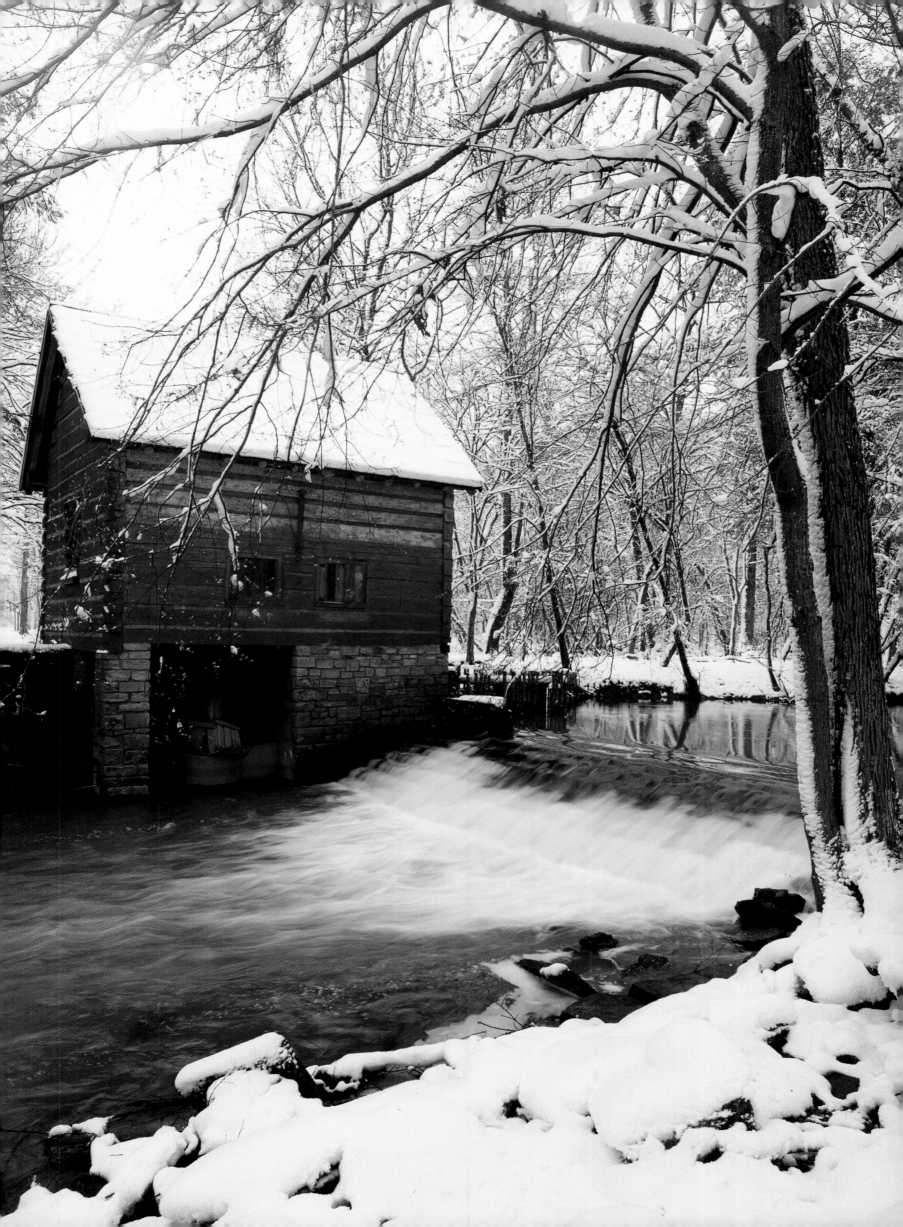

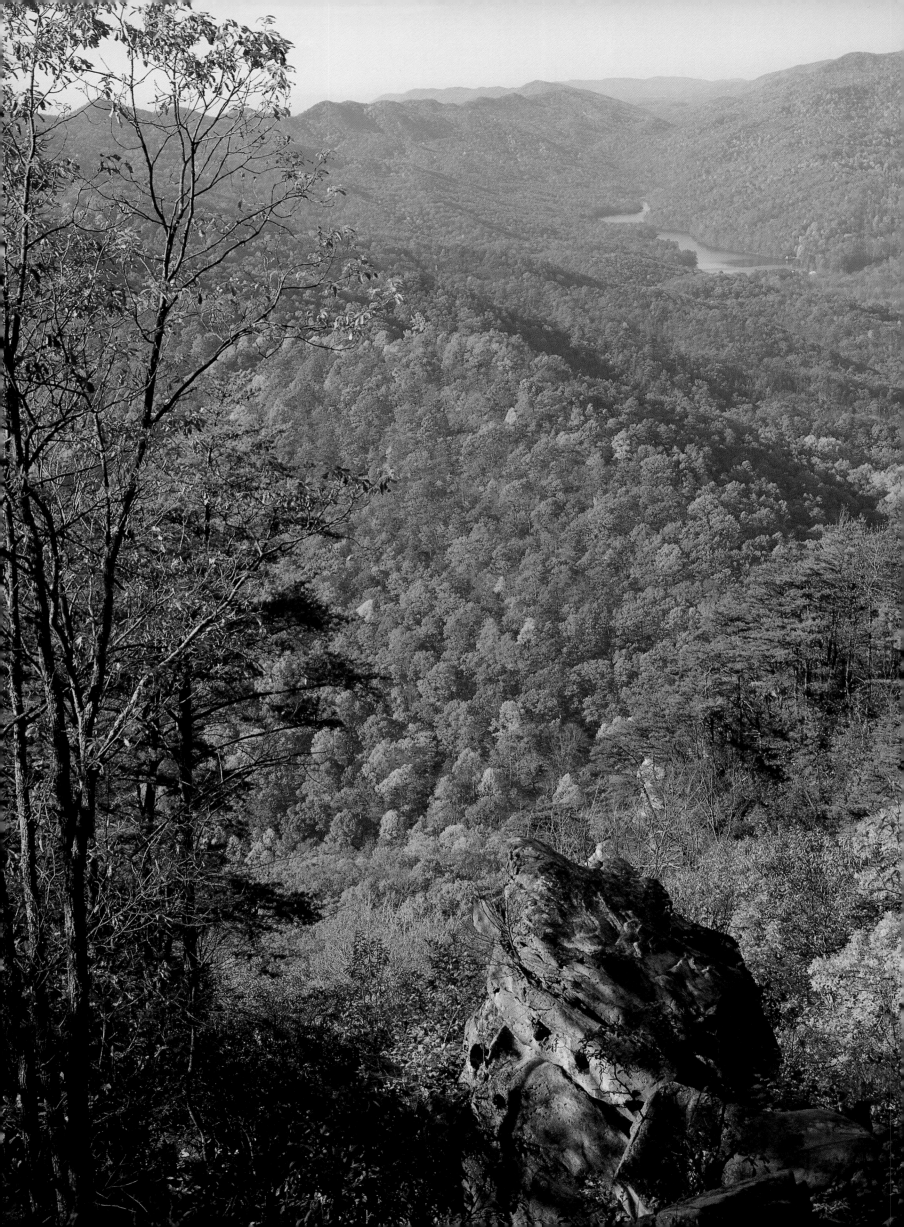

◄ Below this point, in 1775, Daniel Boone first led a band of pioneers through a gap in the mountains that became famous as the Cumberland Gap. ▲ Standing at forest's edge in western Kentucky's Land Between the Lakes National Recreation Area, this young buck exemplifies wild animals' natural ability to camouflage themselves.

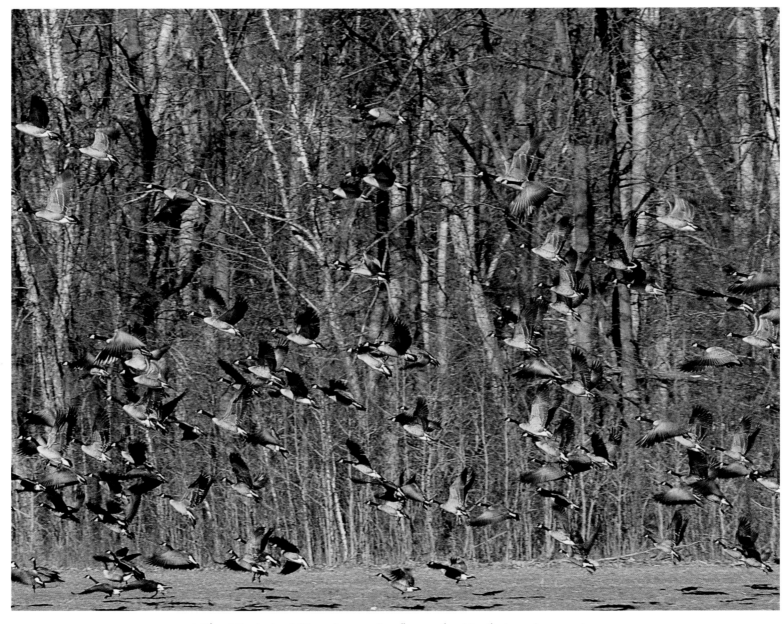

▲ The Mississippi River is a major flyway for North American water-fowl. At times, more than 200,000 Canada geese winter in far western Kentucky. ► This barn stands south of Hopkinsville in Christian County. ► ► Louisville's system of city parks is second to none. Big Rock, shown on the right, is on Beargrass Creek in Cherokee Park.

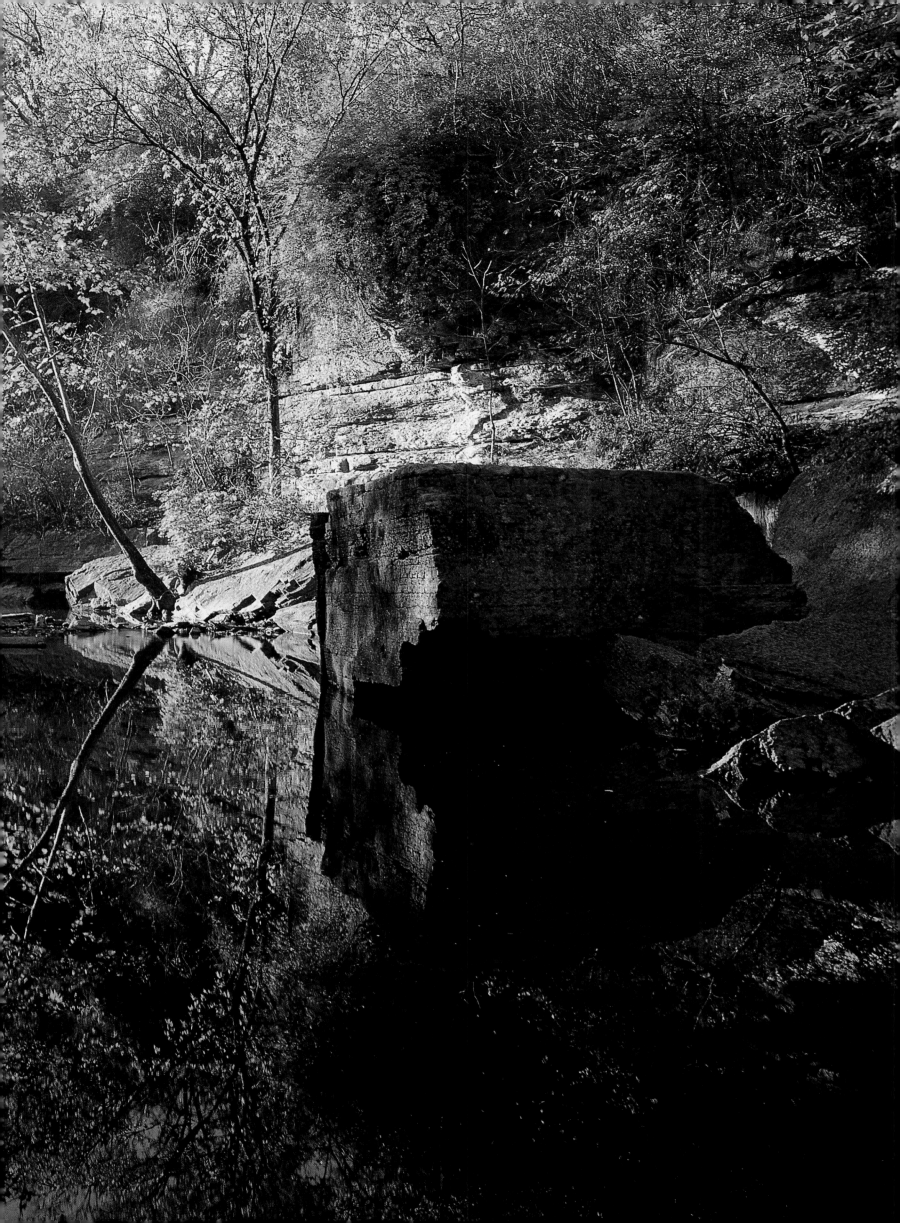

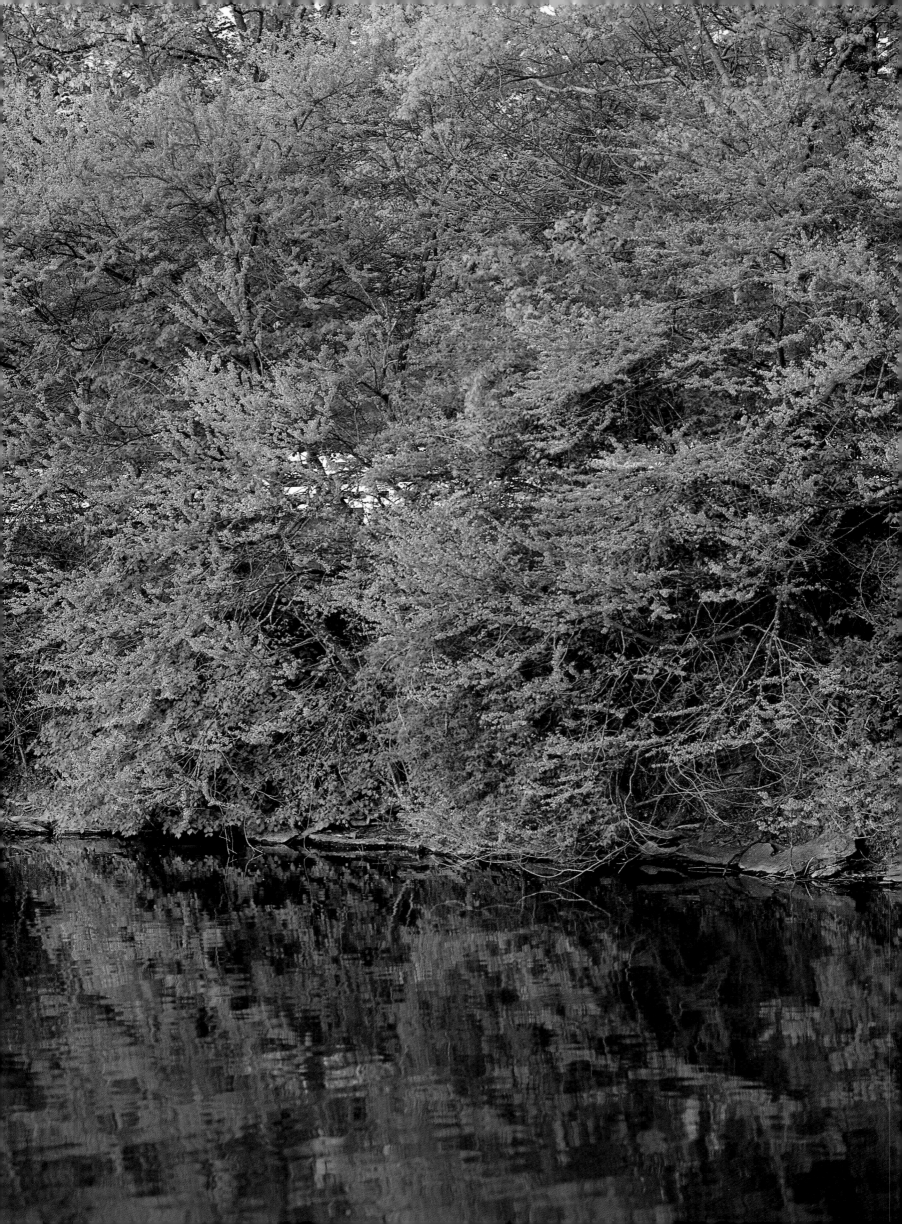

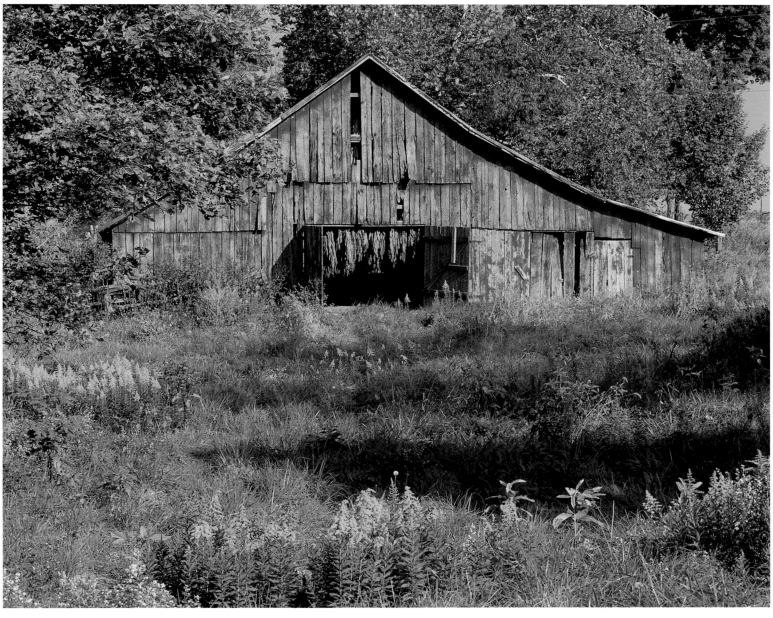

◄ A sure sign of spring in Kentucky, the brilliant pink blossoms of redbud trees adorn roadsides, fencerows, and hillsides throughout the state. ▲ Burley tobacco and goldenrod are two symbols that are ever present in the minds of Kentuckians. Here, tobacco leaves cure amid blossoms of the state flower on a farm near Rough River Lake.

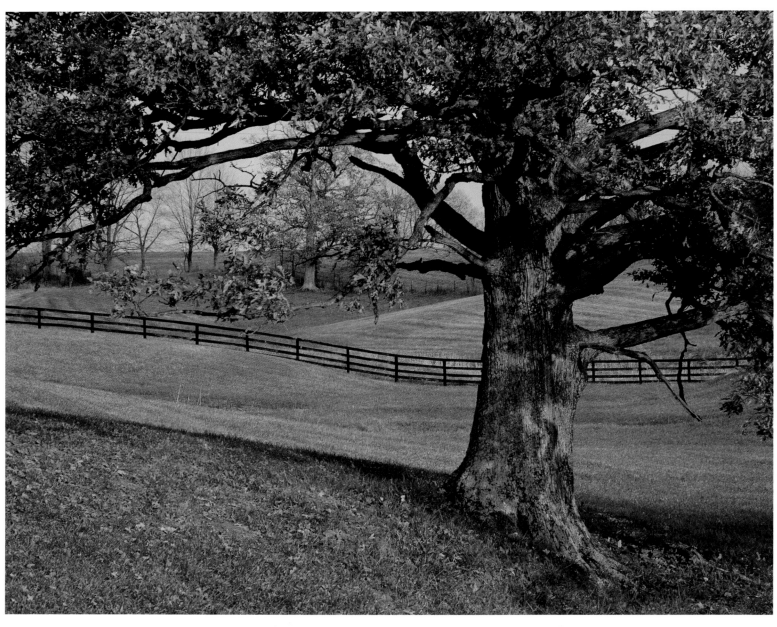

▲ Due primarily to easier maintenance, black fences are replacing
the more traditional white fences in the heart of Bluegrass country.

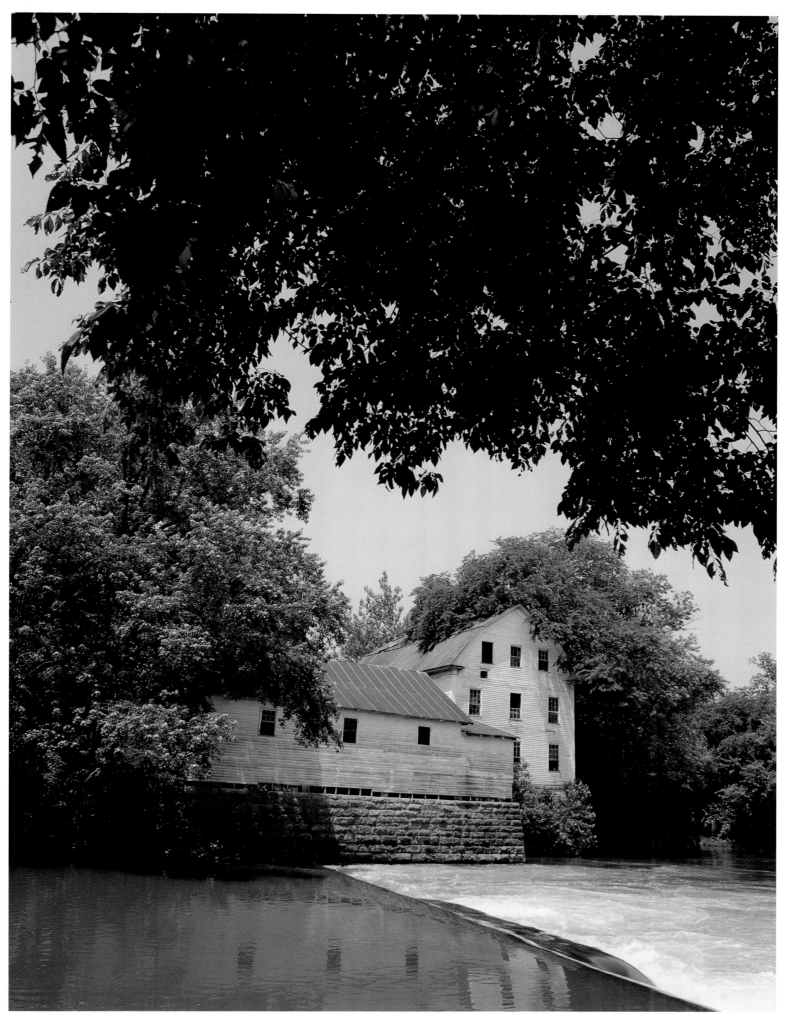

▲ During the nineteenth century, the historic Green Mill at Falls of Rough in Grayson County was the center of the area's agricultural commerce and its social activities.

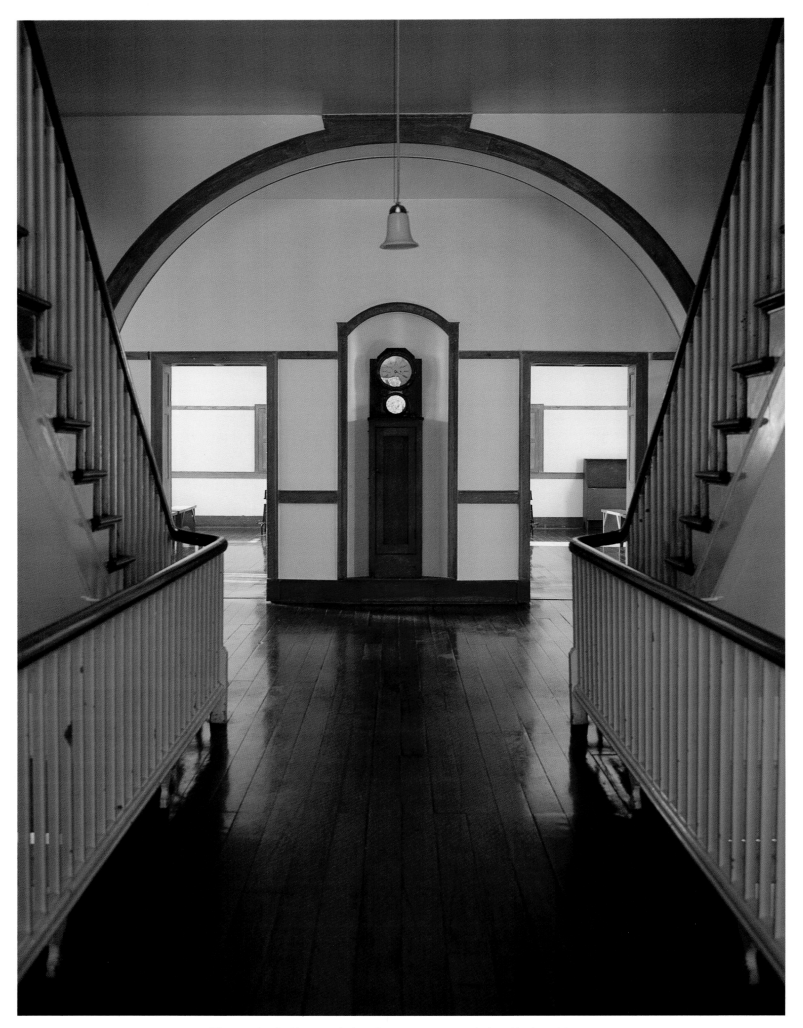

▲ The main hallway of the Centre House of the Shaker Museum
at South Union in Logan County exemplifies the delicate architecture
of the Shaker religious sect that settled the area in the early 1800s.

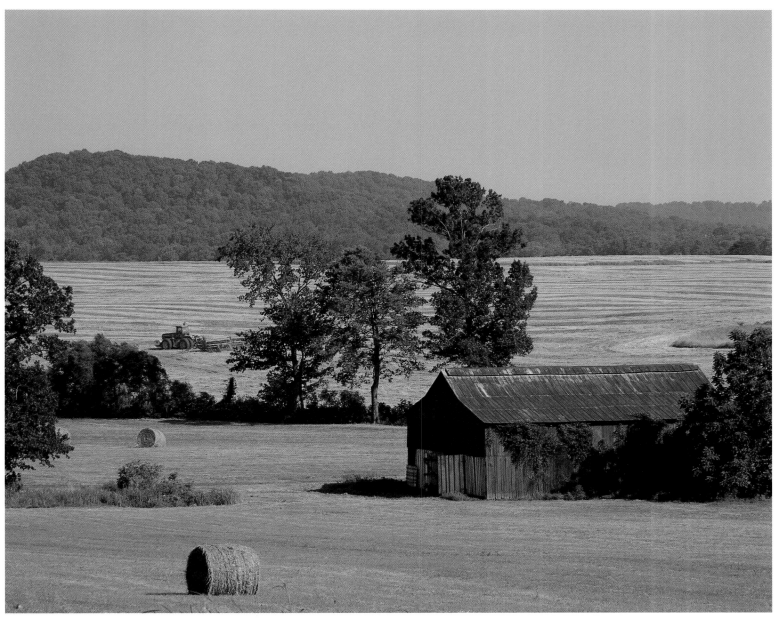

▲ North of Russellville in western Kentucky, an air-conditioned tractor
completes the job of cutting winter wheat on a Logan County farm.

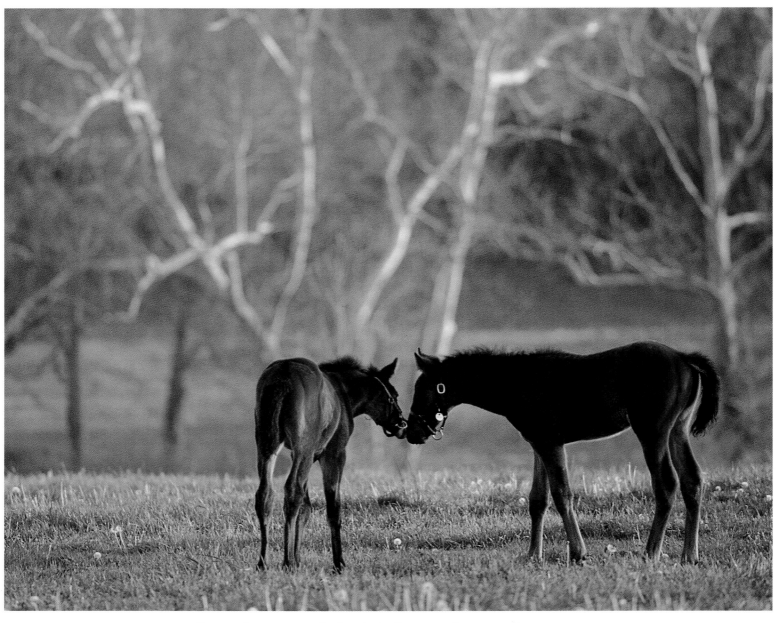

▲ For curious young foals, their first months are a time to get to know the new world around them. Each spring, bluegrass pastures attract horse-loving visitors with scenes like this.

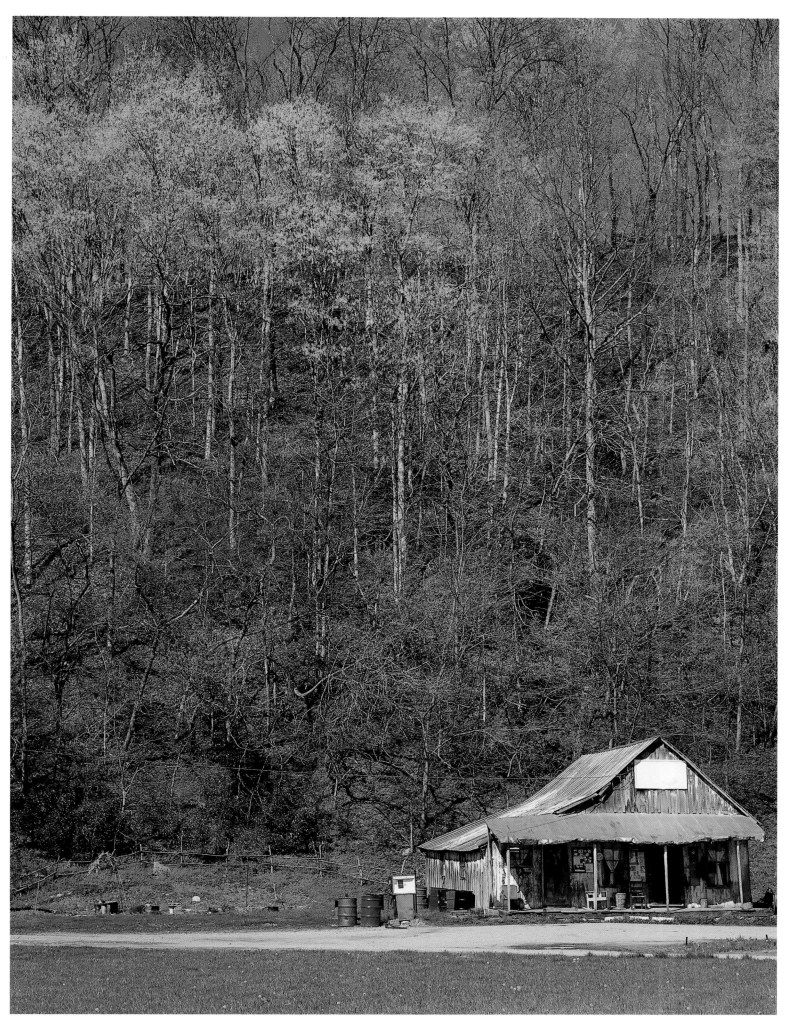

▲ Penn's Store, west of Danville, is Kentucky's oldest operating general store. Penn's was once a hub of commercial and social activities for the agricultural communities of Boyle, Casey, and Marion Counties.

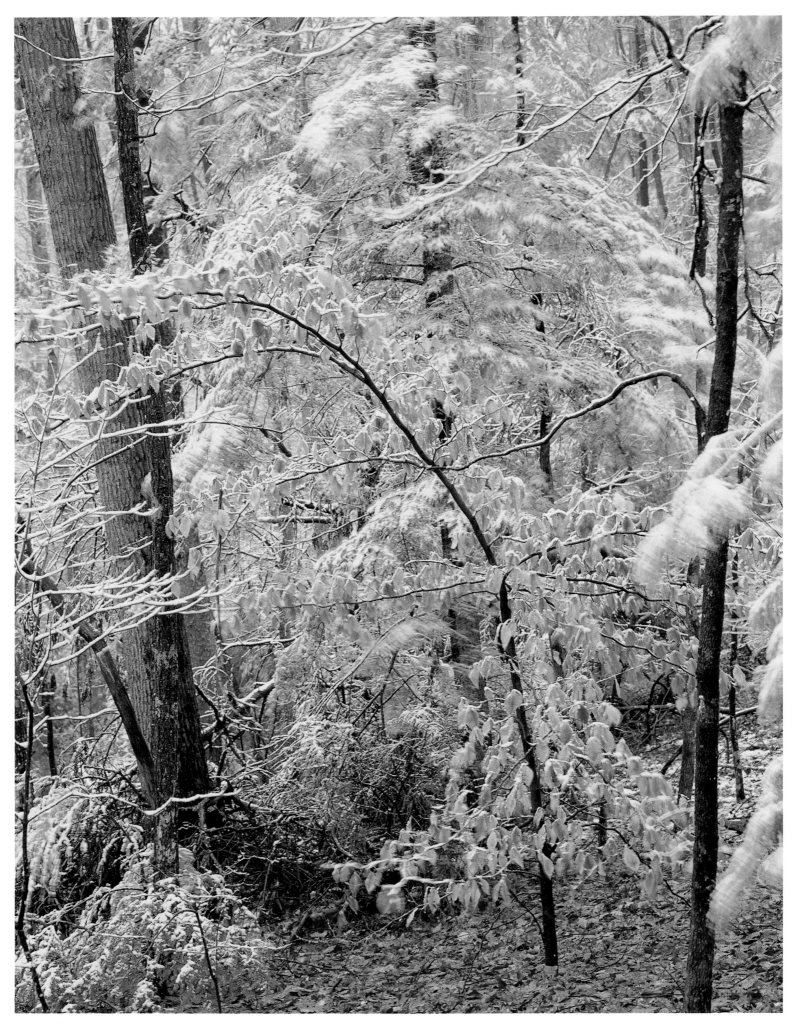

▲ New snow etches trees in the renowned 14,000-acre Bernheim Arboretum and Research Forest, south of Louisville in Bullitt County.

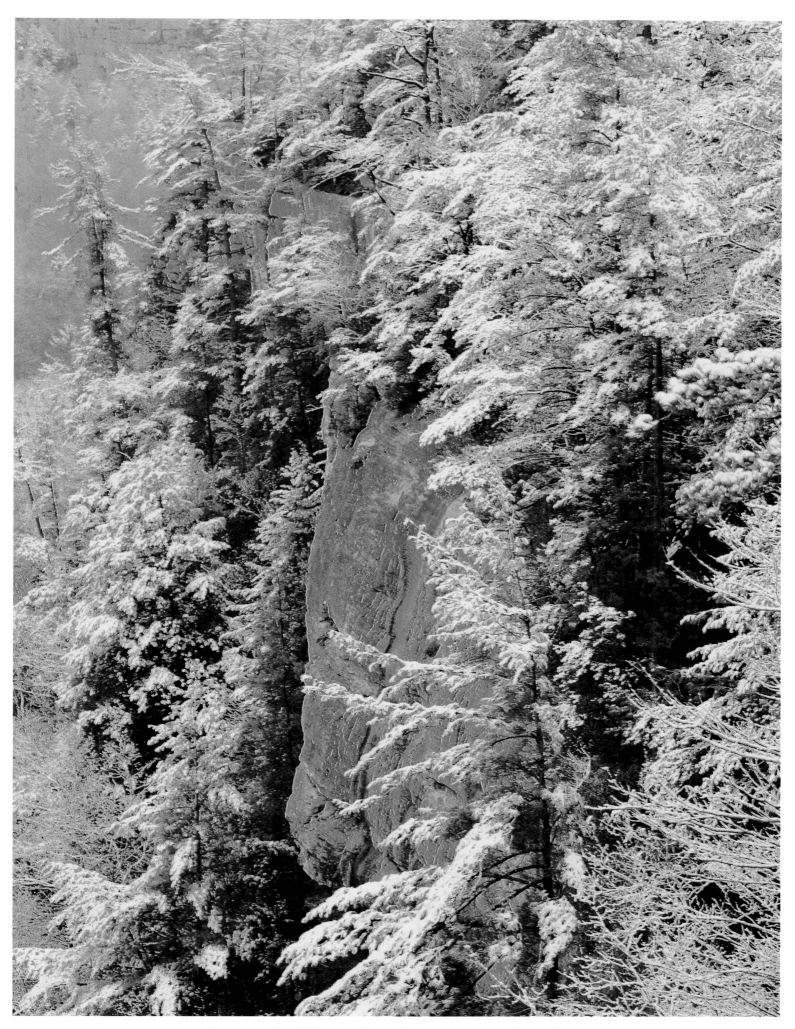

▲ This vertical rock face in the Red River Gorge Geological Area in eastern Kentucky is one of thousands of natural stone sculptures that have been carved by water and wind over millions of years.

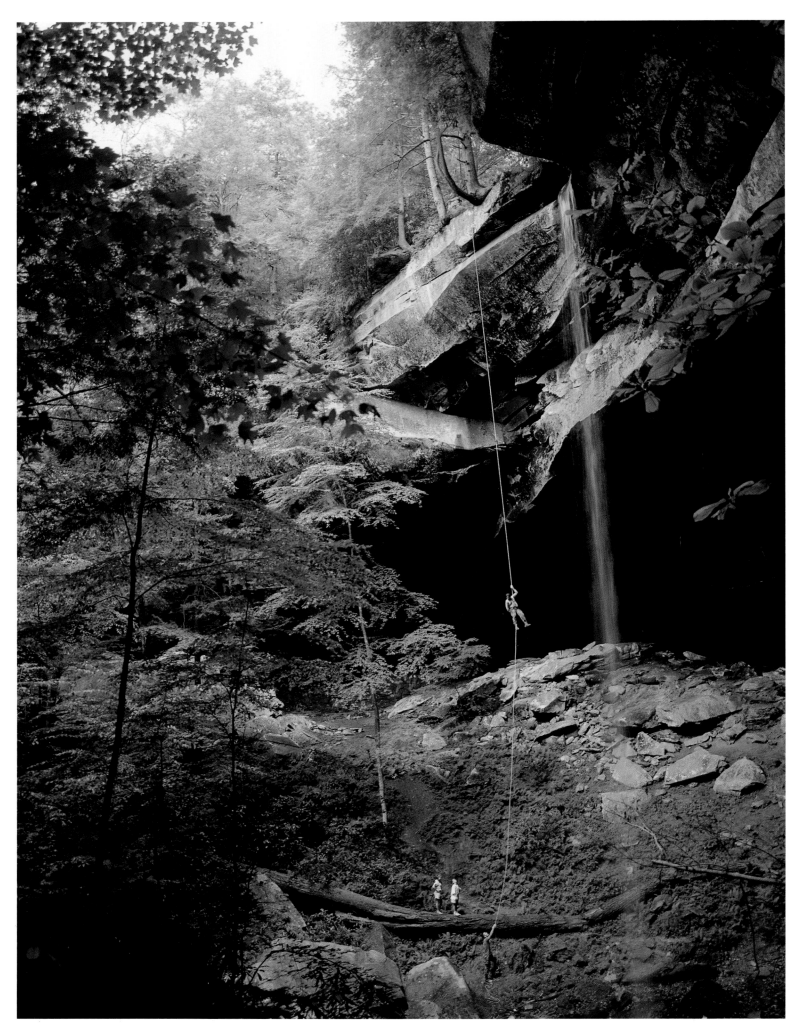

▲ With their rope secured to a tree, these two men take turns rappelling from the top of 113-foot Yahoo Falls in the Daniel Boone National Forest in McCreary County.

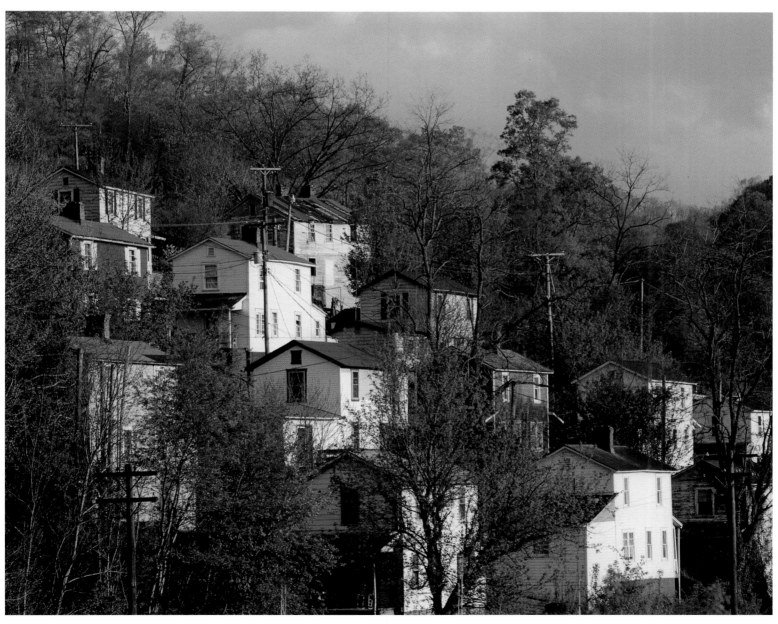

▲ The virtual absence of flat land in the Appalachian Mountains of eastern Kentucky necessitates stacking dwellings up the steep inclines. These houses in Floyd County, dating from about the 1920s, were built for coal miners and their families.

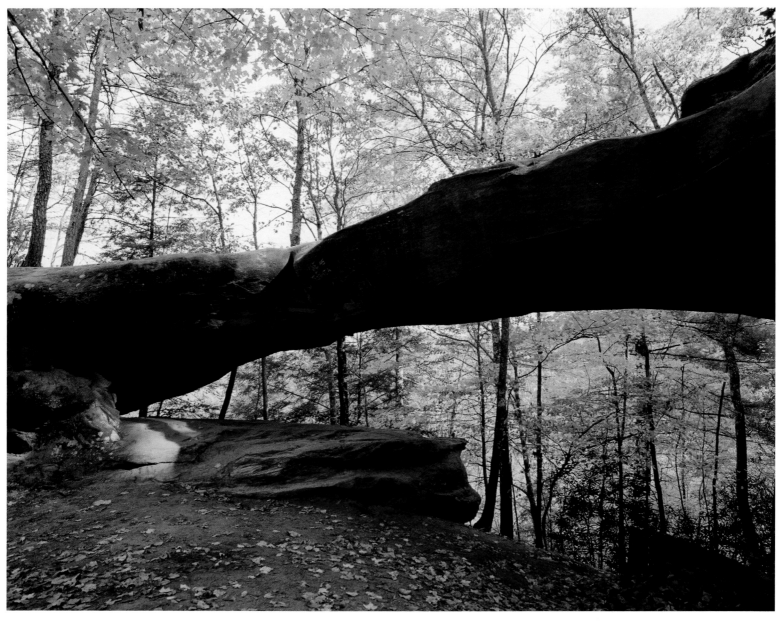

▲ The 32-foot span of Princess Arch is one of the many natural rock bridges in eastern Kentucky's Red River Gorge Geological Area.

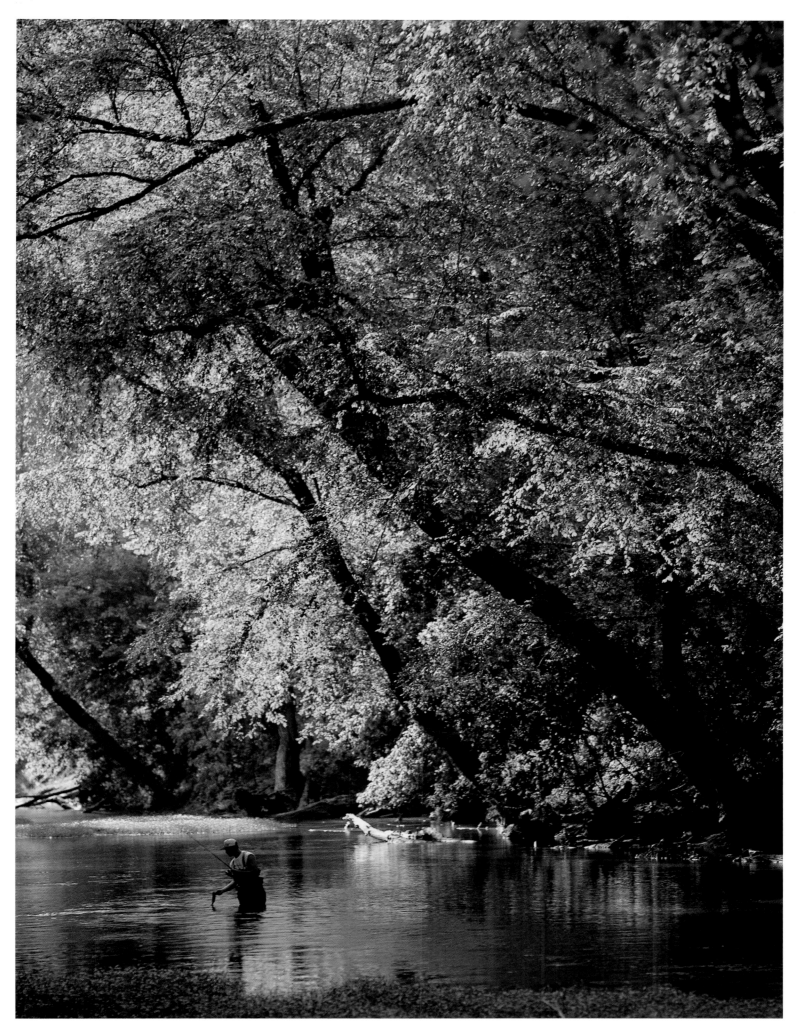

▲ Brad Mullins releases a smallmouth bass back into the North Fork of the Red River in the Red River Gorge Geological Area, in Wolfe and Menifee Counties. ►► The Pine Mountain Range formed part of the impenetrable natural wall through which pioneers had to find a way. This view is from Kingdom Come State Park near Cumberland.

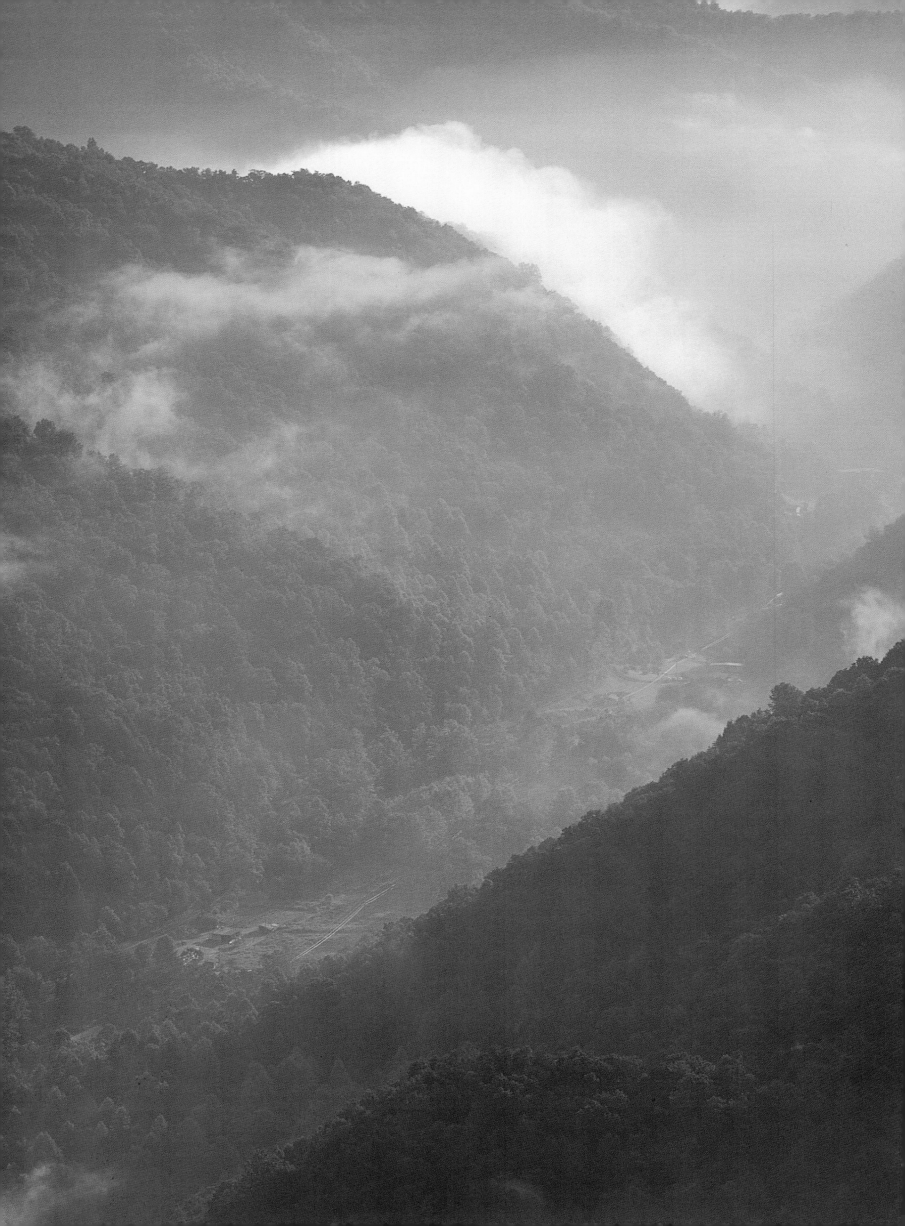

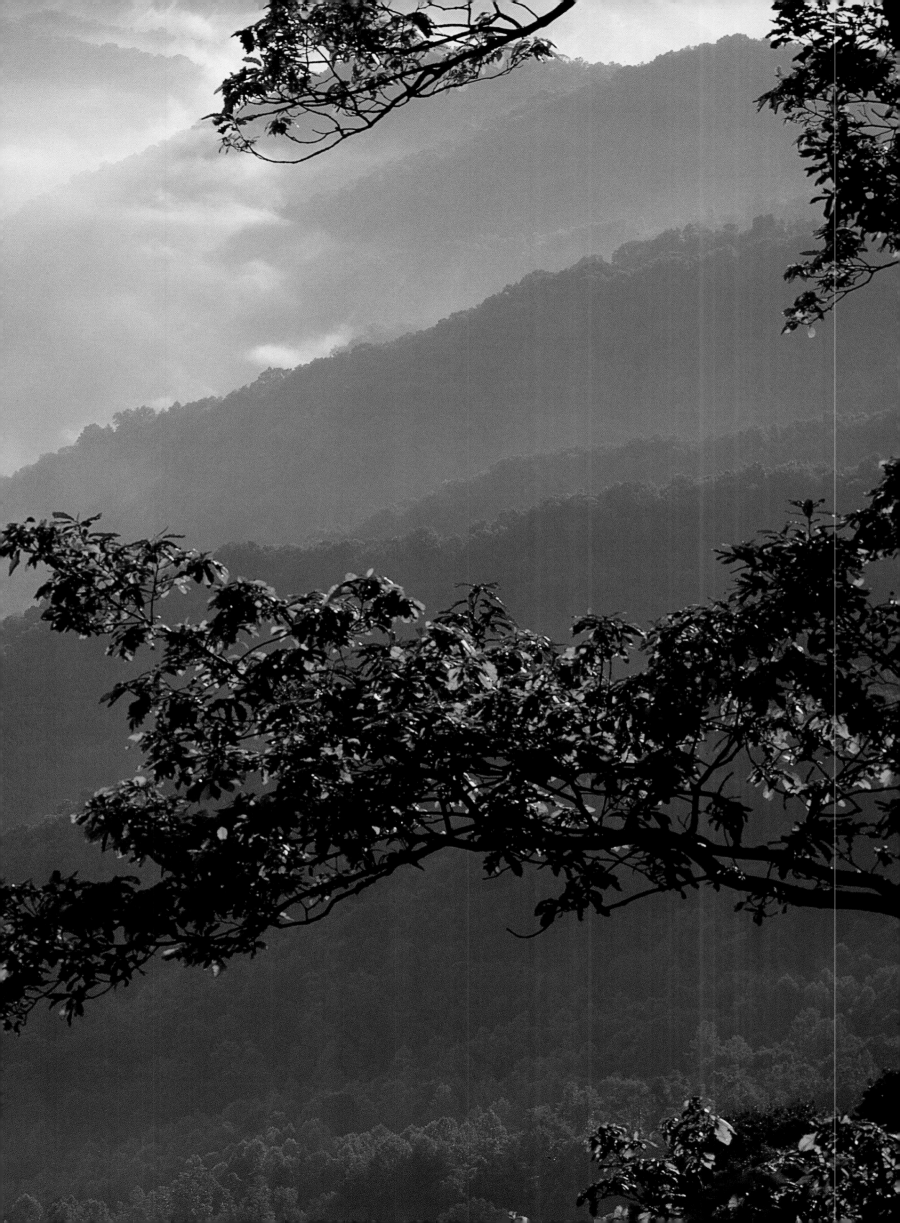

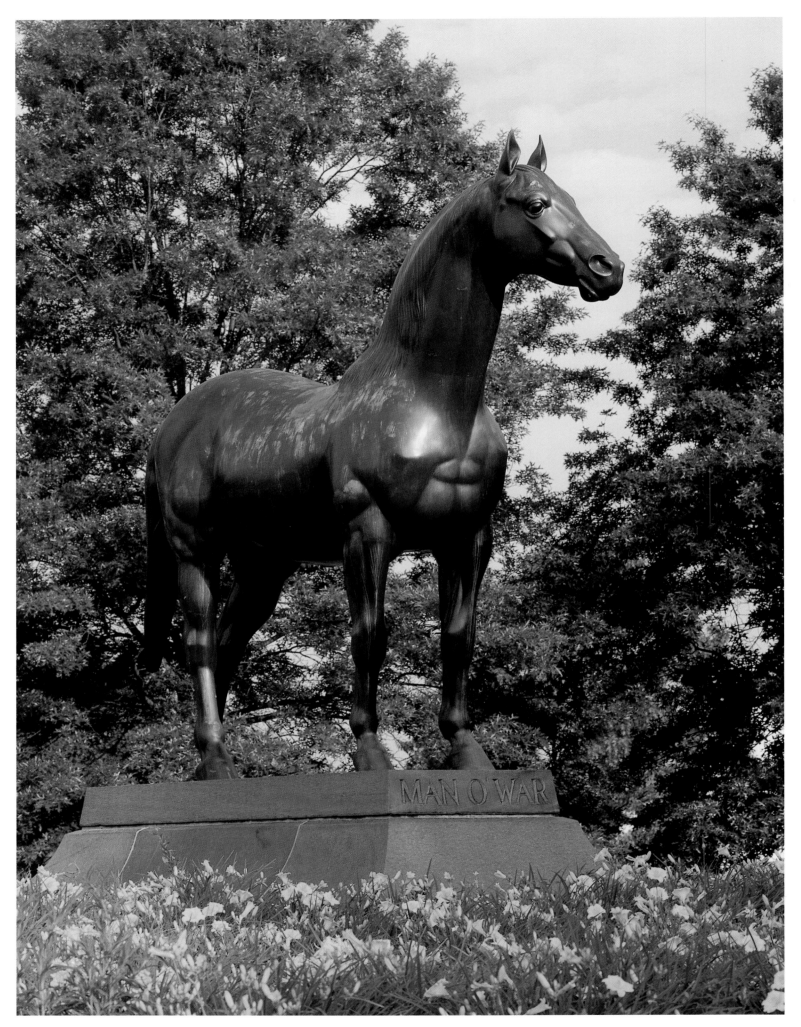

▲ Man O'War is still considered the greatest horse ever to race in the history of the thoroughbred. His bronze statue is the most visited attraction at the Kentucky Horse Park in Lexington.

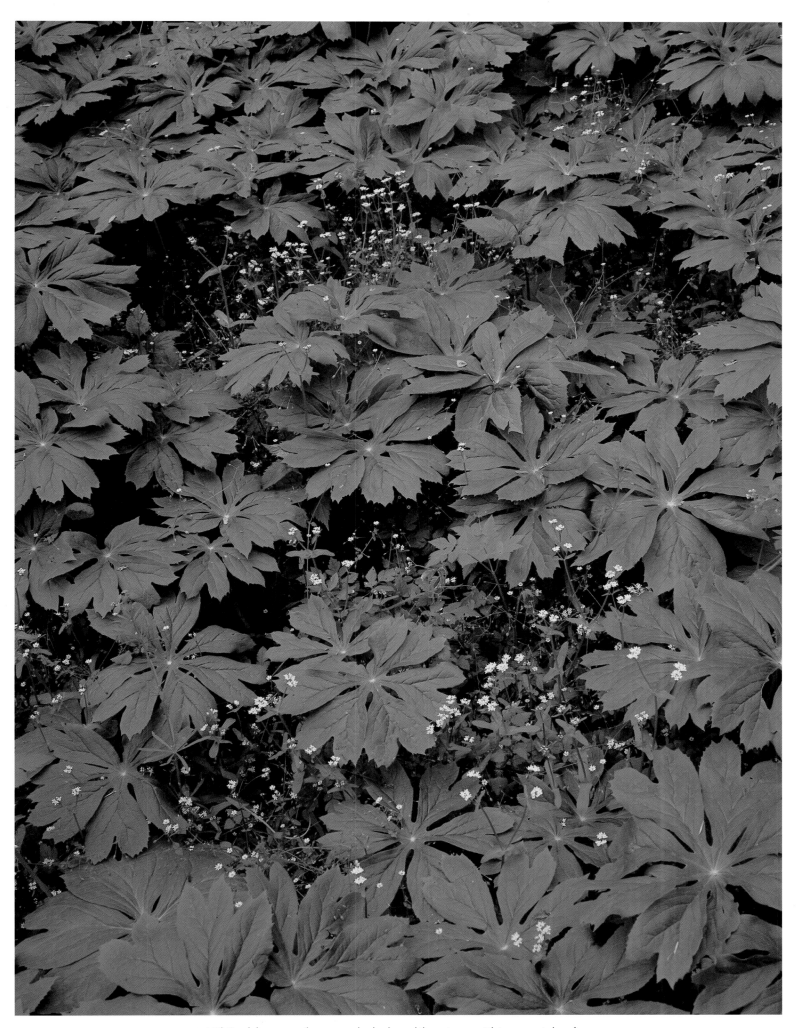

▲ White blooms of corn salad glow like stars within a patch of may apple in the General Butler State Resort Park in northern Kentucky.

▲ Jefferson Davis, the only president of the Confederate States of America, was born here in Todd County in 1808. Just one hundred miles away is the site of Abraham Lincoln's birth in 1809.

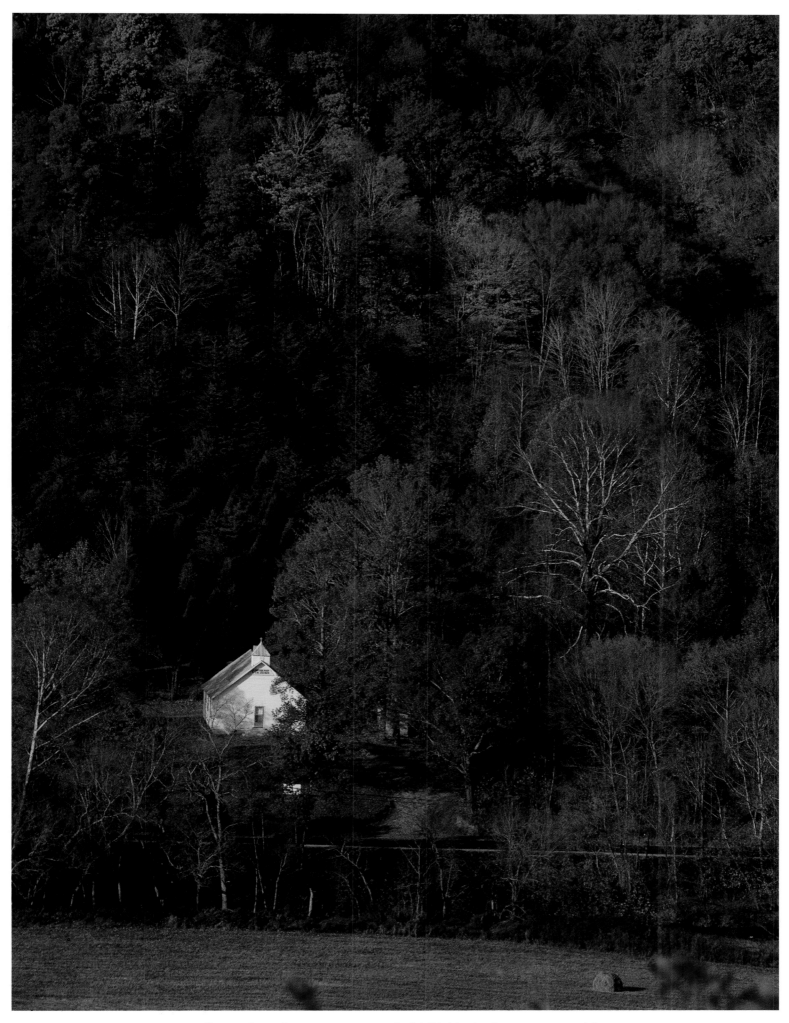

▲ Pressed against a steep wooded hillside in late autumn, this church in west central Kentucky is one of thousands of rural churches that dot Kentucky's visual and social landscapes.

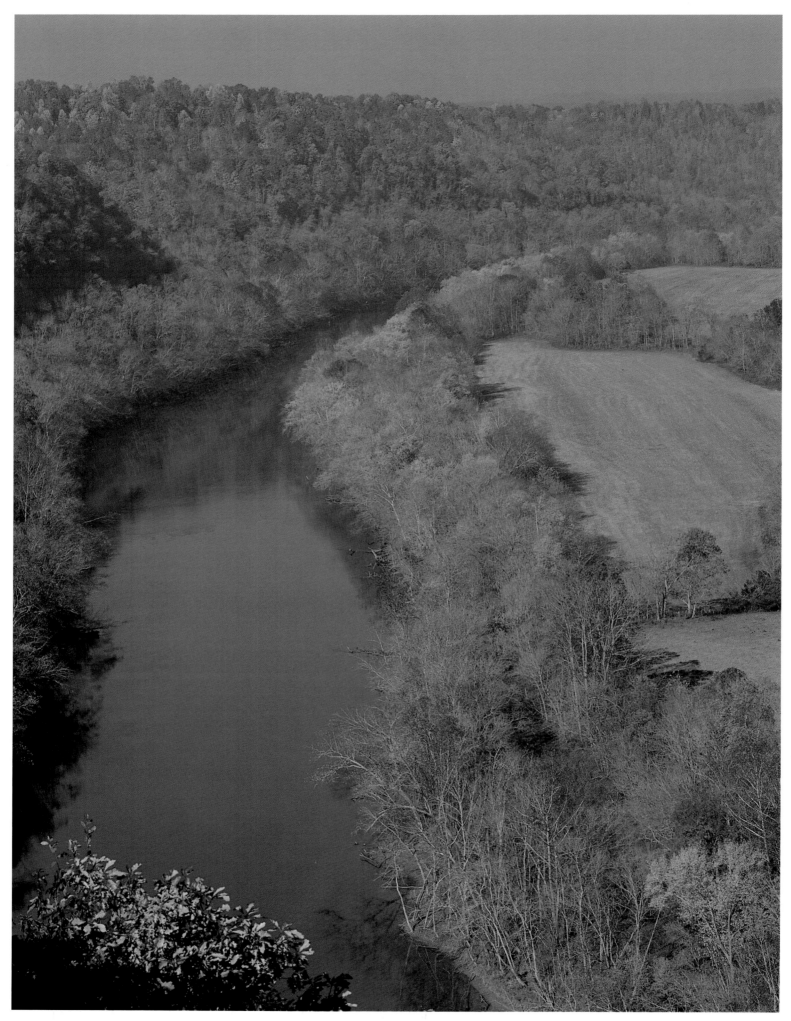

▲ Traversing the state fully from east to west, the Cumberland River has been a dominant force in the history of Kentucky since pioneer days.

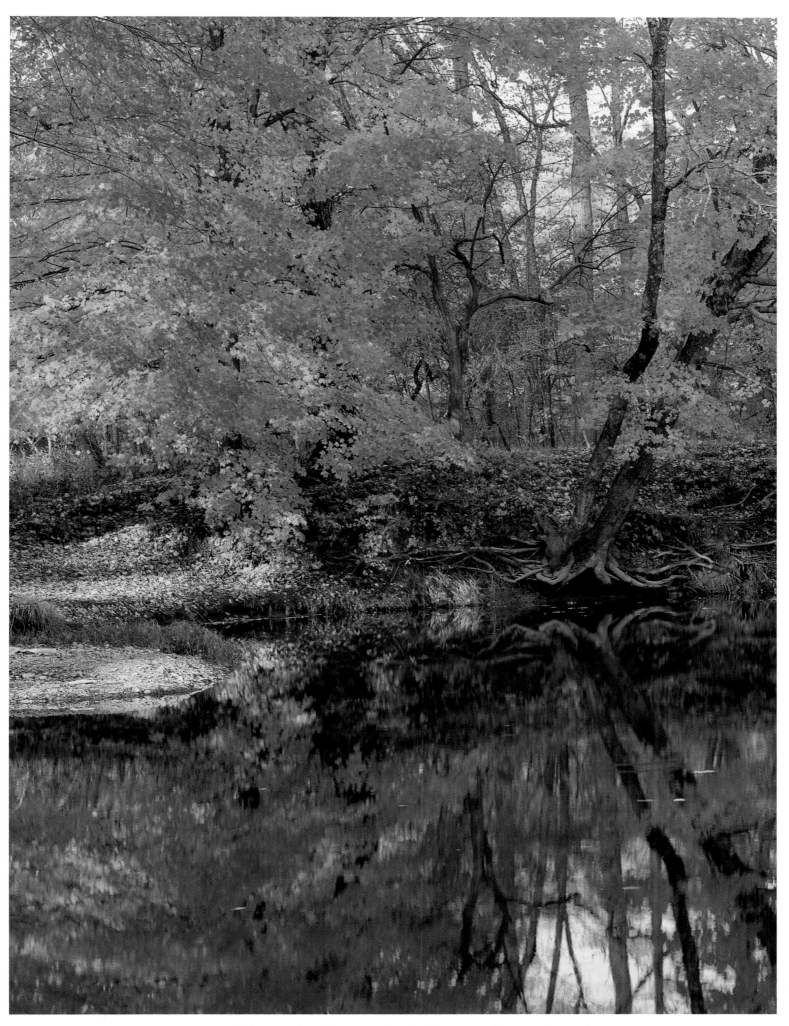

▲ Tens of thousands of farm ponds offer beauty and recreation to the people of Kentucky. This one is found in Boyd County near Ashland.

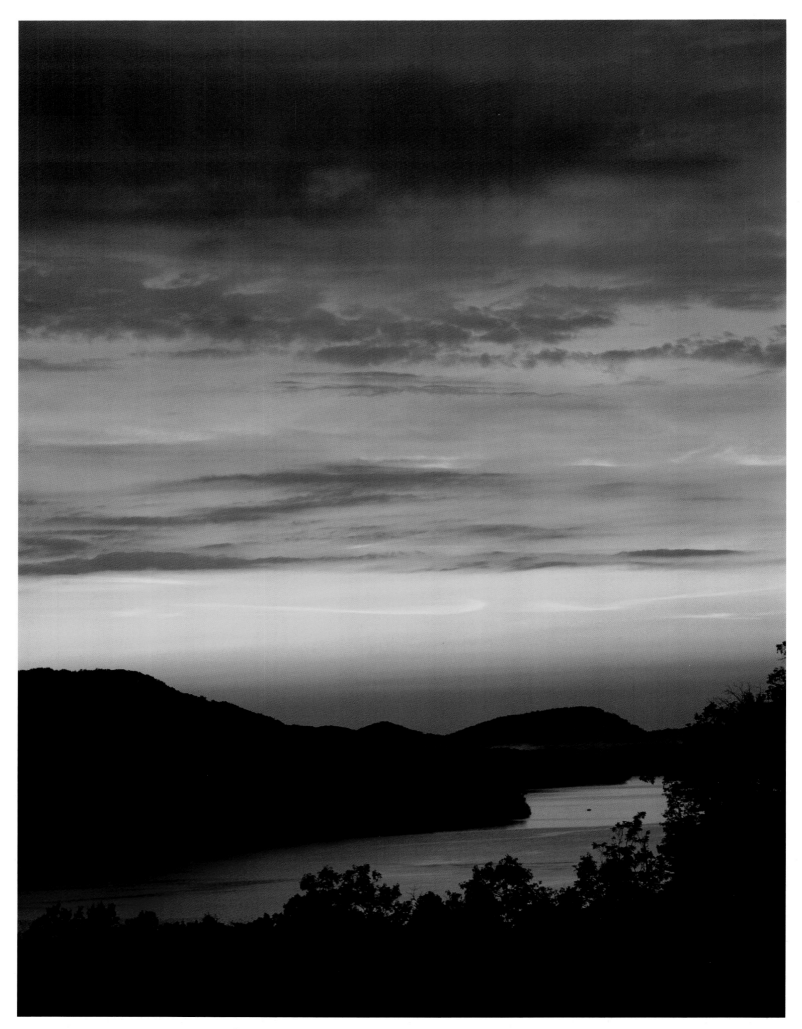

▲ Bordered by the steep mountains of the Licking River Valley, Cave Run Lake is one of many impoundments that have been created for flood control and recreation in eastern Kentucky.

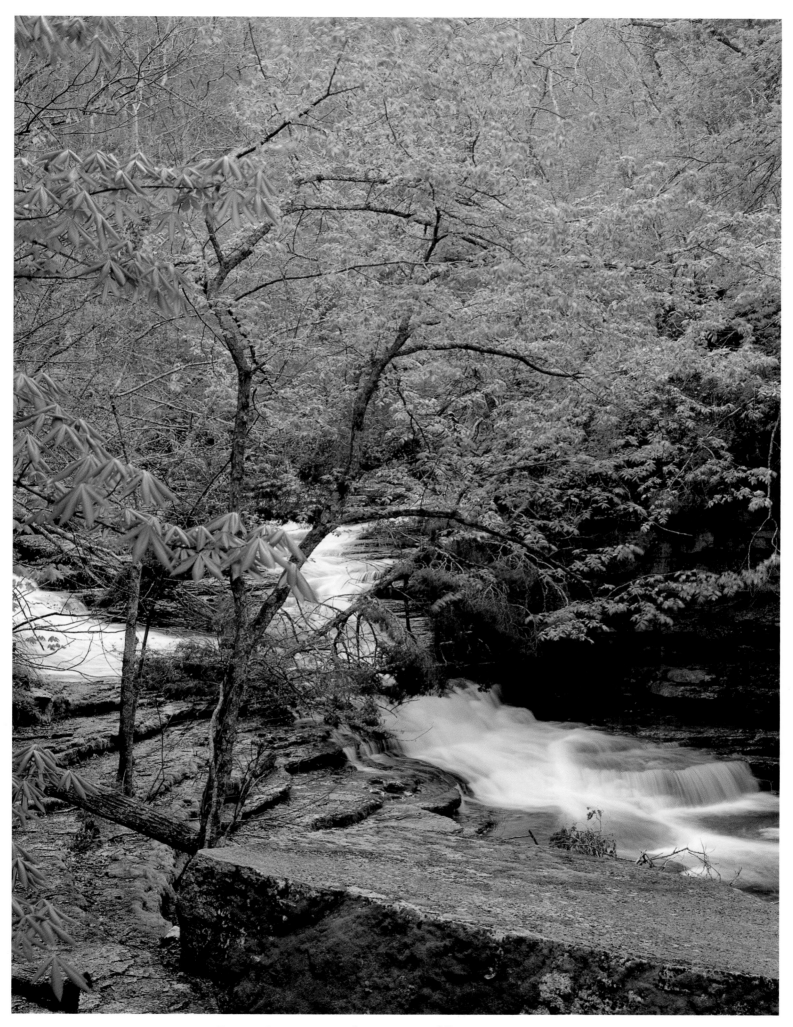

▲ In Fayette County, spring brings rain to fill Raven Run, one of many
nature preserves in the Bluegrass region and throughout Kentucky.

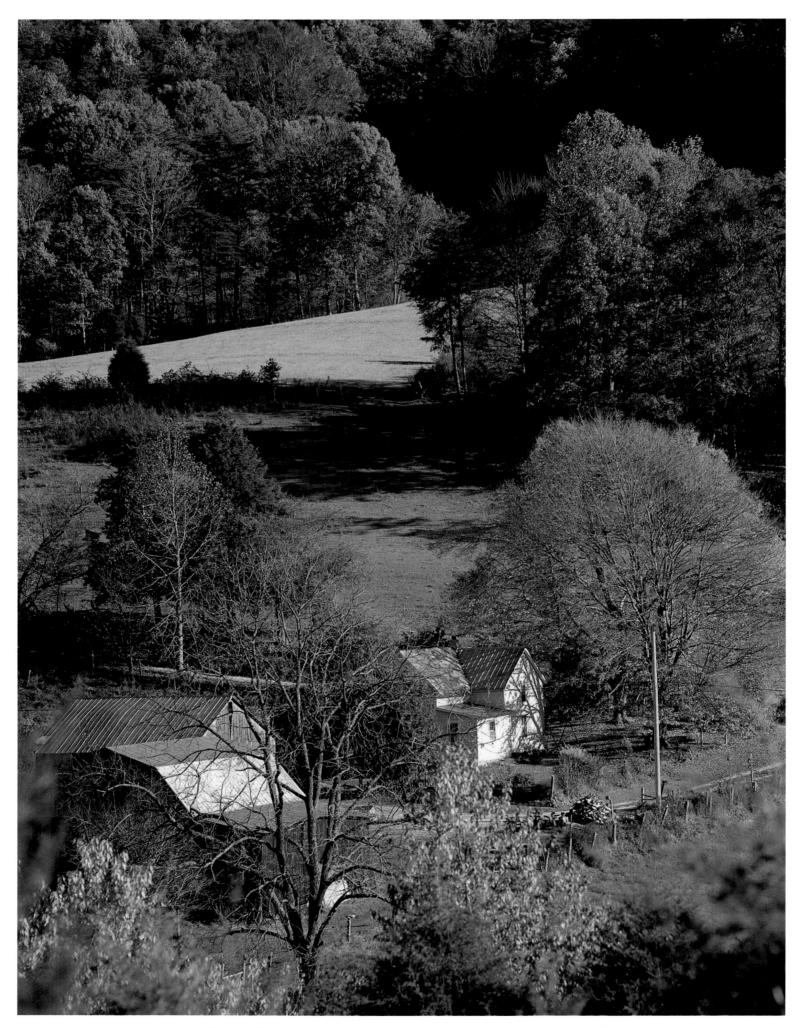

▲ This well-cared-for farm lies in a valley near Somerset in Pulaski County. Although they are fast disappearing, small farms like this still form the backbone of Kentucky agrarian life.

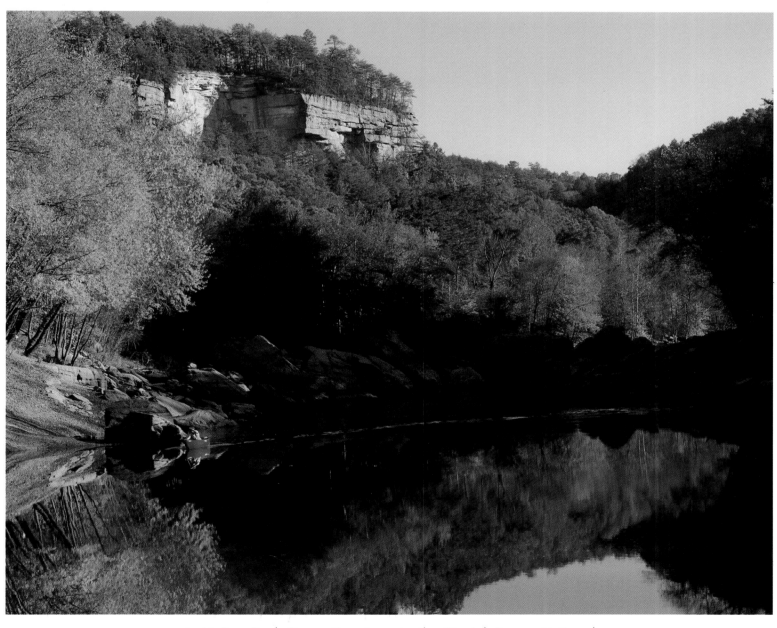

▲ At Bee Rock Recreation Area in the Daniel Boone National Forest, a canoeist silently hugs the shore of the Rockcastle River beneath the autumn-colored cliffs.

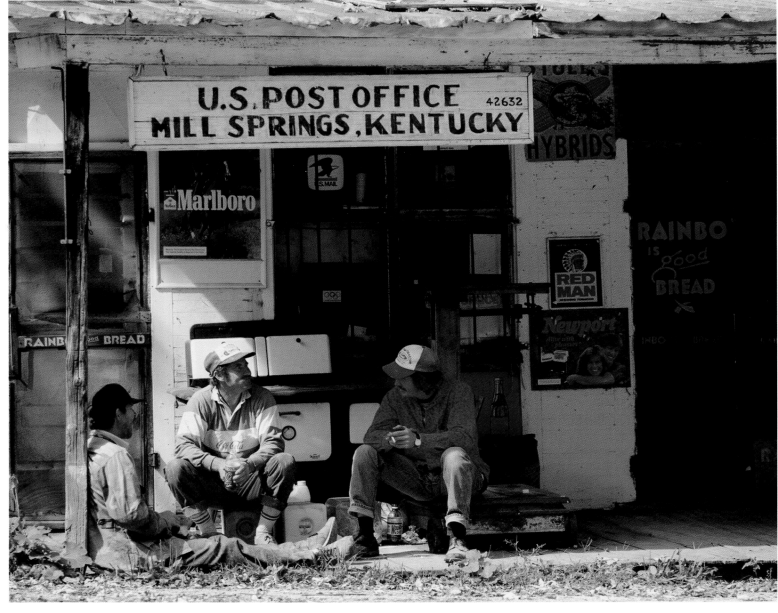

▲ Modern life seems held at bay, as these men pass their lunch hour on the porch of the Dunagan Grocery and Supply and General Delivery Post Office near Lake Cumberland in Wayne County.

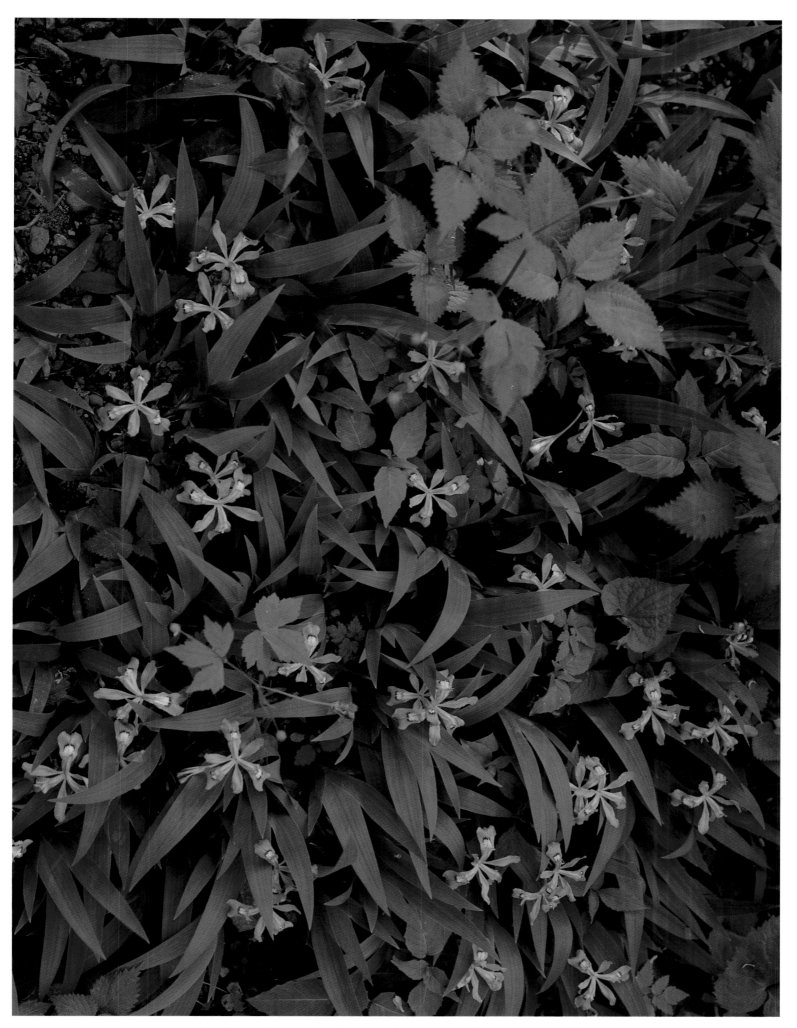

▲ In Carter Caves State Resort Park in eastern Kentucky, the brilliant
blue petals of the crested dwarf iris draw the eye of any hiker lucky
enough to find a stand such as these along a spring trail.

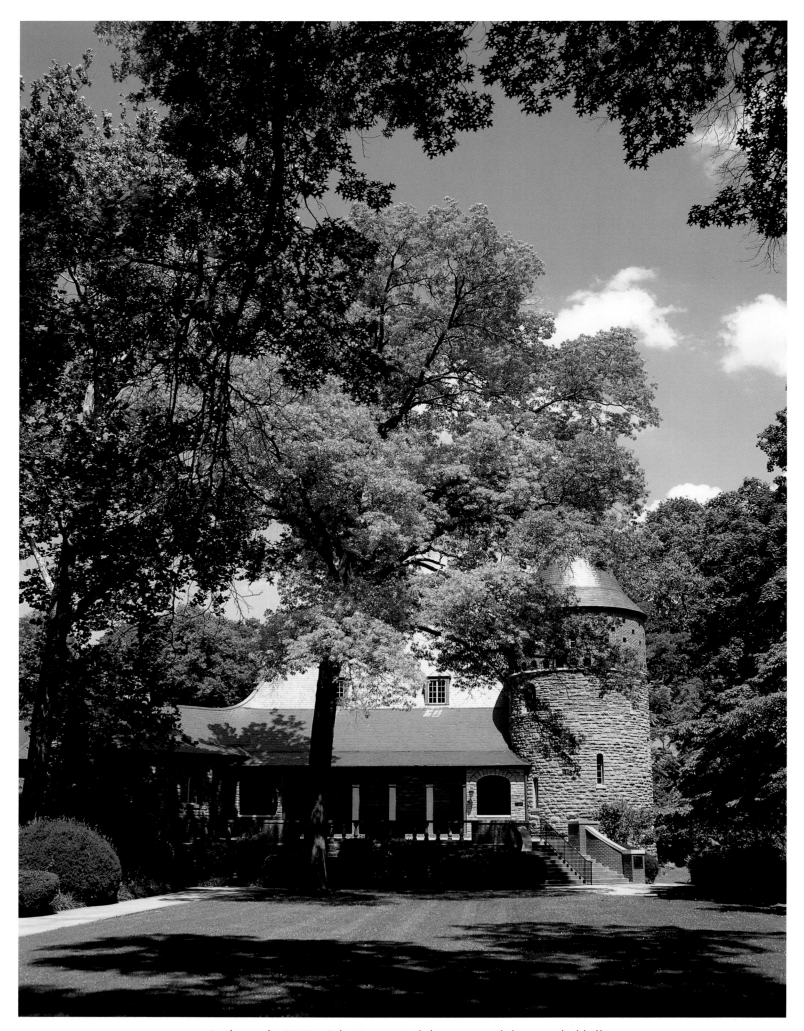

▲ In the early 1800s, John James Audubon roamed the wooded hills
along the Ohio River, drawing and painting his now-famous works
of American wildlife. This nature center at Audubon State Park
houses some of his original paintings.

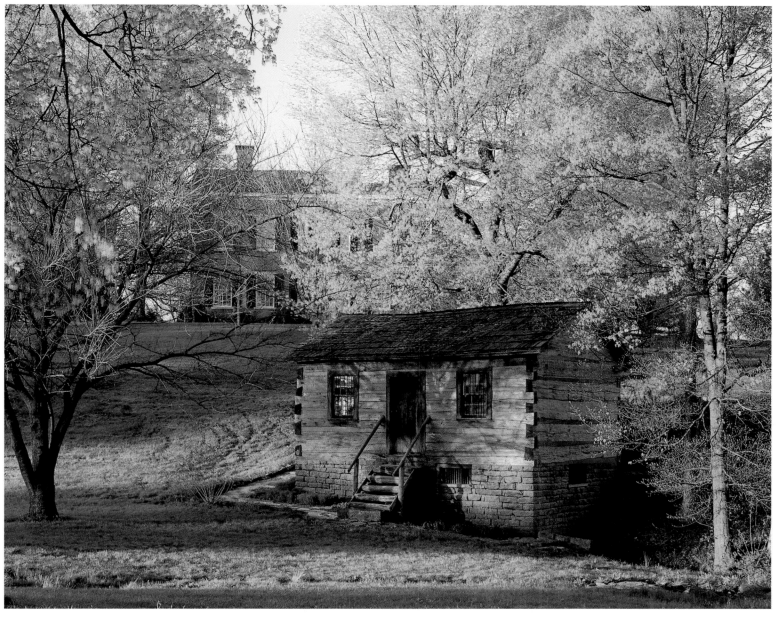

▲ Federal Hill Mansion in Bardstown sits above the former law office of John Rowan, owner of the home in the nineteenth century. The mansion is famous for being the subject of Stephen Foster's song, "My Old Kentucky Home." ►► A portion of the elegant Donamire Farm lies in Fayette County near Lexington.

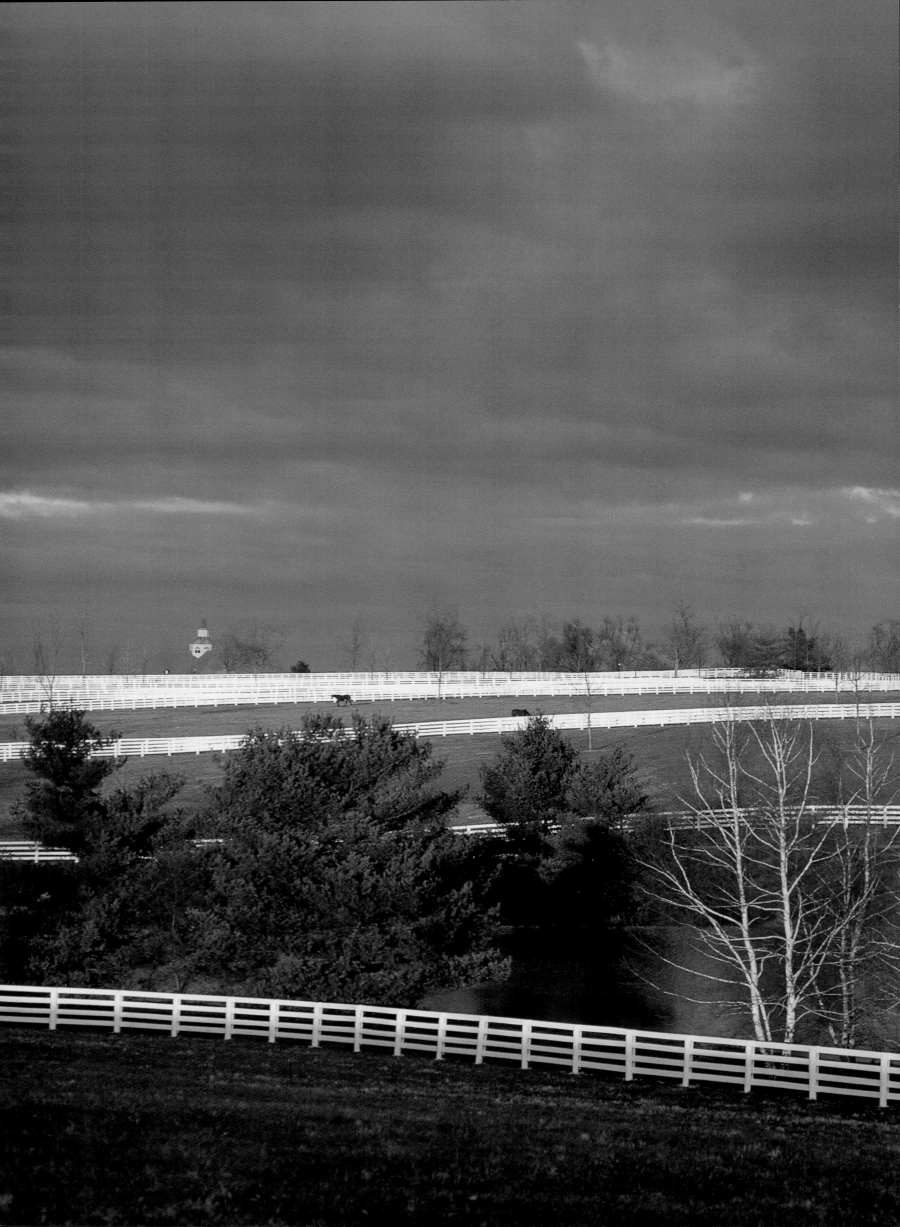

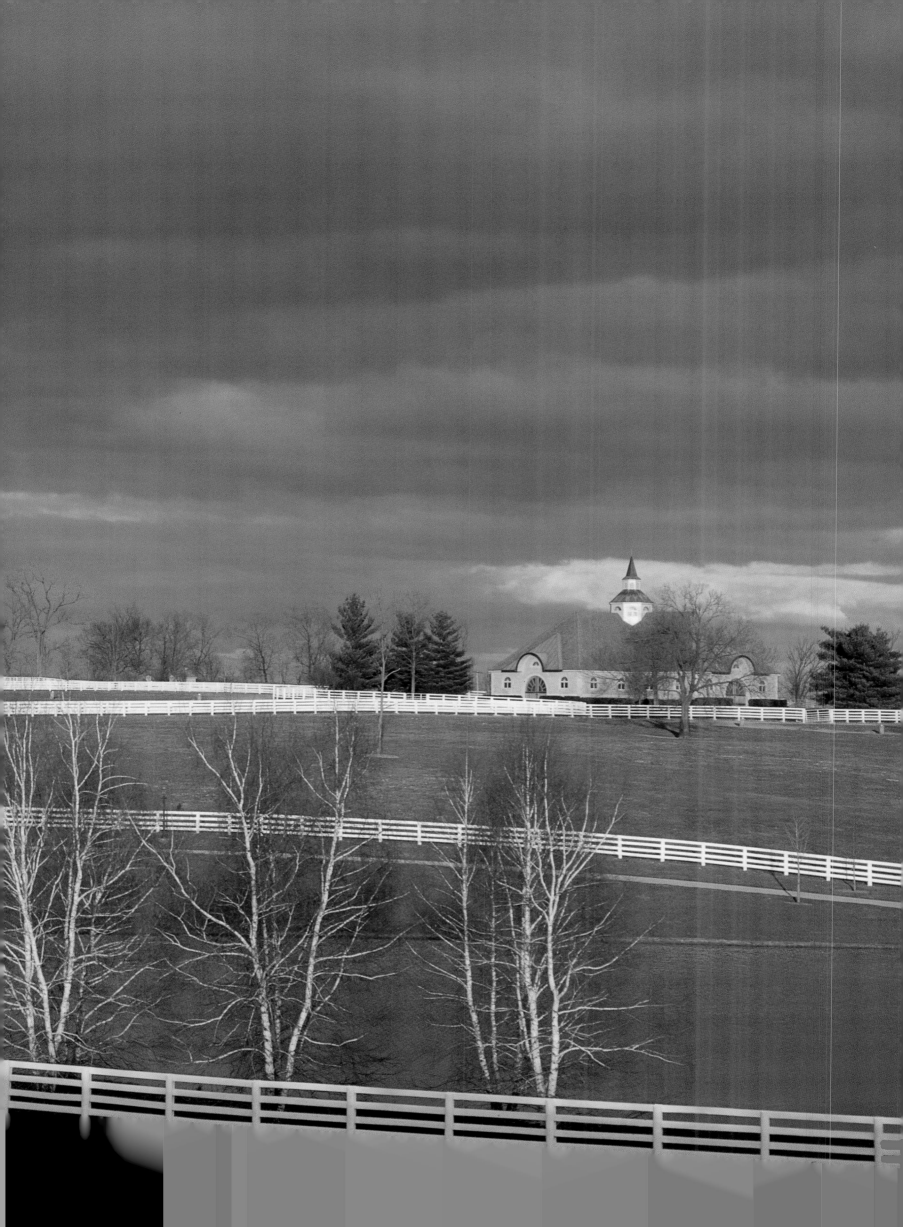

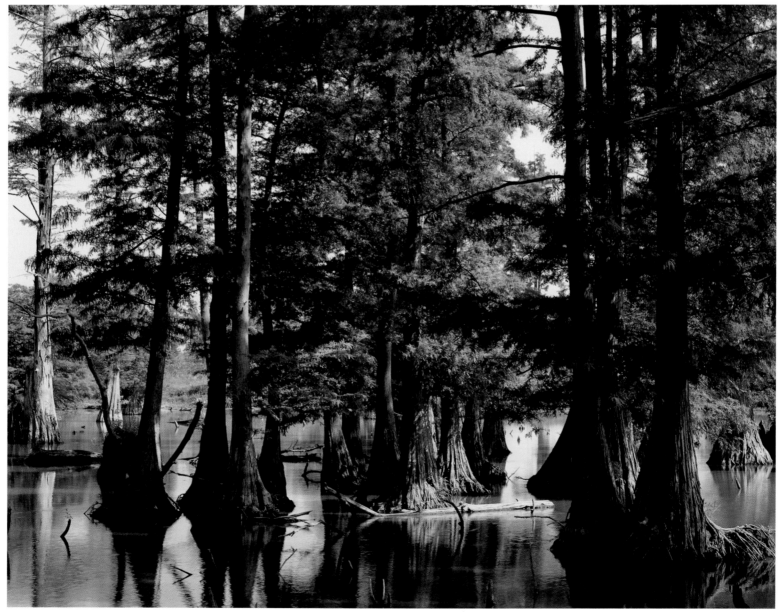

▲ The climate of far western Kentucky is similar to that of the more southerly states of Mississippi and Louisiana. Here, cypress trees grow in a slough along the Mississippi River. ▶ Illuminated by the thin light of a late autumn afternoon, this stand of hardwoods graces a ridge top in Pennyrile State Resort Park in Christian County.

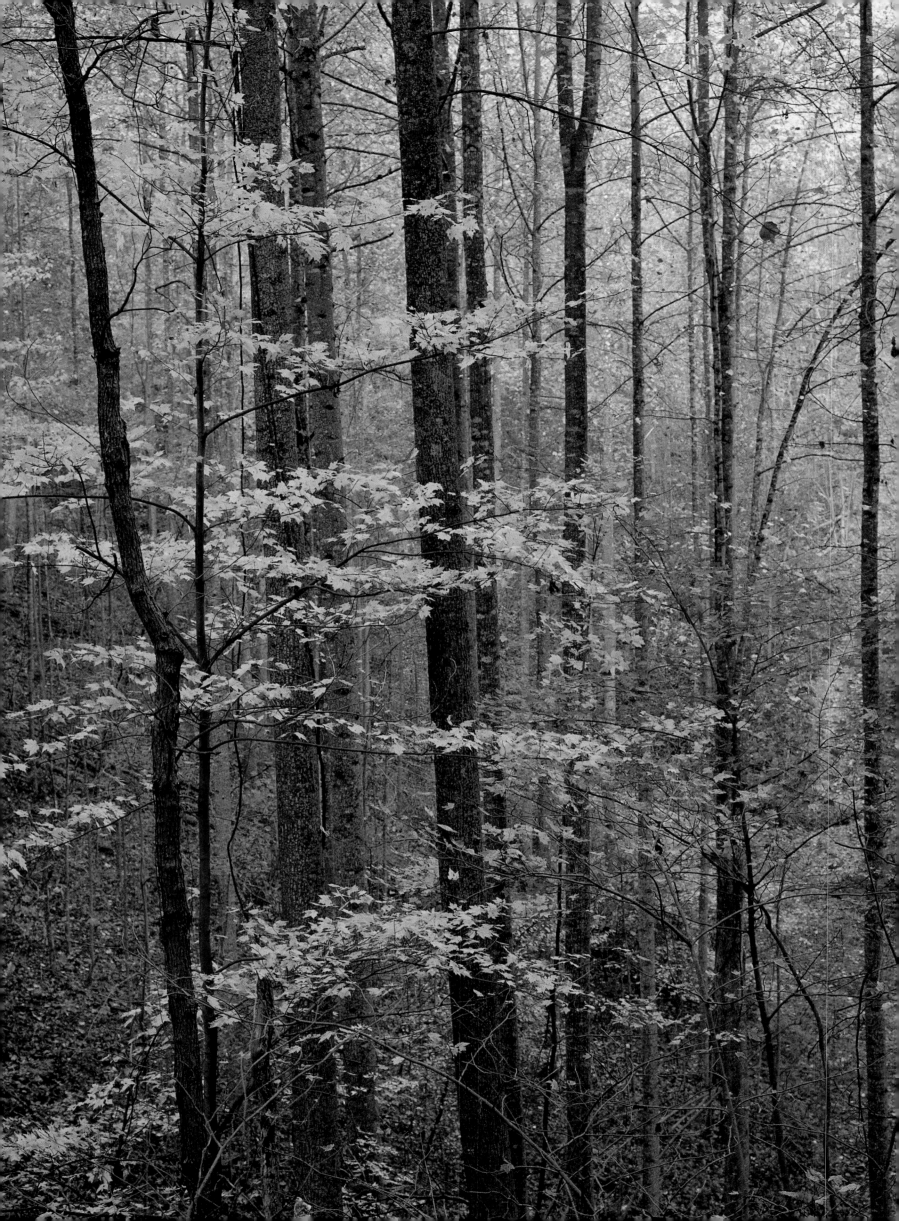

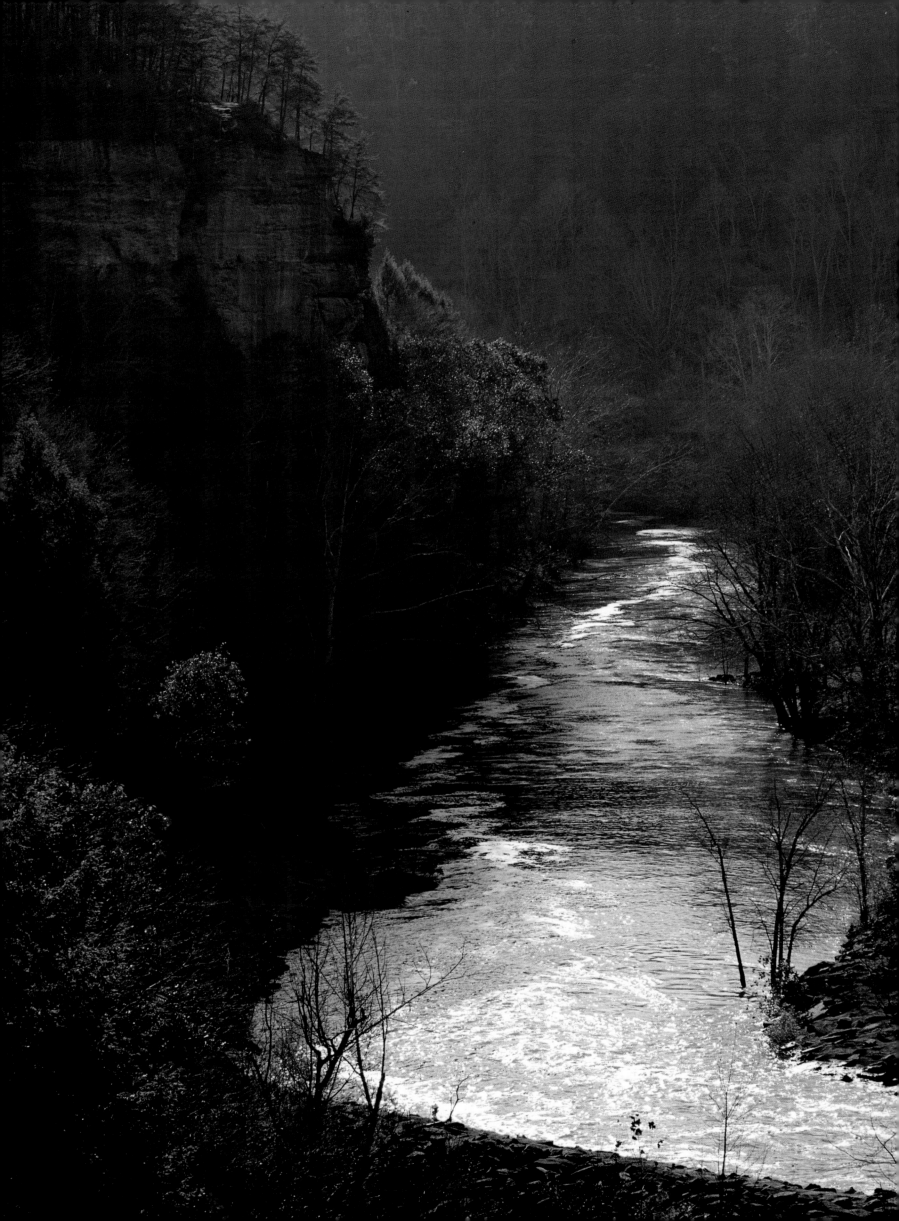

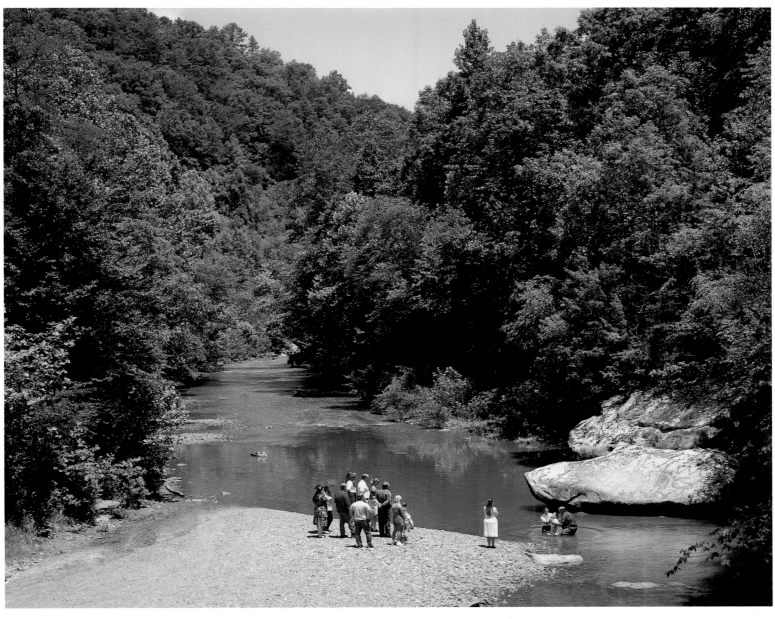

◄ Kentucky has more miles of rivers and streams than any state except Alaska. Here, the Nolin River flows along a cliff line below the dam at Nolin Lake in Edmunson County. ▲ As her family looks on, a young girl is baptized in Rock Creek following Sunday service at East Appletree United Baptist Church, near Revelo in McCreary County.

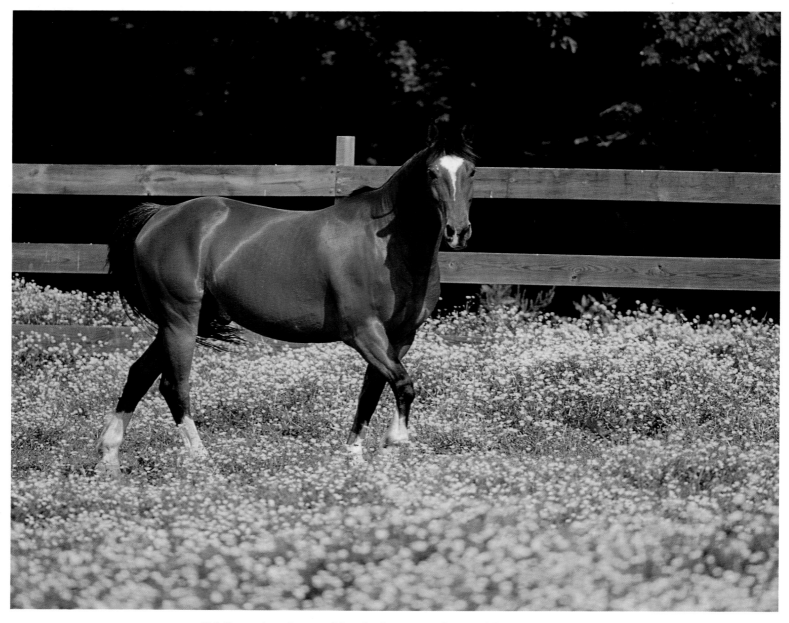

▲ While racing thoroughbreds dominate the world's attention, most horses in Kentucky are "family pets," ridden just for pleasure. Here, a stallion stands in his paddock in western Kentucky. ▶ Nature is taking its toll on this building in Oscar, in western Kentucky's Ballard County. Some old stores still operate, contributing to the charm of Kentucky.

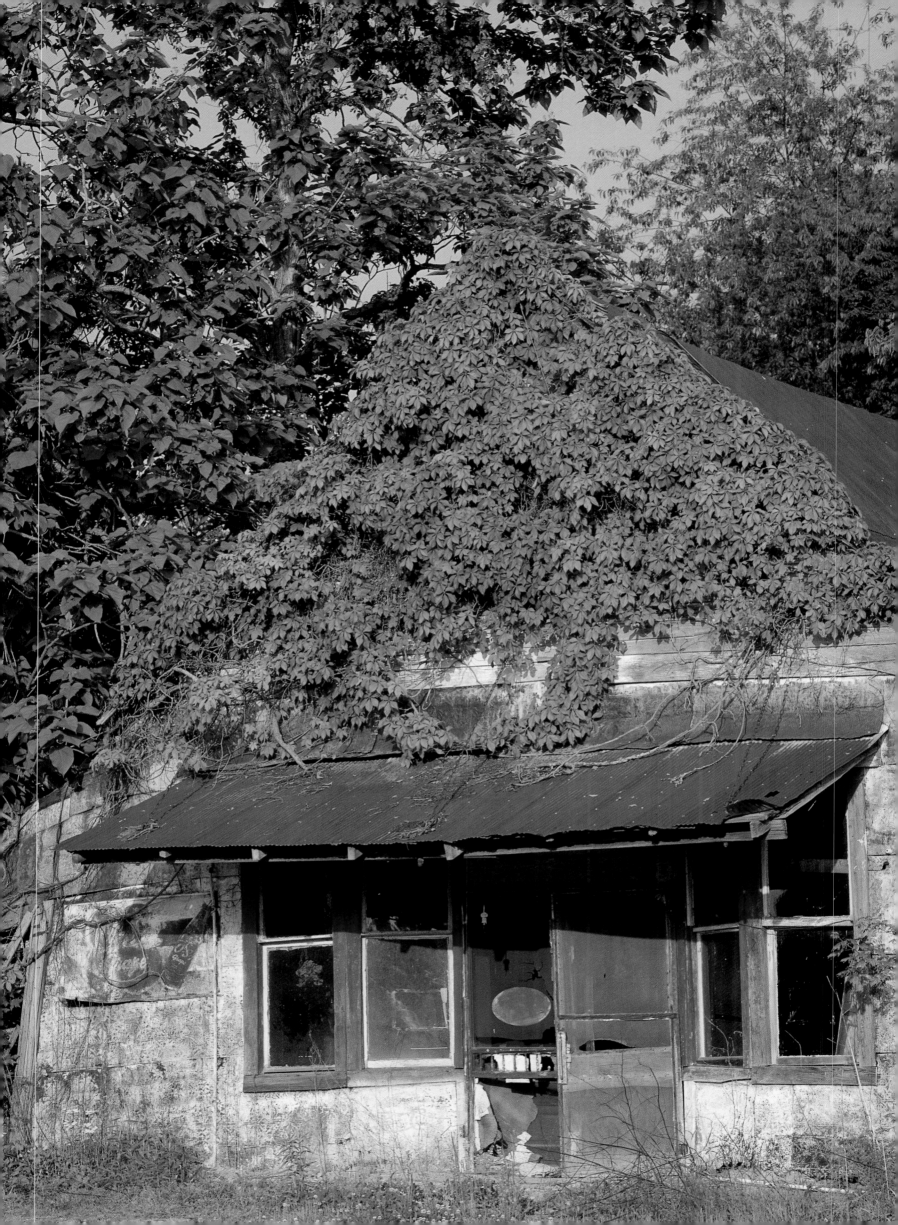

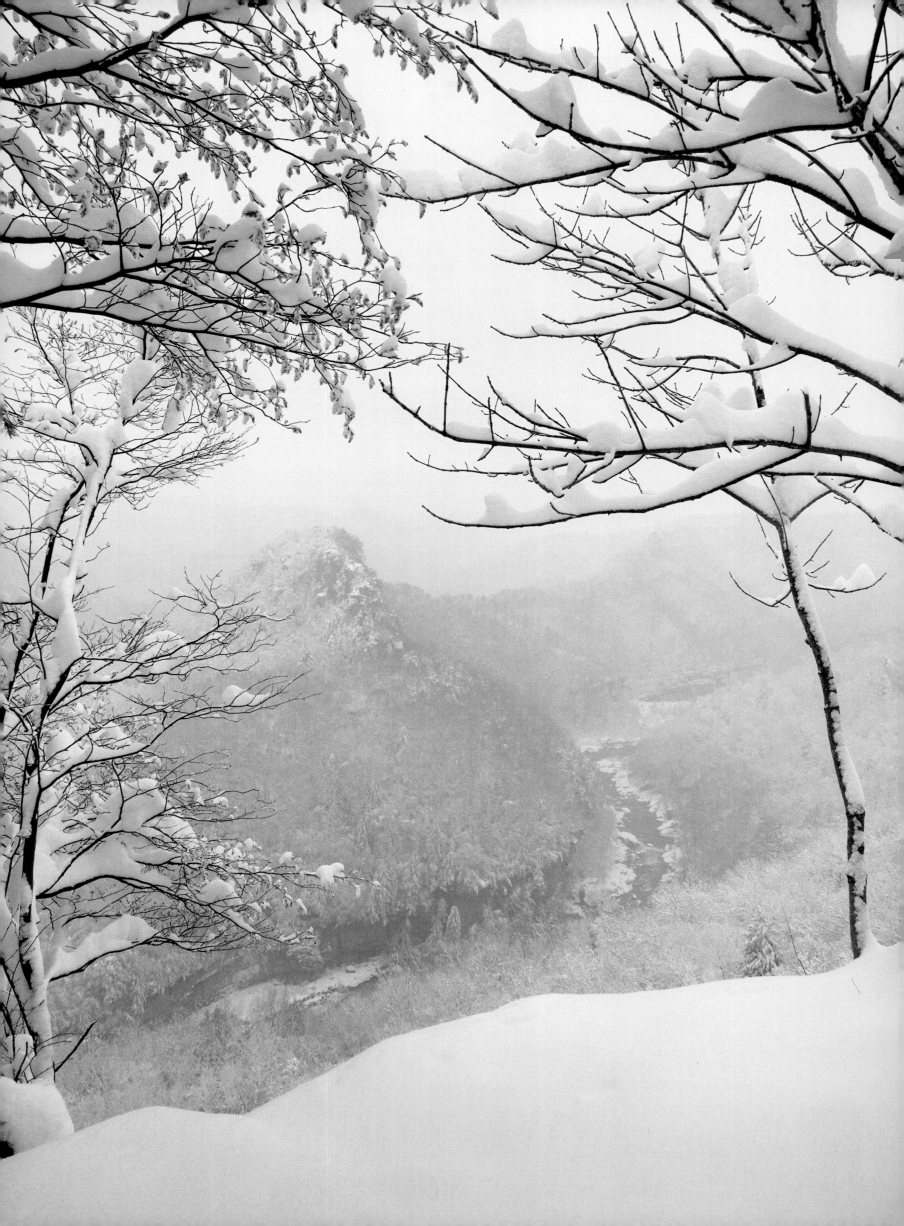

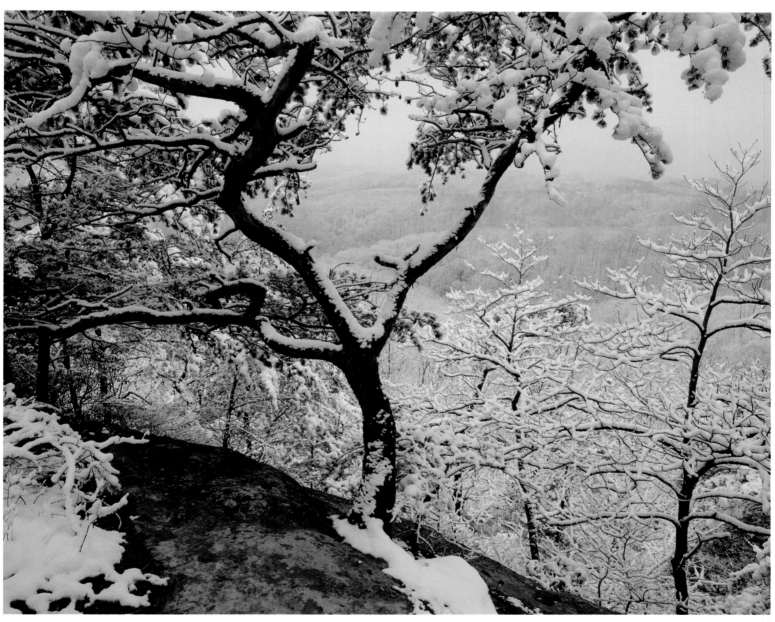

◄ Over millions of years, the Big Sandy River has cut a deep gorge, forming this rock pinnacle in Breaks Interstate Park on the Kentucky-Virginia border. ▲ Little Shepherd Trail is steeped in romantic history and folklore dating back to the early mountaineers who settled here.

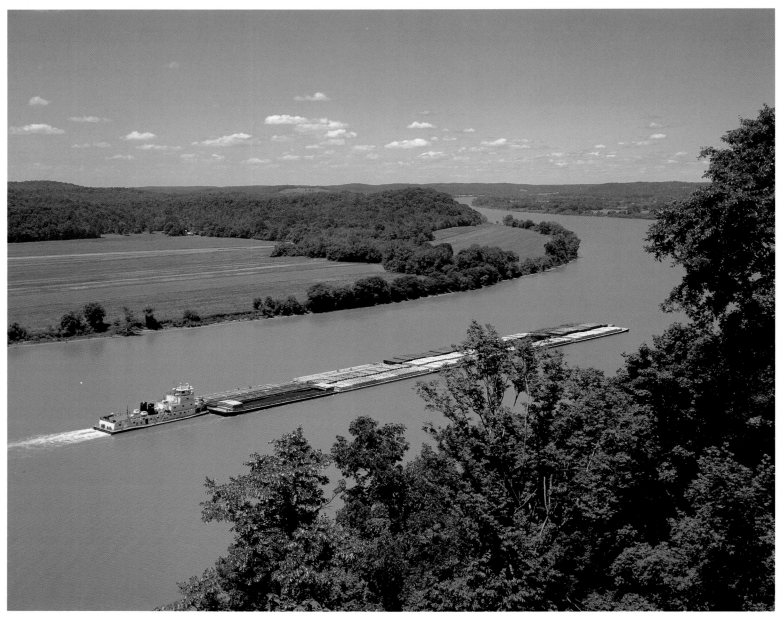

▲ Near Owensboro, a barge carries freight on the Ohio River north to Louisville and Cincinnati and on to Pittsburgh. ▶ The University of Kentucky's Memorial Hall exemplifies tradition in the shadow of UK's modern campus and the new state-of-the-art William T. Young Library.

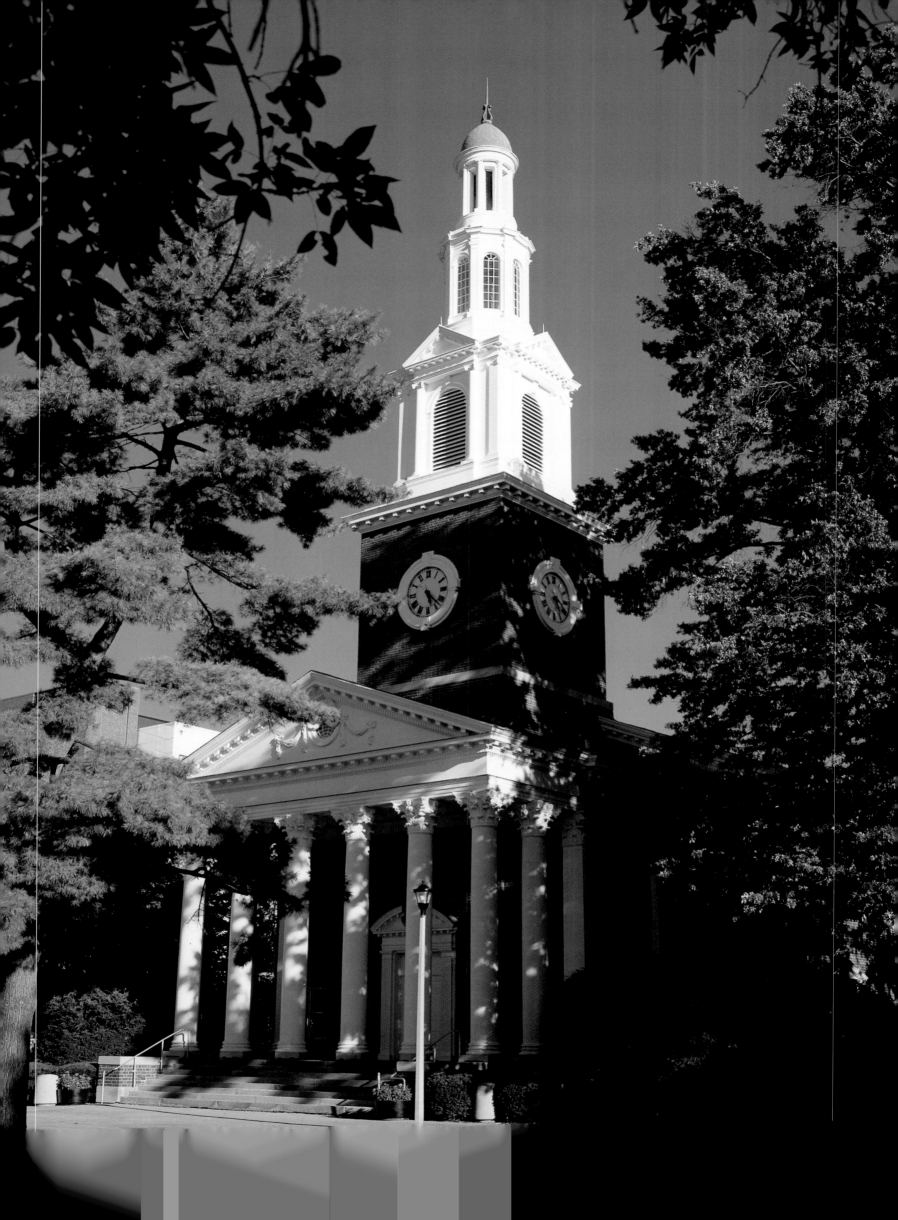

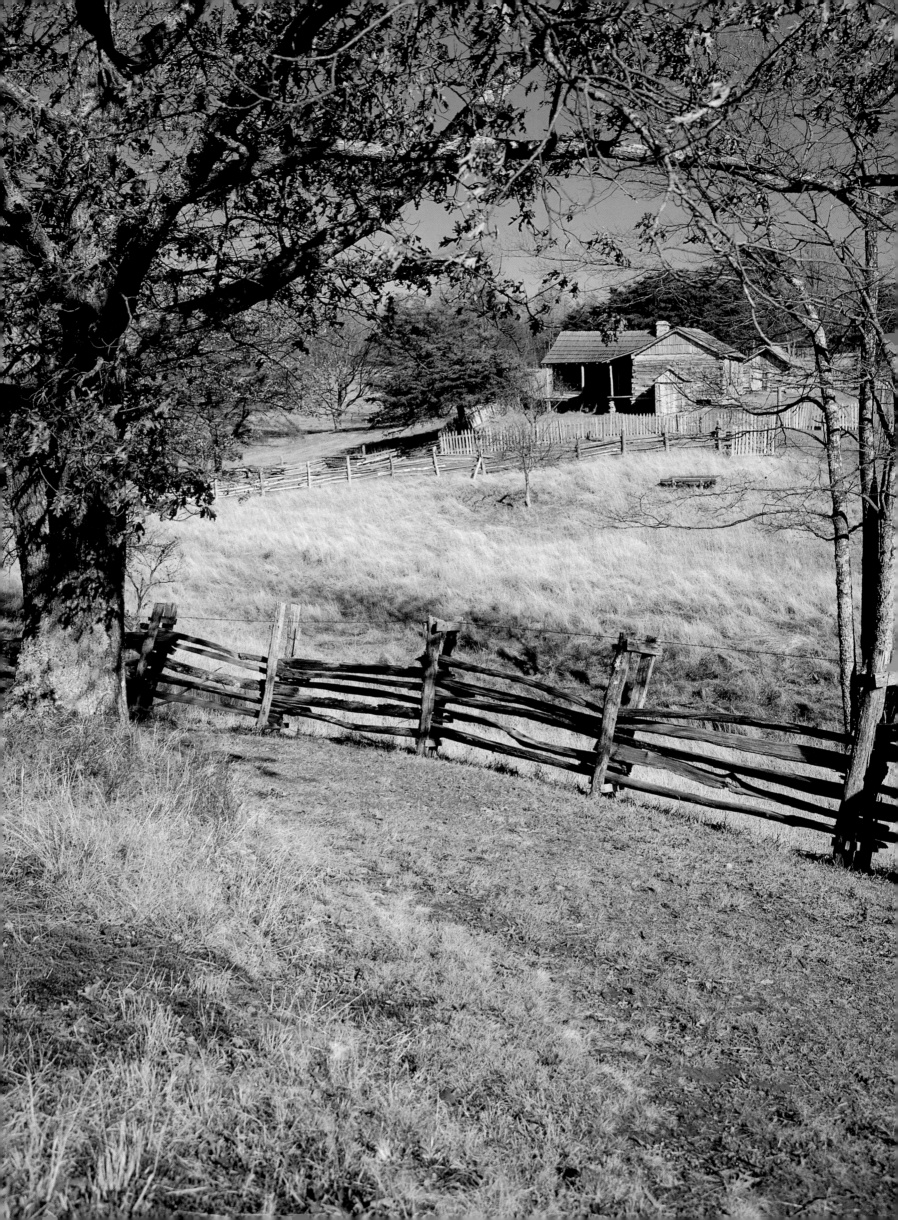

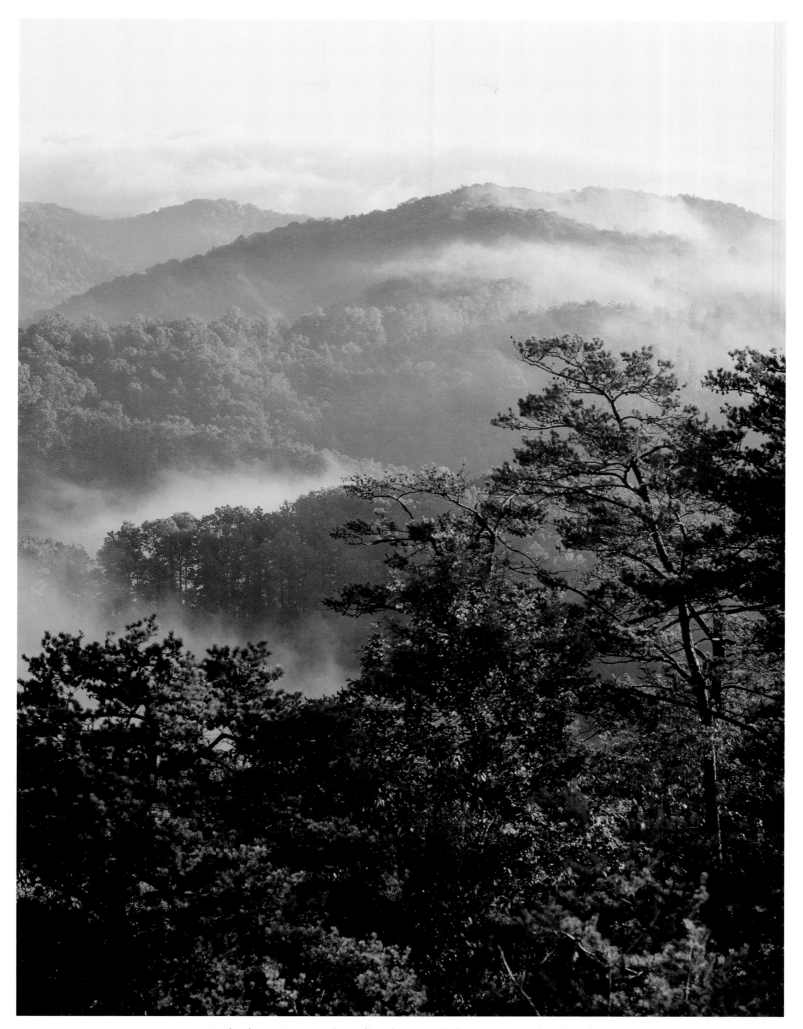

◄ In the late nineteenth and early twentieth centuries, the Hensley family lived and farmed the isolated mountaintop above Cumberland Gap in southeastern Kentucky. The National Park Service has restored the old settlement buildings. ▲ In late September, hints of autumn are found in the high, rugged, mist-shrouded hills of eastern Kentucky.

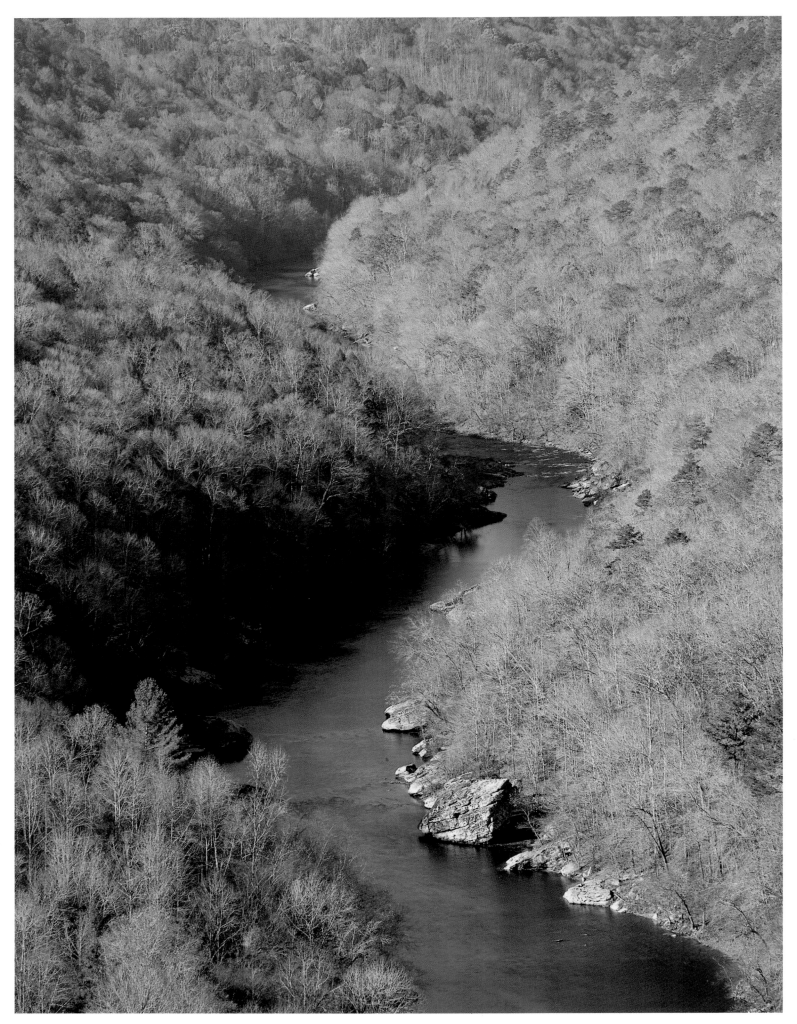

▲ The Big South Fork of the Cumberland River cuts a sharp, blue highway through the winter wilderness of the Big South Fork River and National Recreation Area in McCreary County.

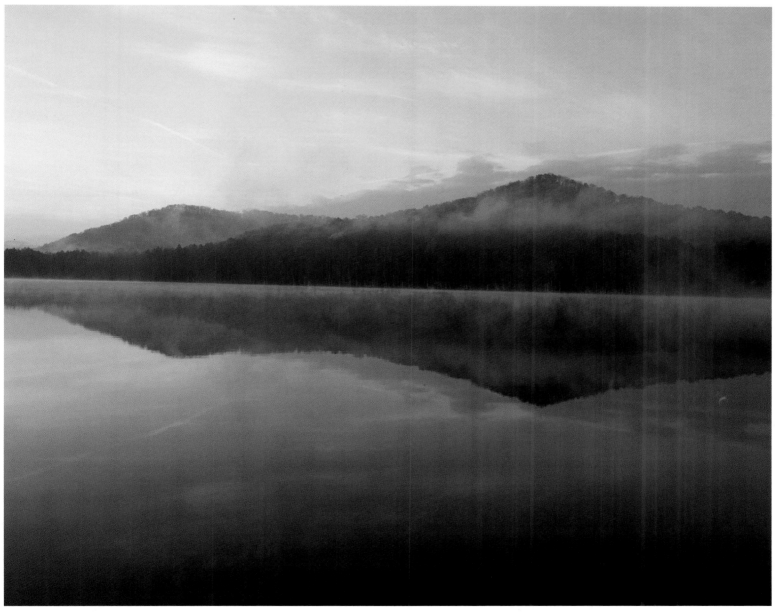

▲ In the higher elevations of the Daniel Boone National Forest in eastern Kentucky, mountain lakes provide recreational opportunities and breathtaking views for the early morning hiker. ► ► Mountain-bordered Dale Hollow Lake in south central Kentucky is renowned for its great fishing—particularly its record-sized smallmouth bass.

119

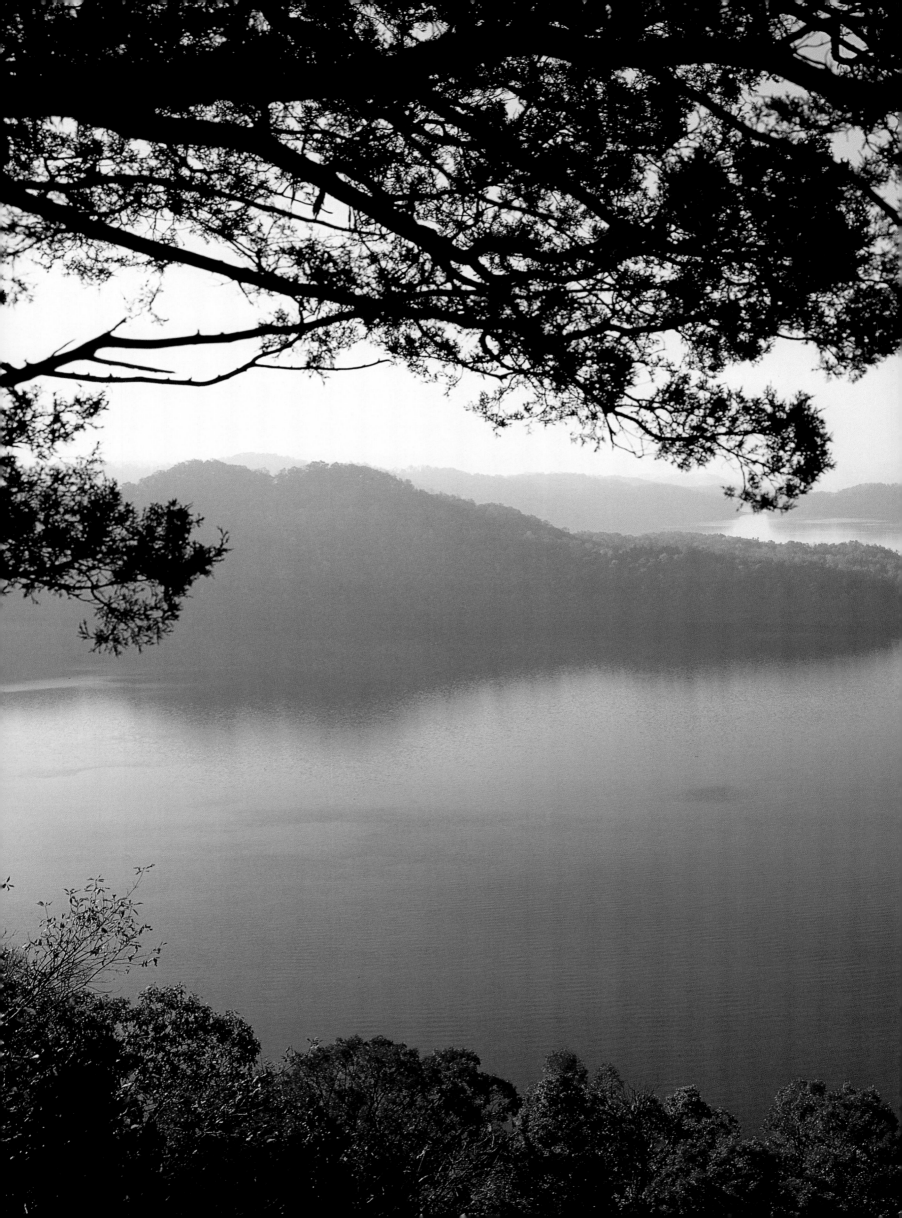

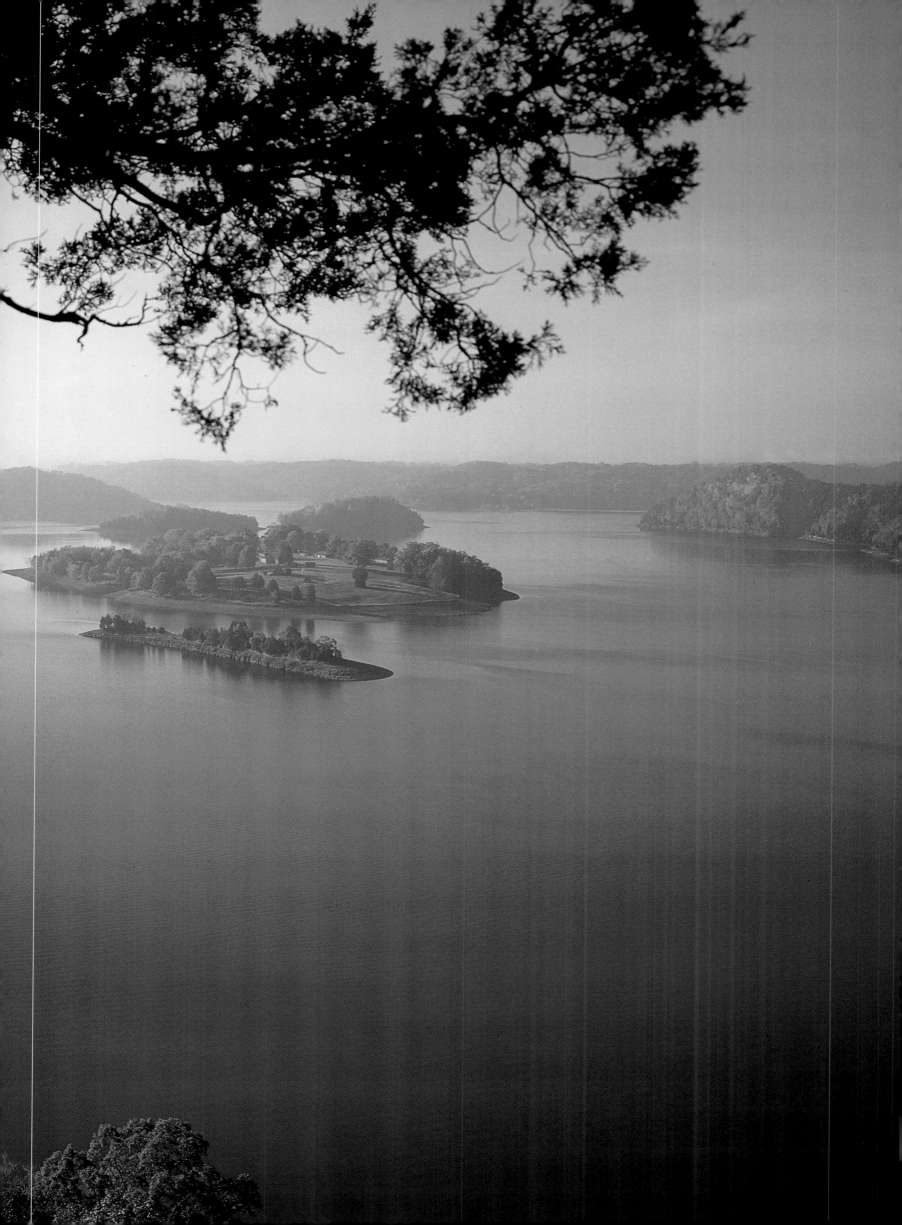

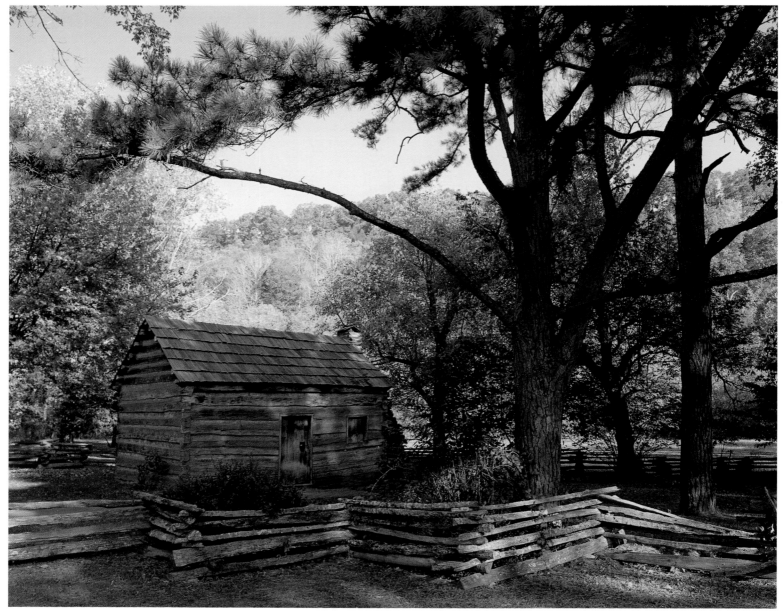

▲ Abraham Lincoln lived his early boyhood years in the original log cabin on this site beside Knob Creek in LaRue County. ▶ This forested hillside in eastern Kentucky's Daniel Boone National Forest shows the state's great variety of tree species. The Kentucky climate lends itself to both southern and northern varieties of trees.

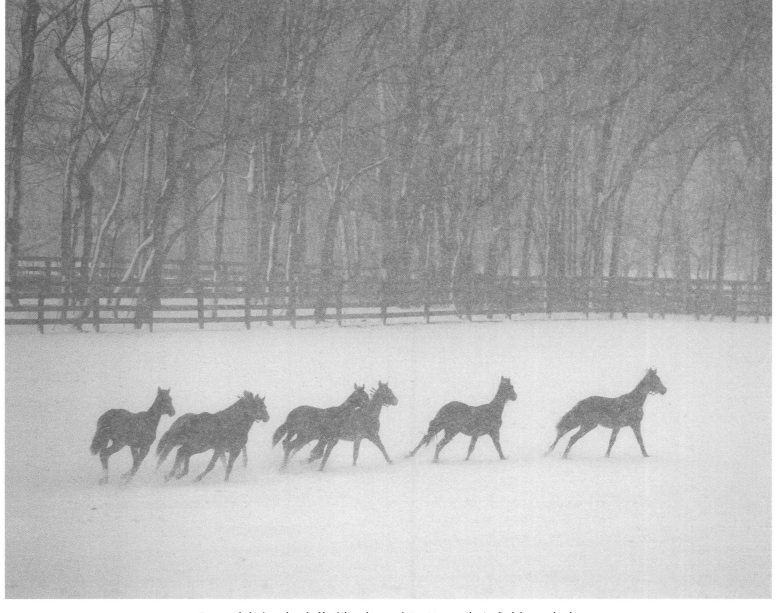

◄ Beautiful, hardy daffodils abound in Kentucky's fields and along the fencerows in spring. These are blooming in a yard along the historic Old Frankfort Pike in Woodford County. ▲ Horses seem to love a good snowfall. These galloping yearlings follow each other in a line through their paddock along the Frankfort-Versailles Pike.

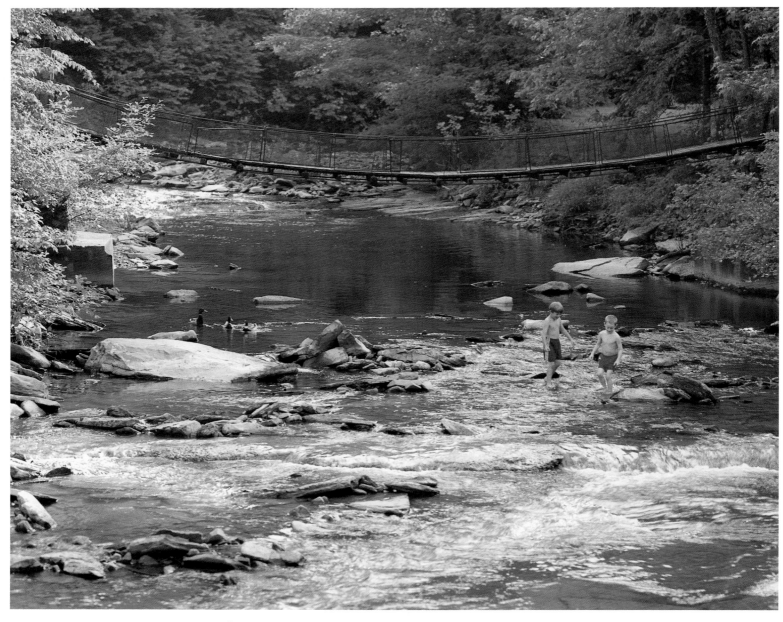

▲ Under a suspended footbridge, common in eastern Kentucky, resident ducks and children play in the summer water of Clear Creek in the Kentucky Ridge State Forest near Pineville.

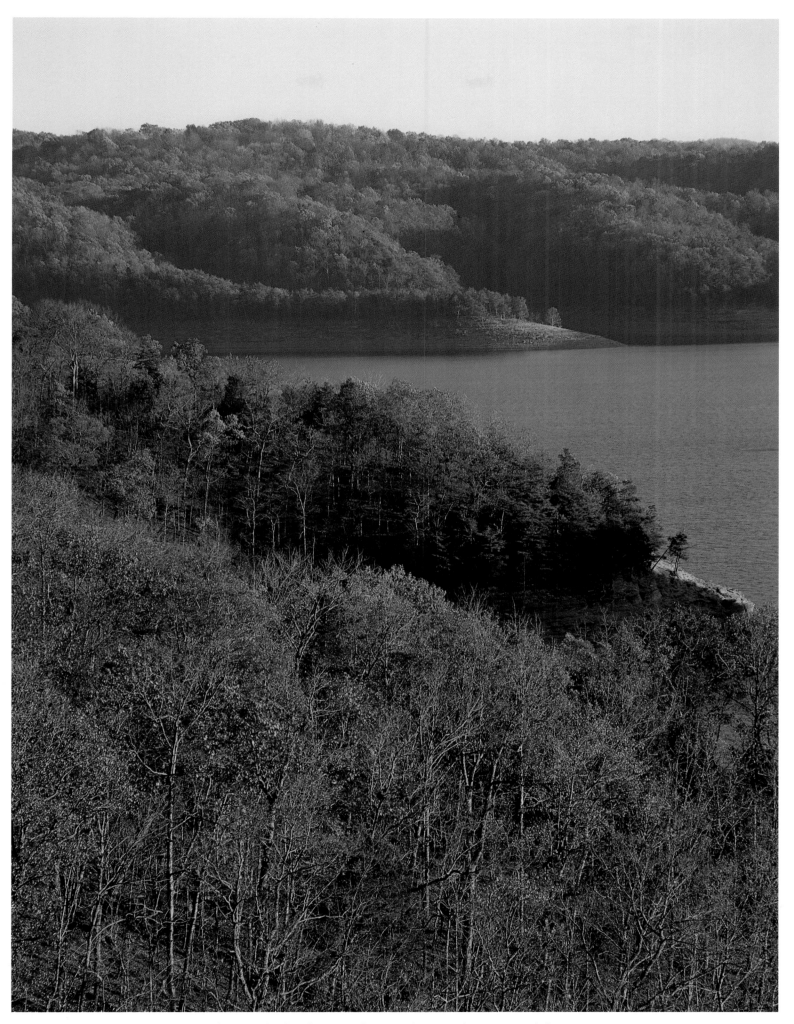

▲ Lake Cumberland, in south central Kentucky, is one of the state's most popular vacation areas, attracting visitors from many northern states who desire longer seasons for their water-related activities.

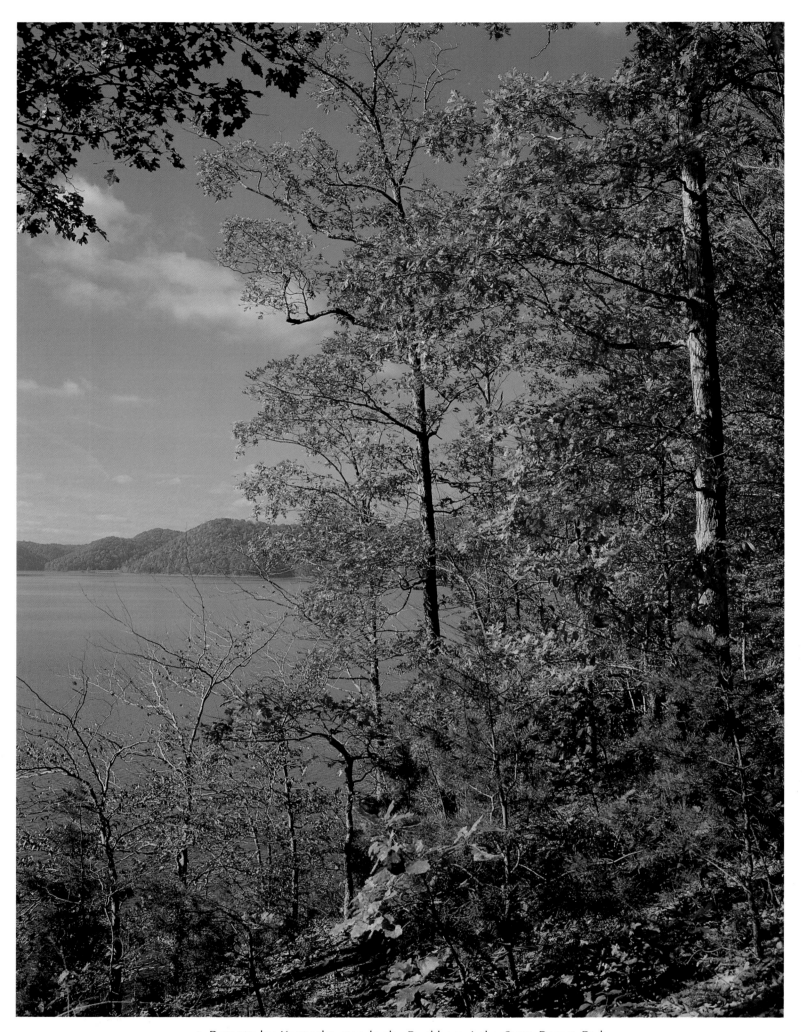

▲ Remote by Kentucky standards, Buckhorn Lake State Resort Park encompasses Buckhorn Lake, deep in a rugged, steep valley of the Appalachian Mountains in Perry County.

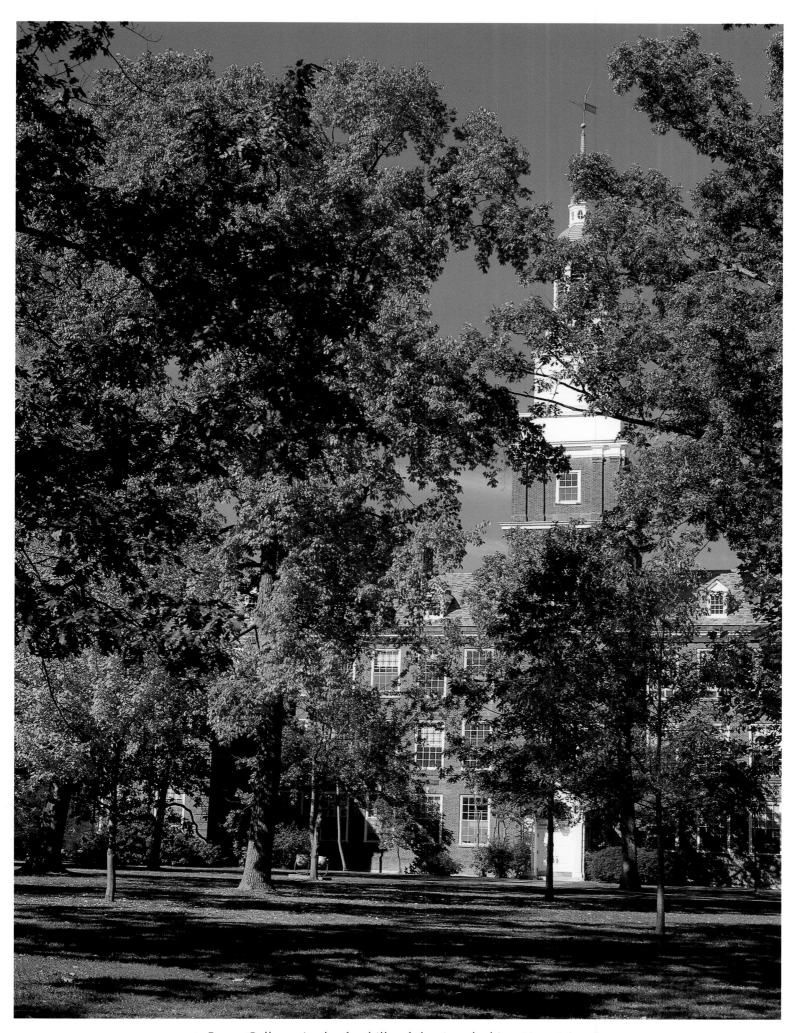

▲ Berea College, in the foothills of the Appalachian Mountains, is known throughout the world for its pioneering educational achievements and for being a regional center for fine arts and crafts.

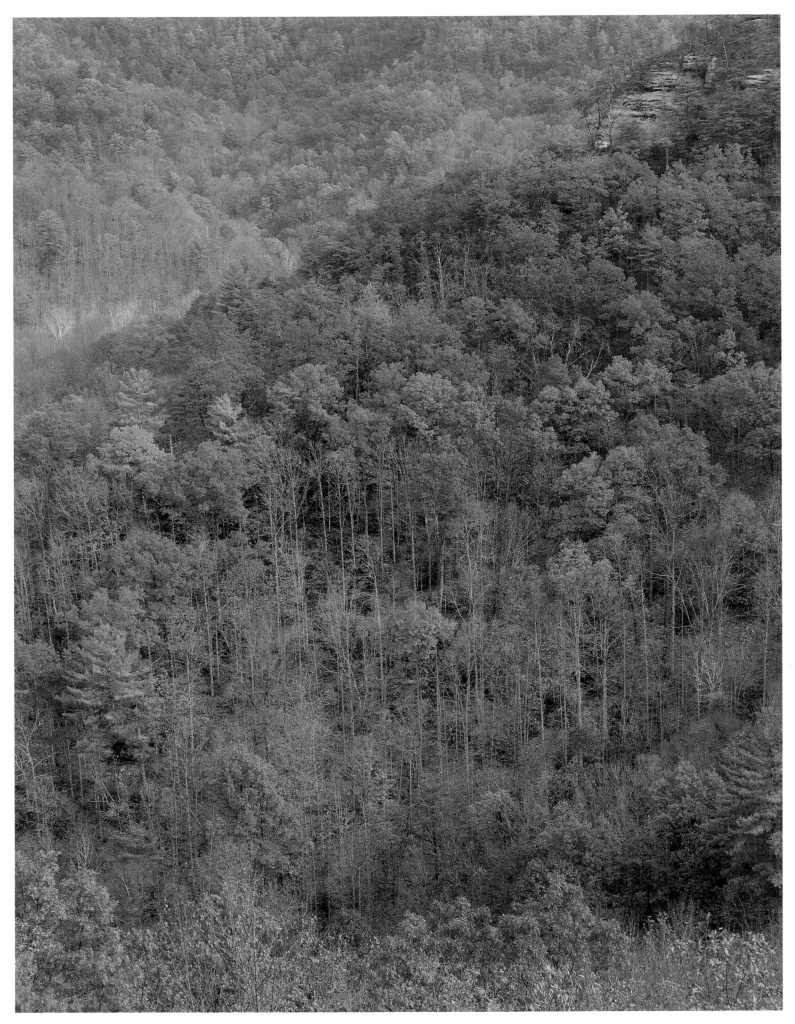

▲ Because of its rugged beauty and challenging terrain, the Red River Gorge Geological Area, in Menifee County, is one of Kentucky's most popular hiking and backpacking destinations.

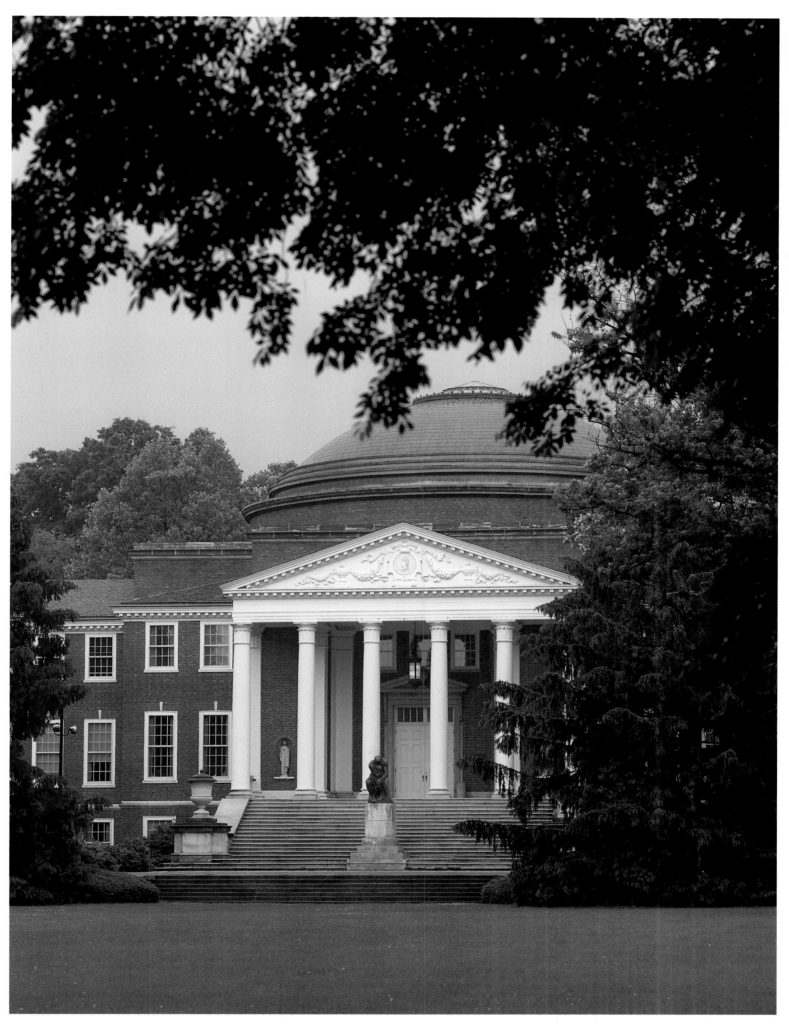

▲ The University of Louisville is one of the premier institutions of higher learning in Kentucky. This photograph of Grawemeyer Hall on a quiet Sunday morning belies an active campus of 23,000 students.

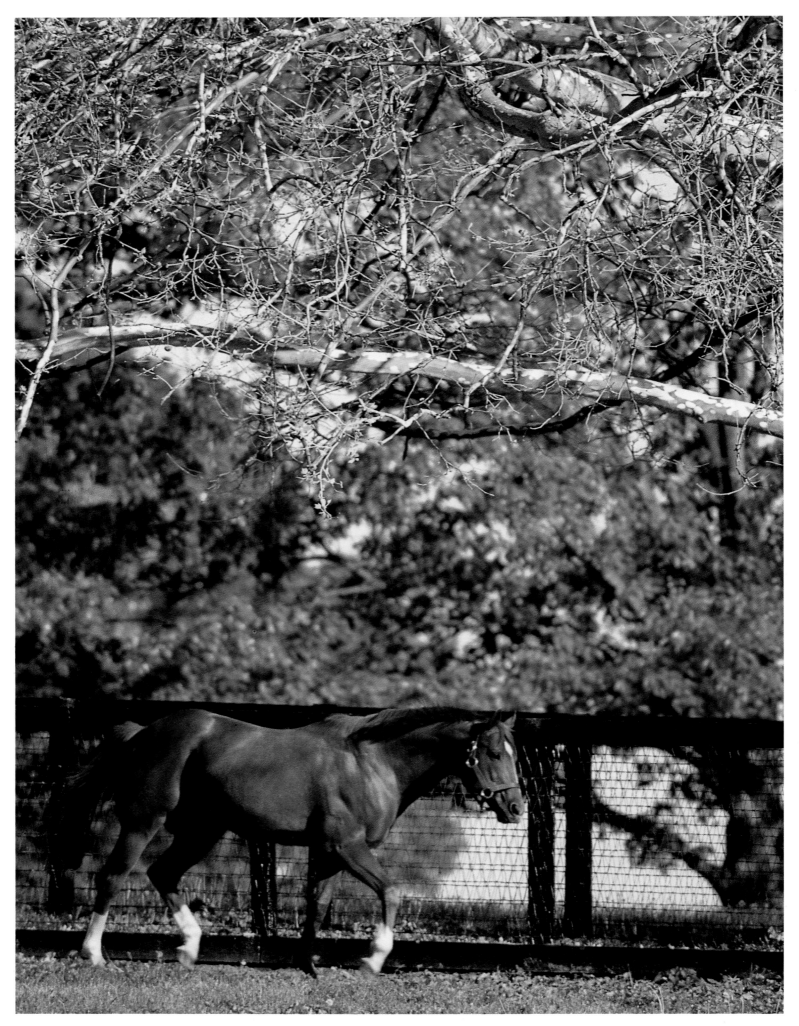

▲ Secretariat is one of the most famous race horses that ever lived. In the minds of those who loved him, "Big Red" still walks the fence line of his paddock on Claiborne Farm near Paris.

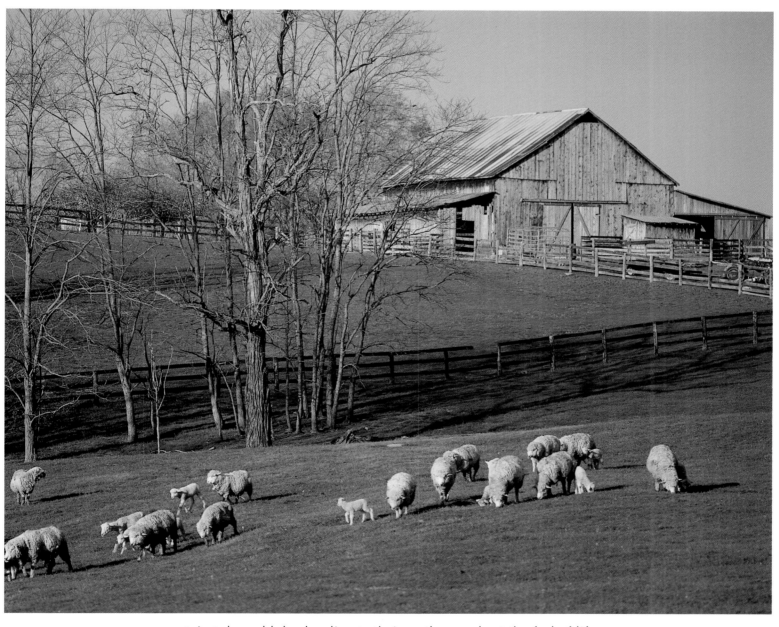

▲ Just days old, lambs cling to their mothers and get the feel of life on Jim and Elizabeth Boggs's Spring Trace Farm in Woodford County.

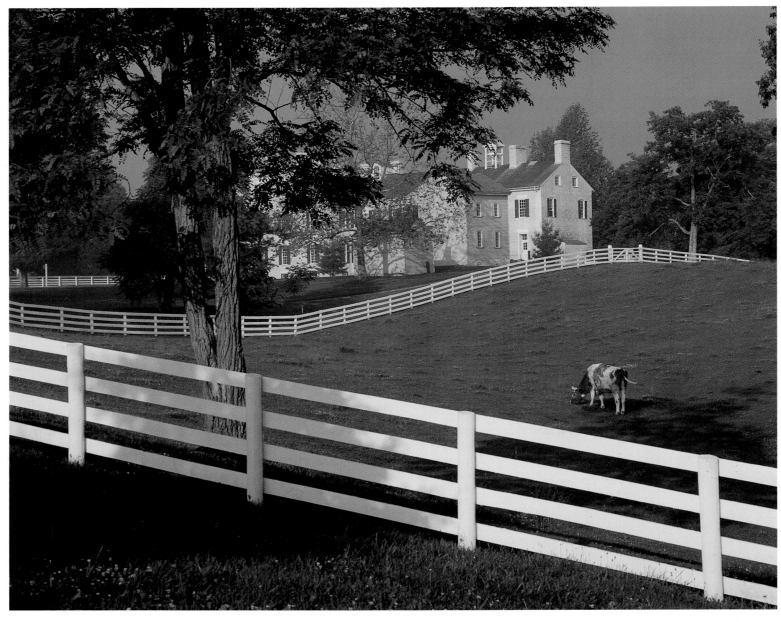

▲ In 1805, the Society of Shakers formed a religious community at Pleasant Hill. Here, the restored Centre Family Dwelling dominates.
▶ Riverview at Hobson Grove, a nineteenth-century Victorian-style home, is one of Bowling Green's historic landmarks. ▶ ▶ Outside Lexington in Fayette County, a thoroughbred grazes under mature trees.

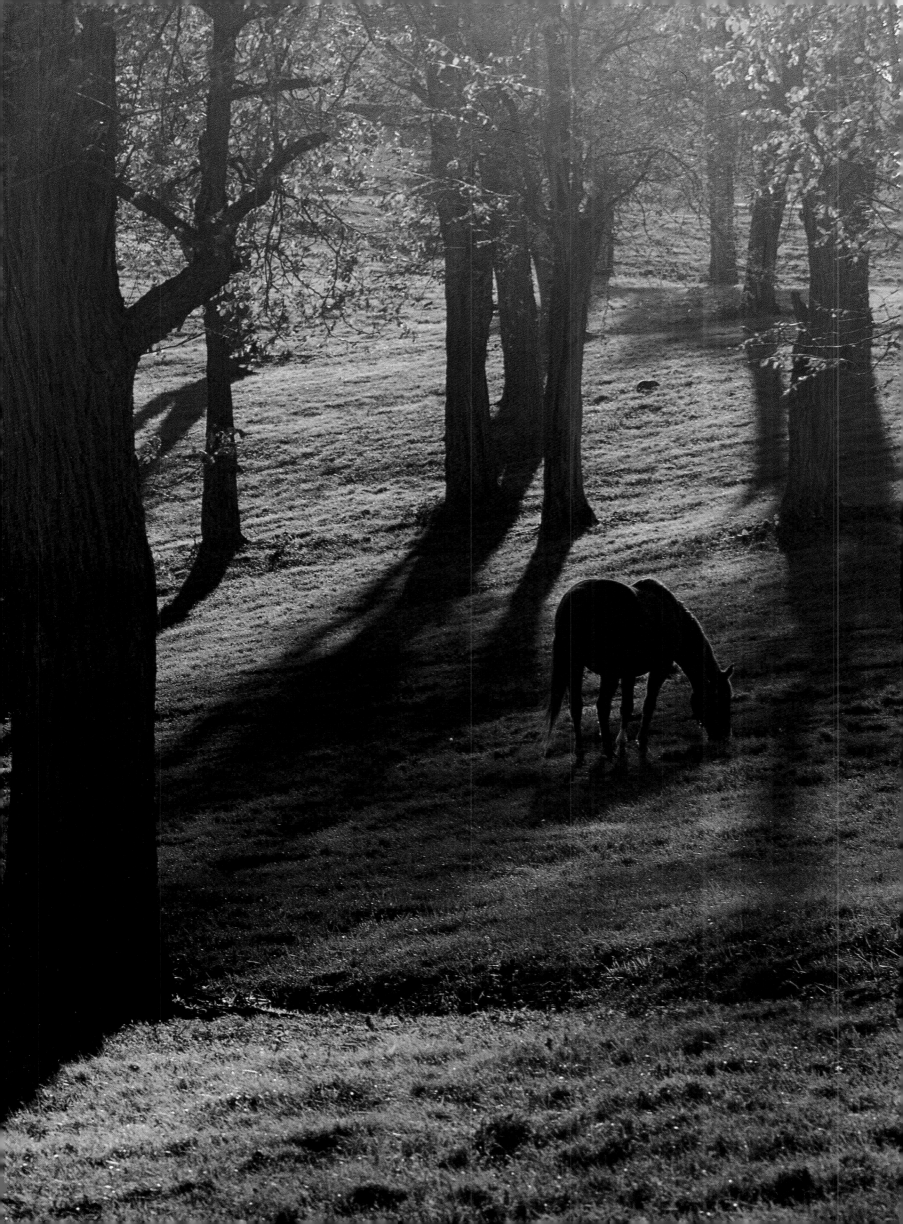

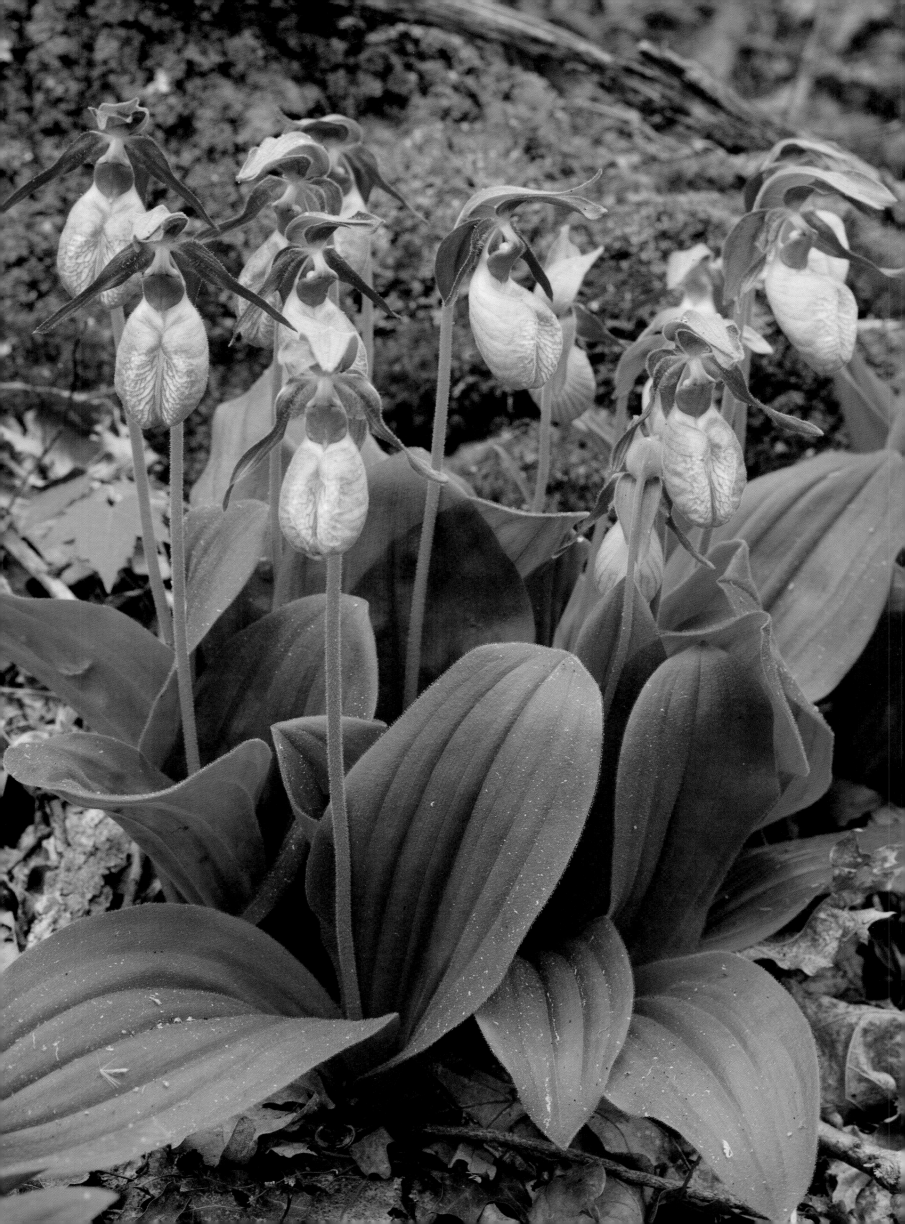

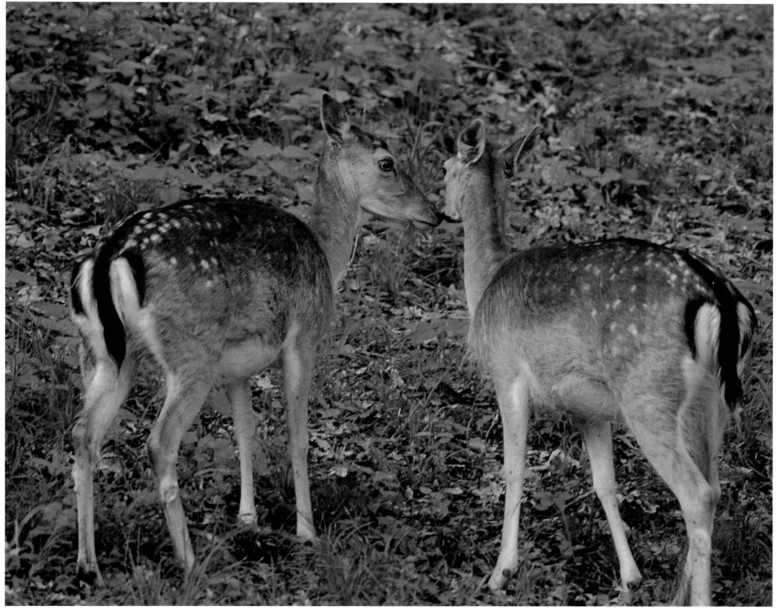

◄ The relatively rare pink lady slipper grows in beds of pine needles in mountainous sections of the state. ▲ These fallow deer fawns pause from grazing in their preserve at Land Between the Lakes National Recreation Area in western Kentucky. The large eyes indicate the low light conditions of the forest in early evening.

▲ Dressed in Union blue, a young man plays his flute to pass the time while waiting for the start of the reenactment of the Battle of Perryville, Kentucky's bloodiest Civil War engagement.

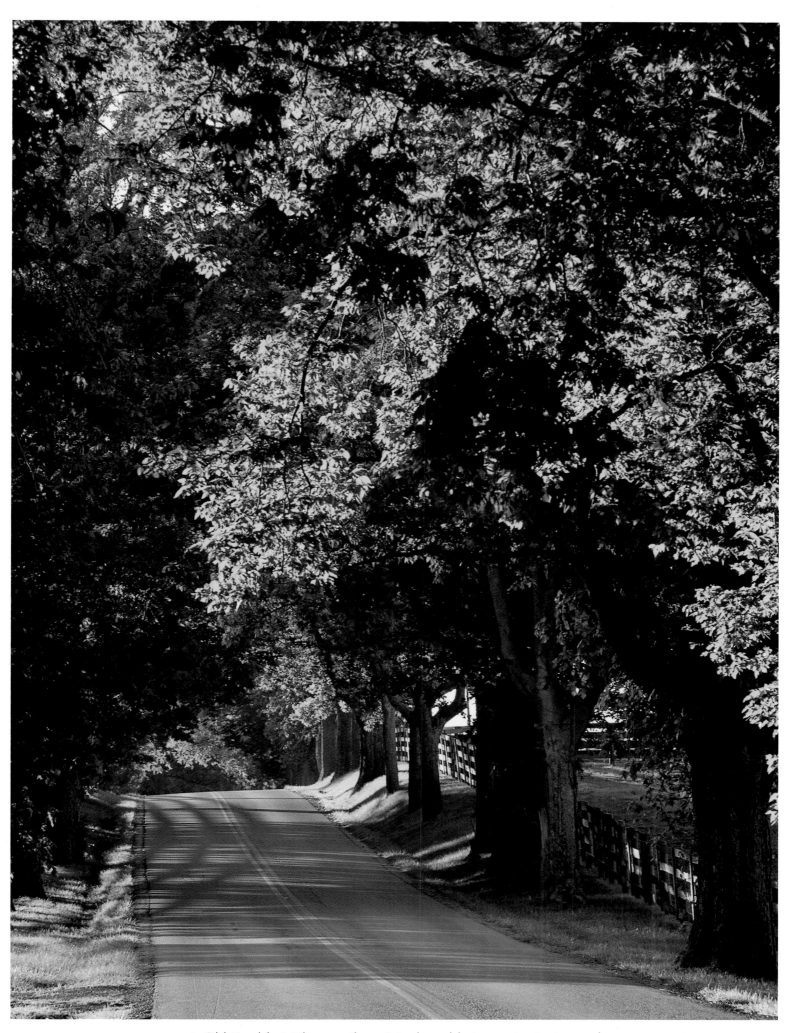

▲ Old Frankfort Pike was the original road between Lexington and the state capital at Frankfort. Some of Kentucky's oldest and most famous horse farms line its historic corridor.

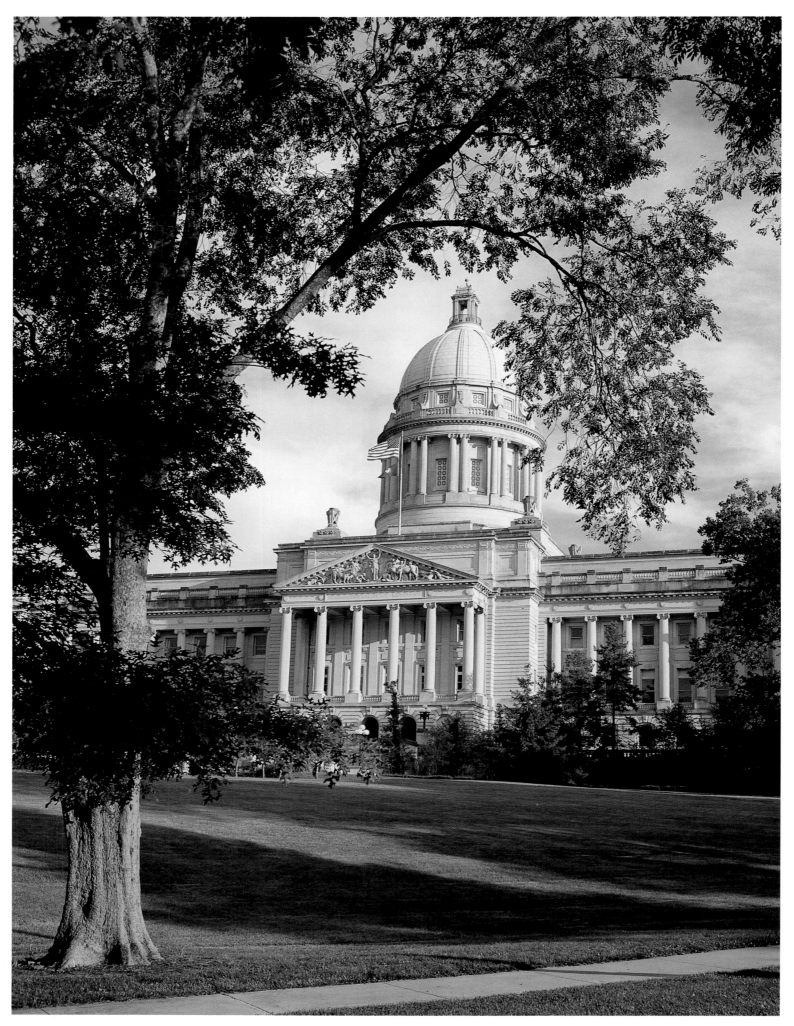

▲ On a soft-lit summer evening, the state capitol at Frankfort reveals
its delicate, calmer side—a contrast to its usual bustling atmosphere
as home to Kentucky's executive, legislative, and judicial functions.

▲ Lake Barkley, formed by damming the Cumberland River, is located in far western Kentucky. Two bodies of water—Lake Barkley and Kentucky Lake—together enclose the region known as Land Between the Lakes National Recreation Area.

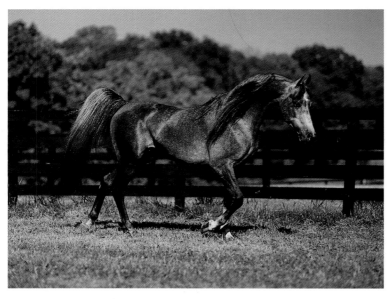

Bred for their beauty, Arabians are coveted show horses. Here, a stallion prances in his central Kentucky paddock.

ACKNOWLEDGMENTS

I first visited Kentucky in February 1963 and recall a strong visual attraction to the beauty I found. Now, thirty years later, after moving here in 1969, I find that visual attraction stronger than ever. Perhaps it is because I have photographed the state many times and have never become tired of its landscape. No matter where I travel and take my cameras, there is no place quite like Kentucky.

There are many people to whom I owe thanks, who have encouraged me and have contributed greatly to my life and my life's work. My gratitude goes first to my wife Lee for her love and support and for being my best friend; to my stepsons Eli and Noah for helping me keep young; and to my sister Kathy, her husband Bennett, and my stepmother Esteleen. I want to give special thanks to Dr. Thomas D. Clark, a true gentleman and friend of all Kentuckians.

—James Archambeault
Lexington, Kentucky, September 1, 1998